The Enjoyment
and Use of Color

BY

WALTER SARGENT

Formerly Professor of Art Education and
Chairman of the Department of Art,
The University of Chicago

New York

DOVER PUBLICATIONS, INC.

Published in Canada by General Publishing Company, Ltd., 30 Lesmill Road, Don Mills, Toronto, Ontario.
Published in the United Kingdom by Constable and Company, Ltd., 10 Orange Street, London WC 2.

This Dover edition, first published in 1964, is a corrected and revised republication of the work first published by Charles Scribner's Sons in 1923. Seven new color plates have been prepared especially for this edition by Anthony Toney.

Standard Book Number: 486-20944-X
Library of Congress Catalog Card Number: 63-20254

Manufactured in the United States of America
Dover Publications, Inc.
180 Varick Street
New York, N.Y. 10014

PREFACE

This volume is arranged primarily as a text-book in color for art departments of secondary schools and colleges, but also as a book for general reading. In it I have endeavored to present a definite and practical method of approach to the study and appreciation of color, which will be helpful to that large class of people who do not expect to be artists but who would like to know more about color and its use, and to increase their own enjoyment of color in nature and in art.

The considerations here presented are based upon my class work with students in the University of Chicago, and upon my own experience as a landscape-painter.

WALTER SARGENT.

CONTENTS

CONTENTS

ILLUSTRATIONS

IN COLOR

BLACK AND WHITE

"Again what meaning lies in Color! From the soberest drab to the high flaming scarlet, spiritual idiosyncrasies unfold themselves in choice of Color; if the Cut betokens Intellect and Talent, so does the Color betoken Temper and Heart."

Sartor Resartus.

INTRODUCTION

Color Is an Important Influence in our Surroundings.— Color is a positive force which affects our nervous systems, probably by an electrochemical activity. Every person with normal eyesight feels its influence. This influence is based upon the stimulation of the senses which results when white light, broken by reflection or refraction into its various wave-lengths, falls upon our vision, so that instead of sombre grays we see varying hues which appear to add a kind of vitality to forms. Each hue exerts its particular effect upon us. The impressions produced by a given hue are so specific that even animals and insects appear to have marked preferences for certain colors. At least their behavior is evidently influenced by changes of color.

Enjoyment of Color Develops Rapidly with Training.— Pleasure in color is so nearly universal that we often take it for granted that our common untrained experience, sums up its possibilities. Our enjoyment of the mere sensations of different hues and their combinations may be considerable, but it is meagre as compared with the expansion of seeing, and of consequent interest and appreciation, when we advance from the state of simple visual stimulation to an acquaintance with the ordered relations of hues, the qualities of color textures, and the harmonies of balanced

1

tones. We break through our habits of thought which
have limited our seeing, and find in nature and in art fresh
sources of keen enjoyment and of profound æsthetic ex-
perience. The advance from the stage of pleasure in ordi-
nary color sensations and combinations to that of trained
appreciation, is comparable to what occurs in the world of
music when we progress from enjoyment of sensations of
sound, and of the more evident and commonplace rhythms,
to the realms of harmony which lie beyond and are accessi-
ble to most of us only by way of some introductory train-
ing. Indeed, color is to some of us what music is to others,
namely the particular form of artistic expression in which
we find greatest satisfaction.

**Response to Color Training Is Prompt and Almost Uni-
versal.**—Classroom work with groups of students who have
varying interests and capacities shows that less technical
ability is required in order to develop a considerable degree
of experience with and appreciation of color than seems to
be called for in the study of form. We may not possess
sufficient dexterity to produce beautiful combinations of
line and to acquire that intimate acquaintance with their
expressiveness which comes when we watch them grow
under the movement of our own hand, but we can watch
the flowing together of complementary or of adjacent hues
and observe their delicate interminglings and modifications
even when their tones are guided by our own brushes before
we have gained much skill. All the capacity we possess
in drawing and painting and design helps in the study of
color. Lacking expertness we cannot do much in using
color as a means of artistic expression, but without special
technical skill we can go farther in gaining direct experience
with color combinations and modifications than with arrange-
ments of line and form. Indeed, experiments sufficient to

interpret an unsuspected range of effects in nature and art are peculiarly available to those of us who have no skill in pictorial expression.

Methods of Studying Color.—We may take up the subject of the study of color in two quite different ways; namely, as a subject in physics, or as a subject in art. If we consider it from the point of view of physics we are dealing with exact laws of light and optics, and may proceed on a basis of fairly well-established facts. If we study it as a part of the language of art we are concerned with what has always been an important source of artistic enjoyment, but a matter of human experience so varied and individual that we have as yet little knowledge of any systematic way of attaining that experience and enjoyment. Consequently the student of art has usually been left to acquire his enjoyment of color and his knowledge of its use in a more or less haphazard way. His special sensitiveness to color enables him to accumulate a good deal of knowledge, although generally with considerable waste of time and energy. Often he is likely to regard this random approach as the only method because it is the way by which he has arrived. For the general student, however, this uncalculated method is still more wasteful than for the student with special talent.

Now although the study of color as a subject in physics differs essentially in its aim from the study of color in the realm of the arts, nevertheless the two lines of investigation have much material in common, especially at the beginning. The qualities that distinguish colors which we call crude from those which we consider to be beautiful, and that make some combinations of colors mutually consistent, in contrast with other groups which do not go well together, have their basis, in part at least, in the laws of light and optics, and can be stated in terms of these laws as well as

in those terms which express our æsthetic pleasure or lack of pleasure in them. While the artistically gifted student may possibly be considered as able to proceed pretty directly by feeling alone, yet for most people some knowledge of the nature of the physical causes of color sensations helps to an artistic discrimination and enjoyment of them. Different minds have different ways of approaching things, and, although the intellectual satisfaction in knowing the nature of and reasons for certain qualities is quite different from æsthetic enjoyment of those qualities, nevertheless, for many of us, some sort of intellectual understanding of color appears to be one gateway to artistic appreciation.

In presenting an introduction to the study of color as used in the arts, this book takes account of the close relation that exists between the laws of color in physics and the quality of color tones and combinations in art. It makes use of the principles of light and optics as furnishing a systematic approach to an otherwise bewildering realm, in so far as an evident correlation exists between the external physical causes of color and the subjective æsthetic experiences. On the basis of these it presents a progressive series of experiments with actual colors in order that the student may become familiar by direct personal experience, with certain typical color effects. A few modifications and combinations of colors are representative of nearly all that commonly occur, so that actual experiment with these few helps to interpret a wide range. The purpose of the book is not primarily to present a new or original theory of color, but to offer some analyses of color effects, and to give a series of typical and interpretative experiments, together with references to examples in nature and art.

Color is so much a matter of direct and immediate perception that any discussion of theory needs to be accom-

panied by experiments with the colors themselves. Only by seeing them and having experience with them, separately and in various combinations, can we gain any genuine acquaintance with them. This is particularly true in the complex and elusive tones which nature and art often present. They charm and at the same time baffle us. At first our eyes cannot analyze them. We can see no farther into their complexity than our knowledge of the factors that make them up extends. We must have seen these separate factors actually mingle to produce the result before we can comprehend its full effect.

Outline of Study.—The following topics are presented:

I. A study of the six hues commonly recognized in the spectrum; namely, red, orange, yellow, green, blue, and violet.
 a) Their external causes.
 b) Their appearances under different conditions of illumination.
 c) The different qualities of each which result from the use of various materials and methods of treatment.

II. A study of typical color combinations.
 a) Groups of similar colors.
 b) Groups of contrasting or complementary colors.
 c) Groups consisting of modifications of a) and b).

Each of these topics is discussed in detail, with directions for experimentation and suggestions regarding the significance of each in nature and in art.

Definitions.—A few definitions are necessary in order that we may have a common understanding of the meaning with which certain terms are used in this book. In order to

describe any given color tone adequately we have to take account of three qualities which we will define as follows:

Hue.—Hue refers to that chromatic quality of a color which we indicate by its name, as, blue, greenish blue, etc. In order to change the hue of a color we must mix another color with it. If a little green is mixed with blue the resulting change from blue to greenish blue is a change in hue.

Value.—Value refers to the relation of a color to white and to black, which we indicate when we say a light blue or a dark blue, meaning thereby a blue that is higher or lower in value than the normal spectrum blue. In order to change the value of a color we must mix it with something lighter or darker than itself. By mixing white or black with a color we change its value without changing its hue. The term value in relation to pigments corresponds to what the physicist, dealing with lights, calls brightness.

Intensity.—Intensity refers to the color strength of a hue as compared with a colorless gray. We indicate this comparison when we say, a brilliant blue or a dull blue. In order to change the intensity of a color we mix with it something grayer than it is. By mixing with a color a neutral gray that is neither lighter nor darker than the given color, in other words a gray that is of the same value as the color, we change the intensity of the color without changing its value or hue. The term intensity corresponds to what the scientist calls saturation or chroma.

Scales for Measuring Hue, Value, and Intensity.—In order to think with any exactness in terms of color we need some means of indicating accurately the amount of light and dark, the character of the hue, and the degree of grayness or of saturation in any given color tone. Then we can

analyze any tone and describe it precisely. The use of an exact notation becomes a means of clear thinking and of increased discrimination. It is possible to divide the gradations of value between black and white, the changes of hue in the spectrum, and the degrees of grayness between full saturation and neutrality into an indefinite number of steps. With charts in which these steps are clearly gradated, we can measure any given color and say definitely what its hue is, just where its value occurs between black and white, and what is its degree of intensity. Scales of this sort are published, and by them colors can be measured with such precision that from the written formula one who understands the notation can reproduce almost exactly any tone described.

Out of the indefinite number of steps into which the possible changes of hue, value, and intensity may be divided, we shall use only those intervals which can be easily distinguished one from another. These steps which constitute our scales are the following:

A Scale of Hues.—From the apparently innumerable hues of the spectrum we shall use twelve. These are far enough apart to be easily distinguishable as separate hues and yet are sufficient to illustrate and interpret practically all color intervals and combinations. These twelve are selected so that when placed in a circular band they present a fairly even gradation of hues, and at the same time any two colors which occur opposite in the circle are mutually complementary, which means that when mixed together in balanced proportions these two will produce gray.

The twelve hues which we shall use in our scale are, first, blue, red, and yellow, the three hues which impress people generally as being the most primary and individual color sensations; second, a green which is about the color of

emerald-green, or of the cool metallic green which creeps into soap-bubbles and is seen in the cracks of ice. This differs essentially from the more composite green of foliage. After we gain a somewhat intimate acquaintance with it, it takes on an integral character, so that we come to regard it not as a mixture of blue and yellow, but as being one of the primary sensations. Indeed, some theories of color vision regard the fundamental color sensations as belonging to two closely related pairs, namely, blue and yellow, and red and this cool, metallic green. Wherever the word green is used in this book in connection with the color circle, it indicates this primary hue of emerald-green. It is the hue which is complementary to red.

In the color circle used by physicists in dealing with the relations and effects of colored lights, these four hues divide the circle into quarters. Paints in their mixtures behave somewhat differently from lights, and as our experiments are mostly with paints we have to use a correspondingly different arrangement of the circle to illustrate the results of pigments. To do this we add to these four basic hues two others, orange and violet, which seem at first to be less integral than the other four; that is to say, more readily produced by mixtures. We now have, as the basis for our color circle, six hues which form a fairly even gradation around the circumference, and which give us three pairs of complementaries.

Besides these, six other hues are included; namely, those that occur as intermediate steps between the first six when they are placed in their spectrum order. These intermediates are red-orange, yellow-orange, yellow-green, blue-green, blue-violet, and red-violet. These twelve colors appear in full intensity and at as nearly spectrum value as possible. Yellow, which is brightest in the spectrum, will therefore be the lightest; and violet, which is darkest in the spectrum,

will be darkest in this scale. The others when placed in order between these extremes will make a fairly even gradation of hue and of value.

Examples of These Twelve Hues.—The foregoing descriptions of colors are only approximate. In order to know just what hues are referred to in our discussions it is necessary to have a chart or scale, so that we may see the actual tones. Several firms make colored papers which accord very well with the spectrum colors. In order to obtain samples of the six spectrum colors and six intermediates which, when arranged in a circle, as shown in Fig. 1, give a good gradation of twelve hues, with complements at the extremities of each diameter, we may buy either a large individual sheet of each color, or a package of assorted smaller sheets. These packages are made up at random, but the needed colors will generally be found among the assortment. We will also need white, black, and light, middle, and dark gray. Color wheels are also available; besides giving the required arrangement of the twelve hues, they provide a key to the results of color mixtures.

Making the Color Circle.—The most convenient arrangement of this scale for our use is in the form of a circle, with yellow at the top and violet at the bottom, and the other hues arranged between them in their spectrum order as in Fig. 1. Draw the outer circle with a radius of 2¾ inches, and the inner circle with a radius of 1¾ inches. In the inch-wide ring between these two circles are to be placed our twelve spectrum hues so as to form a band of gradated colors.

The radius of the outer circle, used as a measure, will go around the circumference just six times, and these points will locate the position of each of the six spectrum colors. Between each two of these will come an intermediate hue. When we have located the twelve points in the circumfer-

ence we need to remember that these points indicate the centres and not the edges of the color areas; in other words, a vertical diameter in the circle will pass through

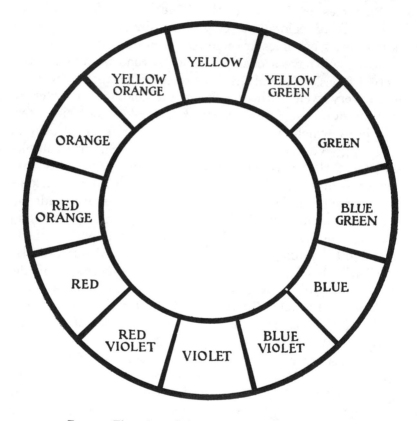

Fig. 1. The colors of the spectrum arranged in a circle.

the middle of the spaces allotted to yellow and to violet. After the circle is planned in outline and the positions of the different tones noted in pencil, we will cut pieces of the corresponding tones from our sample book and paste them

in place. The color circle thus completed will furnish us
with a fairly gradated scale of hues in full intensity. In the
centre of the circle place a sample of neutral gray of middle
value, about 1¼ inches square, cut from your sample sheet.
This is the tone which theoretically will result if you mix
any two opposite colors in the circle. Actual mixtures with
water-colors will nearly if not quite match it. This scale
we shall continually use for reference. To make a scale
with paints is excellent practice. (See Plate I.) The
grading and adjustment of the colors help us to discrimi-
nate the tones. However, for those not skilful in the use of
colors, this is a time-consuming process. At the beginning,
at least, it is simpler to make a scale from colored papers.

A Scale of Values.—White is our nearest approach, in
pigments, to full reflection of light. Black is our nearest
approach to complete absorption. As a matter of fact,
white paint or paper absorbs about half the light which
falls upon it. We can see how much is absorbed if we com-
pare white paper with the high light of glass or highly pol-
ished metal held beside it. The glass and metal reflect
nearly all the light. On the other hand black paint or paper
reflects from one-twentieth to one-tenth of the light which
falls upon it. Therefore it is considerably lighter than an
absolute black. However, because we are to work with
pigments, black and white paint represent the extremes of
value which we can use.

Doctor Denman W. Ross thus describes a scale of neu-
tral values: "It is evident that we have in black paint the
least quantity of light which we can produce. Black is the
lowest of all values. It is equally evident that in white
paint we have the greatest possible quantity of light. White
is the highest of all values. Mixing Black and White in
different proportions we can produce an indefinite number of

intermediates. We do not want, however, to be indefinite in our terms; on the contrary, we want to be as definite as possible. Let us, therefore, establish between Black and White, a Middle Value (M); between Black and Middle Value an intermediate Dark (D); between Middle Value and White an intermediate Light (Lt); and between these five values the intermediates, Low Dark (LD), High Dark (HD), Low Light (LLt), and High Light (HLt). Further intermediates (eight) may be established, but to these we need not give any particular names. If we have occasion to refer to any one of them we can say it lies between certain quantities or values of light for which we have names." *

In our exercises we shall use only five steps of value; namely, white, light, middle, dark, and black. Each of these terms as used by Doctor Ross, and as we shall use them when we refer to a scale of values, indicates an exact level of value between white and black. The white, black, and grays of our colored papers give us the steps in this scale.

A Scale of Intensities.—The strongest note which we can make with pigments of any given hue constitutes for our work the fullest intensity of that hue. At the other extreme is a neutral gray. Between these we can establish any number of steps of intensity by mixing the full color with different proportions of neutral gray. There are two useful types of scales of intensity. One is made by mixing any given hue with a neutral gray whose value is the same as that of the hue. This means that the gray which we mix with yellow will be lighter than that for orange or green, and still lighter than that for blue or red because these hues come to their full intensities each at a particular value. By this method of mixing with a color a gray of the same

* *A Theory of Pure Design*, pp. 133–134.

value, all of the varying degrees of intensity for any one color will be of the same value. On the other hand, we may take as the neutral extreme for each color the middle-value gray that lies at the centre of our color circle, Fig. 1. Then all of our degrees of intensity refer to this central gray. For our purposes this second method is simpler. Our discrimination of degrees of intensity will be greatly increased if, in the case of at least four hues, namely the primary sensations of blue, yellow, red, and green, we work out in water-color scales of three intermediate steps between the full intensity and the neutral gray of middle value.

Ability to discriminate these five degrees of intensity is sufficient for our experiments. We shall call these degrees respectively, full intensity, three-fourths intensity, one-half intensity, one-fourth intensity, and neutrality. Other degrees we can indicate as occurring between any two of these.

These scales provide us with a means of analyzing and describing accurately twelve gradations of hue, five of value, and five of intensity. A recognition of these few intervals is sufficient for our purpose. The notation of values in our scale follows closely that described by Doctor Denman W. Ross, and is here used, rather than a decimal system, because the terms are self-explanatory.

Absolute fulness of intensity for any given hue can occur only at one value, but we can consider it as having relative fulness of intensity at any value. This means that while a dark yellow has necessarily become grayer in the process of being darkened, it may yet be at the fullest intensity possible for yellow at that value. This may be illustrated by taking a yellow of full intensity at the value where yellow can come to its greatest saturation, and another yellow at the same value but of half intensity. If now we carry them both into shadow until the gloom is at the level

noted on our scale of values as dark, both yellows will be lessened in intensity, but the yellow which was brighter in the light will still be at the fullest intensity possible in that depth of shadow. The other will be only half as intense. Similarly with the addition of black paint we can carry these yellows down to the level of dark in our scale of values. Both will be grayed, but one will be of as full intensity as a yellow can be and still be so dark, while the other will be only half as intense.

This and similar experiments will help us to learn by actual experience to see the close relations between different values and intensities on the one hand, and varying degrees of illumination on the other. Paint an area of any pure color. Paint another area of the same color mixed with a little black. Hold the sample of color mixed with black in fairly strong light. Hold the piece of pure color so that it can be seen beside the color with black, but at the same time be carried back into shadow. See if you can tell when the pure color in shadow matches the darkened color in light.

Materials for Use in Experiments.—The materials here suggested for use in illustration and experiment are inexpensive and easily obtainable, and of the sort which are in general use in schools. Of course, results better in some ways may be produced with more expensive materials, but these here listed are entirely satisfactory for purposes of introductory study:

1. *Colored papers* as previously described. Those made by the Color-aid Co. accord particularly well with the hues used in our experiments.

2. *A color circle* made according to the diagram in Fig. 1.

3. *A color top.* This is a small top with a wood or metal spindle, a cardboard measuring disk for noting the propor-

tions of colors used, and a series of disks of colored paper. Each disk is a circle with a hole in the centre so that it can be placed upon the spindle of the top. A slit extending from the centre to the circumference should be cut in the disks (*A* in Fig. 2). This enables us to slip two or more disks together and adjust them so as to show the colors in any proportion we may desire (*B* in Fig. 2). When we spin the top the colors will appear to be mixed in a single tone.

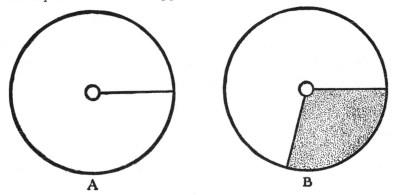

A B

FIG. 2. Method of combining disks of different hue.

In preparing to spin the top the cardboard disk is placed first on the spindle. Then the colored disks, arranged so as to show the hues in the proportions that we wish. Then the top of the spindle is added to hold the disks firmly in place. If this is not tight the top will not spin smoothly. For analyzing colors and for observing the effects of mixtures by rotation, a color top with disks is necessary. These small tops, which should be in the hands of each pupil, cost but a half-dollar. The instructor will usually find it worth while to have for class use a color wheel similar to what is used in classes in physics—a wheel which rotates large disks in a vertical position. The effects produced by

rotating it are the same as those which result when we spin the top.

4. *Paints, Brushes, and Paper.* The ordinary school water-colors, brushes, and white drawing paper, serve fairly well for introductory study. Most firms supplying color for schools now furnish the six spectrum colors. A box containing the following pigments is best for the work outlined: red, orange, yellow, green, blue, violet, burnt sienna, and black. Burnt sienna, which is a dark orange, is included because many combinations can be produced much more directly with a dark orange than with one which is light and more brilliant. Black and the neutral grays which can be made with it are important decorative tones; therefore black is included in the list. White is omitted because the lighter tones are produced by diluting the paint with water. Vermilion, which is an orange-red, and prussian blue, which is a greenish and very transparent blue, are useful if one wishes a wider range of pigments, but are not necessary. Of course it is possible to produce all hues from the three colors, red, yellow, and blue, but little is gained by this limitation, and much is lost by the difficulties of manipulation, especially in experiments with intermediate hues. Opaque or tempera colors are excellent and are now much used in design. However, the more transparent colors interpret better some of the complex and luminous tones in nature and in art.

In addition to paints, a bottle of Higgins's black waterproof India ink is needed. This ink is used for outlining designs and for painting the portions which are to be black. It can be washed over without being disturbed where black paint would be dissolved. For graying colors with neutral, however, black paint is better.

At least two brushes are needed. No. 6 and No. 7 school

brushes are useful sizes. We should have also a water cup and white blotting-paper.

5. *A Finder.* By cutting a rectangular opening in a piece of stiff paper or card we can make what is called a finder. This sets off any bit of color which we wish to isolate, just as a frame sets off a picture. When we place it upon a colored surface, a leaf or a piece of polished wood or a portion of a painting, it enables us to see the character of the enclosed portion of color much more discriminatingly than when the surface merges into its surroundings. Artists often look through a finder at views in nature, in order to see them marked off by a frame. The finder should be gray, so as not to contrast so strongly as black or white would, with the colors seen through it. A useful size for the opening is about two by three inches. The frame should be at least an inch and one-half wide.

With an understanding of these definitions, and with this list of materials, we are ready for our further discussions of color and for the experiments which illustrate them.

I

COLOR SENSATIONS

A World Without Color.—We would have difficulty in imagining a world without color, a world of white, and gray, and black forms. When we look at ordinary photographs we see this neutral sort of world, but even then we do not realize the full experience of grayness that living in a really colorless world would give us, because our minds are full of memories of the actual hues of nature, the greens of foliage, the blues of the sky. Therefore, when we look at a photograph these memories are awakened and promptly associate themselves with the gray forms of the print, and impart to them a feeling of color borrowed from our past experiences.

If we were totally color-blind we would see the landscape, flowers, people, and all other objects like a photograph in black and white, because color-blind persons can see forms and light and dark perfectly well. Fortunately, it is very seldom that any one is totally color-blind. Almost no one is blind to yellow, blue, and violet. About one man in twenty, and one woman in two hundred are more or less blind to red or green, or both. Even people who cannot see at all have to take color into account, because they hear about it as one of the distinguishing qualities of objects. They try to imagine and understand it, and consequently develop some sort of conception of it, so that color affects their ideas of things. Miss Helen Keller, who is both blind and deaf, and who receives all her impressions of the out-

18

side world through the senses of touch and smell and taste,
writes:

"I understand how scarlet can differ from crimson be-
cause I know that the smell of an orange is not the smell of
a grape-fruit. I can also conceive that colors have shades
and guess what shades are. In smell and taste there are
varieties not broad enough to be fundamental; so I call
them shades. There are half a dozen roses near me. They
all have the unmistakable rose scent; yet my nose tells me
that they are not the same. The American Beauty is dis-
tinct from the Jacqueminot and La France. Odors in cer-
tain grasses fade as really to my senses as certain colors do
to yours in the sun. . . . I make use of analogies like these
to enlarge my conceptions of colors. . . . The force of as-
sociation drives me to say that white is exalted and pure,
green is exuberant, red suggests love or shame or strength.
Without the color or its equivalent, life to me would be
dark, barren, a vast blackness.
"Thus through an inner law of completeness my thoughts
are not permitted to remain colorless. It strains my mind
to separate color and sound from objects. Since my edu-
cation began I have always had things described to me with
their colors and sounds by one with keen senses and a fine
feeling for the significant. Therefore, I habitually think of
things as colored and resonant. Habit accounts for part.
The soul sense accounts for another part. The brain with
its five-sensed construction asserts its right and accounts
for the rest. Inclusive of all, the unity of the world de-
mands that color be kept in it whether I have cognizance
of it or not. Rather than be shut out, I take part in it by
discussing it, happy in the happiness of those near me who
gaze at the lovely hues of the sunset or the rainbow." *

Color Helps Us to Distinguish Things.—If the world was
devoid of color for us, we should not only be without a
great source of pleasure which we now possess, but we should

* Helen Keller, *The World I Live In*, pp. 105 ff. The Century Co.

also lack one important means of perception. In speaking of their investigations of form and color two English writers say:

"As we have already shown by our first two elementary experiments comparing the seeing of a white and a colored blank, color makes things easy to see. Color gives the eye a grip, so to speak, on shape, preventing its slipping off; we can look much longer at a colored object than an uncolored; and the coloring of architecture enables us to realize its details and its ensemble much quicker and more easily. For the same reason colored objects always feel more familiar than uncolored ones, and the latter seem always to remain in a way strange and external; so that children, in coloring their picture-books, are probably actuated not so much by the sensuous pleasure of color as such, as by a desire to bring the objects represented into a closer and, so to speak, warmer relation with themselves." *

External Causes of Color.—What is the cause of the colors which we see in objects about us? They have their source in light. Light is supposed to consist of waves of various lengths, and vibrating with different degrees of rapidity. When these waves of light enter the eyes they produce the sensations of illumination and color. We might naturally think of white as the simplest and purest of colors, and until the time of Sir Isaac Newton this was the general opinion. We know now, however, that the white light of the sun is not simple, but is made up of rays of all the colors which our eyes can perceive. It is possible to separate these rays which compose white light, so that we can see each of the colors that go to make it up. One way is to let a ray of sunlight pass through a triangular prism. When light passes from a medium of one density into a medium of an-

* Vernon Lee and C. Anstruther-Thomson, *Beauty and Ugliness*, p. 203. Lane, London.

other density, for example, from air into water or glass, so that the ray of light strikes the surface which separates the two mediums at an oblique angle, the rays are bent, or as we say, refracted. The degree to which the rays are bent or refracted bears an exact relation to the angle at which the light strikes the plane of the dividing surface. When we look at a straight stick placed so that it is oblique to the surface of water, and one end is under the water, the stick appears to be bent sharply at the surface of the water. This is because the rays from the submerged portion of the stick are refracted when they pass from the dense water into the rarer air. When a ray of light passes through a triangular prism at certain angles, it is refracted once in passing from the air into the glass, and again when it emerges from the glass into the air. If the light is compound, that is, made up of different colors, which as we shall see means that it is made up of different wave-lengths, something more happens to it than simply a uniform bending. The short waves will be refracted more than the long ones. Consequently, in passing through a prism the rays of white light will be spread out like a fan and separated so that we can see all the colors which entered into the composition of the light. (Fig. 3.) These colors are called the spectrum. If by means of a lens we converge all these separated colors upon one spot they will unite and form white light again.

The most familiar and splendid example in nature of the breaking up of white light into the hues which compose it, is the rainbow. The rays of the sun falling upon the nearly spherical raindrops are reflected and refracted within them so that they emerge as colored rays. They arrange themselves with bands of different hues according to the degree of the refraction of each. When the sunlight upon the rain

is clear and brilliant, we can see a secondary bow, caused
by rays which undergo additional internal reflections and
consequent refractions. The colors are weakened by the
additional reflection, and also their order is reversed, so
that this secondary bow is always fainter than the first

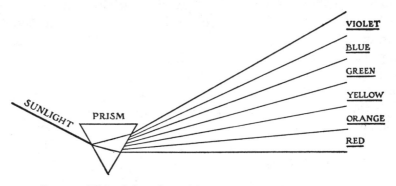

FIG. 3. White light refracted into the colors of the spectrum.

and its hues appear in the reverse order. In the primary
bow, the red band is on the outer edge and the violet on the
inner, while in the secondary bow the inner band is red and
the outer violet.

There are many other instances where we can see white
light broken up into the colors which compose it. These
colors appear in the film of a soap-bubble or of oil as it
spreads out thin upon a wet surface. If we look at a brilliant
white light in the night we can frequently detect colors in
the rays. If we hold a piece of black paper or cloth or fur
in full sunlight, so that the light falls obliquely across the
surface and directly toward our eyes, and then move it
slowly until it is so close as almost to touch the eye, we will
see the white light as it streams toward us across the sur-
face, broken up by interference of the different wave-lengths

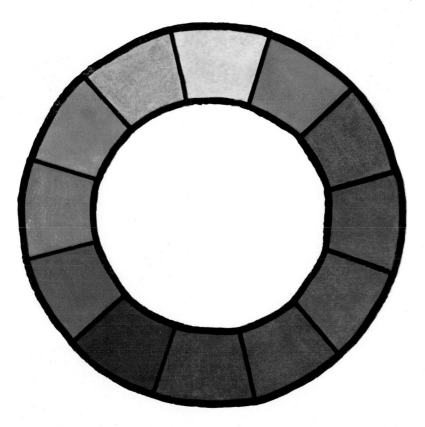

PLATE I. The color circle. (See pp. 9–11.)

PLATE II. Mingling of single hues with neutral to show gradations of
value and intensity.

PLATE III. Mingling of complementary hues.

PLATE IV. Mingling of adjacent hues.

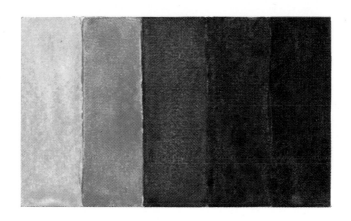

PLATE V. Hues produced by mixing the two near complements, yellow-orange and violet, and a design using these hues and neutrals.

PLATE VI. Mingling of triads, alone (left) and with black (right).
Top: red, yellow, blue; center: yellow-orange, blue-green, red-violet;
bottom: red-orange, yellow-green, blue-violet.

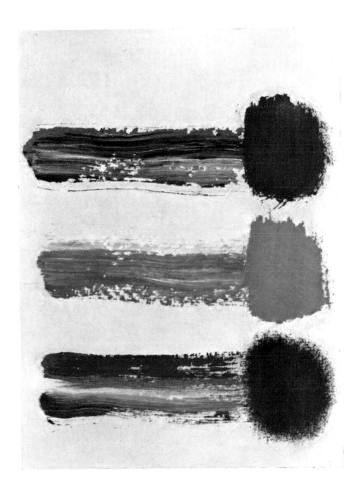

Plate VII. Difference in vitality between broken colors
and colors thoroughly mixed.

into all the various colors of which it is composed. The surface will sparkle with minute dots of the spectrum colors.

The Differences in Colors Are Due to Variations in Length and Rapidity of Vibration of the Waves of Light.— Everything which we can see is visible either because it is luminous, sending out its light like the sun, or a lamp or fire, or because it is reflecting the light which falls upon it from some luminous source. We can see a flame by its own light. We cannot see a chair or a book unless some light falls upon it which it can reflect. Objects which are self-luminous send out light because certain electrical activities are taking place. These activities radiate electromagnetic disturbances, the waves of which appear to spread in all directions, very much as waves spread from any disturbing centre on still water, as when one throws a stone into the water. The length and intensity and rapidity of these electromagnetic waves depend upon the electric energy of the body which produces them. They must attain a rapidity of about 350 billions of vibrations a second before they affect the eye in such a way as to produce a sensation of light. For example, if we heat a piece of iron we increase the amount of electromagnetic energy which it sends out, but at first this energy which it emits will be invisible, although it may be sufficient to give us a sense of heat. Unless the vibrations reach a rapidity of 350 billions a second, the iron, if it is in a dark room, will remain invisible. When the rate of vibration reaches about this point the iron begins to glow, and as the rapidity increases, it not only grows bright, but its color changes. At first it is red, then orange, then yellow, and lastly white. If we hold our hands near the piece of iron as its temperature is raised, we feel the growing energy of the waves as increase of heat. Our eyes perceive it as changes of color. If as the iron becomes

hotter and the waves increase in rapidity, we could separate them so that only those of a particular length came to our eyes at one time, we should find the order of colors as follows: first, red, the waves of which are longest and vibrate least rapidly, then orange, yellow, green, blue, and lastly, violet with the shortest and most rapid waves.

The reason why we do not see all these colors successively as the piece of iron grows hotter is because it continues to send out the slower together with the more rapid waves. At first, when only the slower waves are being radiated we see a fairly pure red. Later when it attains sufficient energy to send out rays rapid enough to give us a sensation of yellow, it is still emitting the rays which produce red and orange. As a result of the mingling of the red, orange, and yellow rays, it appears as orange. When the green enters, it with the red reinforces the yellow, because in colored lights, which differ from paints in the results of their mixing, red and green together produce yellow. Blue and yellow lights when mixed produce white. Consequently, as the iron grows hotter and the very rapid rays are emitted, they mingle with the yellow and give a sensation approaching that of white light which we found to be made up of all colors.

If the vibration of the light-waves becomes more than 770 billions per second the eye cannot perceive them. Doctor Edward A. Ayers says: "The eye can see only 20 odd per cent of the color waves that fly through space. We are totally color-blind to the remainder. All waves that are longer than 36,000 to the inch (red), or shorter than 61,000 to the inch (violet), are invisible. There are waves longer than the red, called infra-red, unknown, and electric; and waves shorter than the violet, called ultra-violet, and Roentgen rays, which may be defined in musical analogy

as covering three octaves, leaving about seven-eighths of
an octave for the six colors which we can see. Our eyes are
to the color scale of nature as the child with its toy piano
is to the master musician with a concert grand. Through
the fluoroscope which retards the speed, the eye can see
some of the ultra-violet rays; and the infra-red rays can be
felt as heat."

Thus we find that our vision can respond only to those
waves the vibration of which ranges from 350 or 400 billions
a second, at which point the wave-length is about 33,000 to
the inch, up to about 770 billions a second, with a length of
from 60,000 to 65,000 to an inch. Within this interval lie
all our sensations of light and of color. Thus we see that
the rays of light which produce in us the sensations of the
various hues, differ from each other only in length and ra-
pidity. The sensation of changing colors is the way in
which our eyes respond to these different wave-lengths and
energies. In a sense, therefore, two rays of light, one of
which gives us the sensation which we call red, and the
other the sensation which we call blue, have in themselves
no color quality. Their only differences are the mechanical
ones of length and rapidity.

As the rays increase in rapidity of vibration they acquire
certain chemical properties, for example, that of affecting a
photographic plate. Red has very little of this so-called
actinic quality, and therefore we can expose an ordinary
plate in pure red light with little effect. As the rays become
more rapid in their vibration this quality increases. If we
photograph a scene with an unfiltered lens the picture is
made largely with the green, blue, violet, and ultra-violet
rays. The X-rays lie in the ultra-violet range, and though
invisible to our eyes, can leave their record on a photo-
graphic plate.

The rapidity of vibration of light-waves has no effect upon the speed with which they travel through space. All rays of light travel at the rate of about 186,000 miles a second. The red ray makes fewer but longer vibrations than the violet ray, but both go on their ways with equal speed, just as two people may walk at the same speed although one is taking more rapid but shorter steps than the other. Light travels so much more swiftly than sound, that while a sound is travelling half of a mile through the air, a ray of light can go from the earth to the moon and half-way back. We can almost detect with our eyes the vibrations which produce low sounds, as in the case of the humming-bird's wings. The slowest audible sound-waves are about sixteen to the second, but the slowest visible light vibrations are still of a rapidity beyond our comprehension. Professor Henri Bergson says of them:

"In the space of a second, red light—the light which has the longest wave-length, and of which, consequently, the vibrations are the least frequent—accomplishes 400 billions of successive vibrations. If we would form some idea of this number, we should have to separate the vibrations sufficiently to allow our consciousness to count them, or at least to record explicitly their succession; and we should then have to inquire how many days or months or years this succession would occupy. Now, the smallest interval of empty time which we can detect equals, according to Exner, $\frac{1}{500}$ of a second; and it is doubtful whether we can perceive in succession several intervals as short as this. Let us admit, however, that we can go on doing so indefinitely. Let us imagine, in a word, a consciousness which should watch the succession of 400 billions of vibrations, each instantaneous, and each separated from the next only by the $\frac{1}{500}$ of a second necessary to distinguish them. A very simple calculation shows that more than 25,000 years would elapse before the conclusion of the operation. Thus the sensation

of red light experienced by us in the course of a second, corresponds in itself to a succession of phenomena which, separately distinguished with the greatest possible economy of time, would occupy more than 250 centuries of our history." *

Professor Bergson goes on to say that while we cannot perceive the enormous number of vibrations which produce for us the sensation of color, as vibrations, we can perceive them as quality of color. If we could adapt our consciousness of separate vibrations to accord with their speed, and thus apparently stretch their duration to fit our sensations, perhaps as the adaptation took place and the speed apparently slowed down, the colors would fade out, and where we saw brilliant hues we should see only a series of motions.

Objects Which Are Not Themselves Luminous Have Color Because They Reflect Rays Which They Receive from Sources of Light.—So far we have considered only self-luminous bodies. Most of the objects which we see are visible because of borrowed light which they receive and reflect. If we can extinguish the source of this reflected light, the objects disappear. Most of the colors which we see in nature are from objects which are not luminous but which reflect the rays of the sun or of other sources of light. Because sunlight is white it is easy to see how any object which reflects the greater part of the rays of this white light, in the proportion in which they exist in the light, will itself appear to be white, and that any object which absorbs all the rays and reflects none will appear as black. We can also see that an object that absorbs a proportionate part of the rays of each wave-length and reflects the rest, will send to our eyes fewer rays than the white object, but more than the black. Consequently, it will be a lighter

* Henri Bergson, *Matter and Memory*, pp. 272–273. Copyrighted, The Macmillan Co. Reprinted by permission.

or darker gray according to the amount of light which it reflects, because gray may be regarded as a reduced or darkened white.

Why then do objects which we see by the white light of day, and which can reflect only the light which they receive, appear so variously colored? It is because most substances do not have the property of reflecting rays impartially; that is, in the same proportion as these rays exist in the light. They absorb rays of certain wave-lengths more readily than waves of other lengths. Now, as we have already seen, white light is made up of rays of all wavelengths, and consequently of all colors. Therefore, when white light falls upon a surface of cloth which absorbs all but red rays easily, it will reflect mainly the red rays. It will be these red rays that reach our eyes, and we shall see the cloth because of them, so that we shall call it a piece of red cloth. If the cloth possesses the property of absorbing all but the blue rays, we shall see it because of the blue rays, and shall call it a blue cloth. This property which most substances have of absorbing out of the white light that falls upon them more of some colors than of others is called selective absorption. In other words, the colors which we see in objects are, in most cases, composed of those rays of white light which escaped absorption by the object and were reflected to our eyes.

Blacks, whites, and grays result from unselective absorption and reflection. They reflect light without changing the balance or relative proportion of waves as these exist in the light which falls upon the object. The relative proportion of wave-lengths is not disturbed by any preference in what absorption does occur. Therefore, what light blacks, whites, and grays do reflect is constituted like the light which they receive. However, in nature perfectly im-

partial reflection is rare. Usually in what we call grays or whites or blacks, a few more rays of one color are reflected than of the others, so that when we compare different gray objects we find one slightly pinkish, another greenish, and another tinged with some other hue. White light is so alive with the vitality of its mingled rays that we generally find colors lurking even on black and white surfaces.

Reflection and Transmission of Light.—We can understand better some of the qualities which we see in the colors of nature when we know that most objects reflect in two ways the light which falls upon them. Some of the light is reflected directly from the surface without change. Wherever this happens white light will be reflected as white, whatever may be the color of the surface. This direct surface reflection is called specular reflection from *speculum*, which means a mirror.

There are all degrees of specular reflection, from that of a perfect mirror to the mere sheen of white light which mingles with the colors of objects. Where specular reflection is complete, as in a mirror, the reflecting surface itself tends to disappear. Sometimes it seems not even to exist. When we look at it we see not it but other things, the rays of which fall upon it. We look in a mirror not to see the mirror but what is before it. Sometimes when the specular reflection is less complete we can see both the surface, and, apparently in it, the objects which are near it, as on a polished table or a wet street. Again the specular reflection is still less, and we see it only as glints or veils of light which modify the color of the surface itself, but do not actually show the shapes of near-by objects. When the light is strong we will see on a red apple a portion which, because of this directly reflected light, appears to be white, no matter how intense the red of the apple may be. If we

look toward a window we can see on the floor and furniture, and on most of the objects between the window and us, patches of these specular or mirror-like reflections. Some light is reflected specularly from practically the whole of any illuminated surface. The spots where these reflections are strongest are what artists call the high lights. The color of these spots is usually that of the light itself and not of the surface which reflects them. From certain positions in a room it is almost impossible to see the colors of an oil-painting hung upon the wall because of this direct surface reflection. These reflections play an important part in the color effects of nature.

In most cases light that is not specularly reflected passes to a greater or less distance beneath the surface before it is reflected. Professor Rood writes:

"The great mass of objects with which we come in daily contact allow light to penetrate a little way into their substance, and then, turning it back, reflect it outward in all directions. In this sense, all bodies have a certain amount of transparency. The light which thus, as it were, just dips into their substance, has by this operation a change impressed on it; it usually comes out more or less colored."

Selective absorption takes place while this light is passing through the fibres or cells, or whatever texture makes up the substance, and consequently it is this light which has penetrated below the surface before it is reflected that we see as color.

The light which objects send to our eyes and by which we see them is made up of these two types of reflection, that which comes directly from the surface without change of color, and that which has passed through part of the substance of the object and in passing has had some of its rays absorbed. Because usually more of some rays are absorbed

than of others, this light is likely to be colored when it emerges. On account of the mingling of these two masses of light, more or less white light appears with most of nature's colors. Even black reflects considerable light in this way. Materials differ greatly as to their degree of transparency. Metals are the most opaque of all substances. When metal surfaces are polished, practically none of the light can penetrate them, but is reflected just about as it is received. Consequently, polished metals are good mirrors. If a film into which light can penetrate gathers upon a metal surface then colors appear. Tarnished bronze may appear quite yellow, but if we polish one spot so that a smooth clean surface of metal is seen, the light which it reflects will be almost white. Good housekeepers in Colonial days said: "Brasses should be polished until they are white."

Transmitted Colors Are Generally Purer and More Luminous than Reflected Colors.—When an object allows all rays to pass through with little hindrance, then we have the transparency of glass. If the glass has the power of selective absorption, then it may be opaque to some rays and transparent to others, and we have colored glass. A piece of red glass placed so that we stand between it and the light, appears dark because nearly all the rays are either absorbed or pass through. Consequently, little except the specularly reflected and consequently colorless rays reach our eyes. When, however, we hold the red glass between our eyes and the light, we see a red that for two reasons is more brilliant than the red of pigments; first because the red rays pass directly through the glass from the source of light, while in red paint the rays are reflected back in a diffused way and lose by the reflection; secondly, because the specular reflection has taken place on the other side of the

glass; namely, the side toward the light. Consequently there is no appreciable amount of white mixed with the red rays, while a painted red is much diluted by the surface reflection of white which mingles with it. When we look at a tree which stands between us and the sunlight, and at a short distance from us, we can see among the leaves which stand at all angles to the direction of the light, some which appear as gleaming white, because of direct surface reflection, some that are, as we say, the actual color of the leaf, because light has dipped into the substance of the leaf, and what has not been absorbed is reflected as color, and some so placed that the light passes completely through them before it reaches our eyes. The color of these is the most brilliant of all, and more golden in hue because undilated by specular reflection of white light from the sun and blue from the sky. So far as we have any historical record, the English landscape painter, John Constable, was the first who tried to represent the brilliancy of specular reflection on foliage. He suggested this by patches of white paint. People called these white spots "Constable's snow."

If we try to paint the colors of the spectrum the results seen by reflected light are always dead and grayed when compared with the actual spectrum. They can only hint at its splendor. But if the pigments which we use are watercolors on white paper, the result is sufficiently transparent so that direct sunlight can pass through and show the colors from the other side of the paper. Therefore, if we hold the paper betwen us and the sun, with the unpainted side toward the sun, the colors seen by transmitted light will approach more nearly the actual glow and richness of the spectrum. When we look again at the painted side and see it by reflected light, it appears particularly cold and dead by comparison. To give any effect of real brilliancy

by reflected light, we must place this painted paper where there is but little specular reflection and give it a setting of dark background for contrast. When we begin to look for examples of this difference in intensity between the colors of reflected light and those of transmitted light, we will find plenty of them. A beam of sunlight falling upon brown wrapping-paper, or thin veneer of wood, will appear as a far richer tone when seen through the paper or thin wood than when viewed from the side on which it falls. As we hold our hands in front of a strong light, when we spread our fingers their edges show gleams of specular reflection the hue of which is that of the light itself. When we close our fingers some light passes through them and becomes more intense in color than any light reflected from our hands can be. Francis Thomson notes a similar effect when he speaks of:

"Re-pured vermilion, like ear-tips 'gainst the sun."

However brilliant the hues of autumn leaves may appear when they are reflected from the surface, they are much more intense when the light is transmitted. Autumn leaves mounted upon a screen of white mosquito-netting, hung in a window, exhibit colors rivalling those of stained glass.

These facts help us to appreciate some of the difficulties of the painter when he tries to represent nature's lights and colors. His most brilliant light is white paint, and even this when used pure absorbs more than half of the light that falls upon it, and reflects back about 42 per cent. Black paint which is his lowest note of darkness, reflects a considerable proportion of light, which makes it really a low gray, so that his darkest areas must be much lighter than nature's glooms. Moreover, his pictures must be seen in diffused light and not in direct sunlight. Consequently,

he cannot rival nature's out-of-door colors. He can only suggest them by relating his colors carefully within their narrow range. The worker in stained glass, on the other hand, makes use of transmitted light, which gives him more brilliant hues and a wider range of illumination. Because the intensity and purity of the hues which can be produced by direct transmission are so far in advance of those which are obtained by reflection from painted surfaces, many of the most splendid examples of glowing color which art has achieved are in glass.

Substances Can Reflect or Transmit Only Rays Which Exist in the Light Which Falls upon Them.—Objects do not create the colors which they exhibit. When white light falls upon a piece of red cloth we have found that we see the cloth as red because it has absorbed, out of the light which dipped into its substance, most of the rays excepting the red, and reflected to our eyes only those which it did not absorb. In the same way the red glass absorbed most of the rays but allowed the red rays to pass through. Neither the cloth nor the glass changed the white light to red. The red rays which the cloth reflects or the glass transmits are only those which were already in the white light which fell upon it. If this is true, what will happen if we place a cloth which can reflect only red rays, in a light which contains no red rays? It will then show no color except that which is specularly reflected from its surface, and that will not be red but the color of the light which falls upon it. A pure blue-green light contains very few red rays. Therefore, in this light a red cloth will appear gray or black, except for a little surface reflection of blue-green.

Several experiments will illustrate these points. Look at the color circle or at the six disks of your color-top, through a piece of blue glass. The blue area in the color

circle, and the blue disk will appear brilliant because the blue rays pass readily through the glass. The green and the violet can each reflect some blue. Consequently, we can see them as fairly bright. The orange area will be greatly grayed or reduced in intensity because nearly all orange rays are absorbed by the blue glass. The red and the yellow areas will be dulled because each contains some rays of orange. The yellow will become greenish and the red purplish. If we look at the same color circle or disks through orange glass the effects will be reversed. The orange areas will appear as brightest, and the blue as dullest. Corresponding effects will be observed if we illuminate these spectrum hues with colored lights instead of looking at them through colored glass. Surprising effects may be produced by illuminating a colored object first with a light, the rays of which it cannot reflect, and then with a light the rays of which it reflects freely. If we illuminate a green disk with strong violet light we can discover no trace of green. It appears gray or even violet if it receives more violet rays than it can absorb. But if we cut off the violet light and turn a yellow light upon the green it will appear as a yellow-green of great intensity. If we place an orange disk against a blue disk and illuminate them with an orange light the blue appears black against a light orange. Now if we extinguish the orange light and turn on a blue light, the orange disk appears black while the blue disk seems to be very light blue (Fig. 4). One who understands this principle of selective absorption can paint a picture in such a way that under light of a certain hue, one composition shall appear, but when light of a different hue is thrown upon it a wholly different composition and color scheme are seen. It is even possible to produce effects of change of scenery and costume on the stage in this way.

Pure Colors Are Seldom Found in Nature.—Substances which reflect or transmit rays of only one wave-length are comparatively rare. Usually even brightly colored objects reflect not only the hue which is most evident, but also a considerable proportion of the hues which in the spectrum

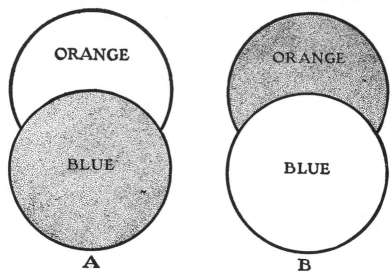

Fig. 4. Reversal of values when an orange and a blue disk are illuminated.— *A*, by orange light; *B*, by blue light.

occur at each side of the dominant color of the object. A red object reflects considerable orange and violet. A yellow object reflects, also, much orange and green, while a blue object reflects rays of green and violet in addition to the blue. The same thing is true in transmitted light. A red glass transmits some orange and violet in addition to the red. Thus, generally speaking, each colored object reflects the hues of half of the six spectrum colors, namely its most evident hue, and the two which lie one at each side of this

hue in the color circle. To this capacity of most substances to reflect not only their characteristic color, but a greater or less portion of the hues which lie at each side of it in the spectrum, together with the effect of specular reflection, is due much of the beauty and complexity of nature's colors. We shall experiment with these adjacent hues later.

Color Perception.—*Because of the Structure of Our Eyes We Perceive Light-Waves of Different Speeds and Lengths as Different Colors.*—The eye is a nearly spherical camera. In many ways it is like a photographic camera. Light enters the eye through the pupil. Just back of the pupil is a lens which focusses the light on a membrane at the back of the eye called the retina. The iris which we see surrounding the pupil is an adjustable diaphragm which enlarges or contracts the opening of the pupil. The lens focusses upon the retina whatever scene is before our eyes just as the lens of the camera focusses views upon the photographic plate. The interior of the eye is lined with black, which absorbs the light that would otherwise be reflected back and forth within the eye and thus dull or confuse the image upon the retina. We line our camera with black for the same reason. The eyeball is filled with a transparent gelatinous substance, which serves to keep it expanded and in shape, and to hold the retina in place.

The optic nerve, which conveys from the retina to the brain the sensation caused by light, is a cable of nerve fibres which arises from the base of the brain and extends through an opening in the bone of the eye socket, and from there into the eyeball through what is called the "blind spot." The fibres of the optic nerve spread out and form the retina, which receives the images of external objects focussed upon it by the lens. The word retina means net.

There are said to be about 137,000,000 of these nerve fibres. Each one terminates in a cellular formation. Because of their shape about 130,000,000 of these nerve-fibre terminations are called rods, and the other 7,000,000 are called cones. The cones are shaped somewhat like a nine-pin. The rods are shaped somewhat as the cones would be if they were stretched lengthwise and thus made narrower. They are microscopic in size, and these millions of them exist in the retina, which is only about one inch in diameter.

The rods and cones are peculiarly sensitive to light. They are supposed to be the special nerve structures that interpret the vibrations of light and color. They behave as if they contained chemical substances especially susceptible to changes under the action of light. The results of this chemical activity are transmitted to the optic nerve, and so on to the brain, where we are made conscious of them as sensations of light and of color. Probably only the cones can give rise to the sensations of color, while the rods interpret light, but not color. In other words, an eye in the retina of which only the rods were present would see forms of dark and light perfectly well, but would be totally color-blind. It would have what we might describe as colorless vision.

The Field of Color Perception Is Less Extensive than the Field of Vision.—The cones are grouped about the central portions of the retina, where it is important that we see clearly, while the rods become predominant in those areas of the retina which are farthest from the centre. Therefore colors are most clearly perceived when they are directly in front of our eyes, where they will be focussed upon the central portion of the retina where the cones are most numerous. On the other hand, the outer portions where the rods predominate are especially sensitive to very slight

stimulations of light, so that faint lights or slight movements can be detected with surprising ease when we see them "out of the corner of the eye." In the retina of some nocturnal animals, for example the bat and the owl, only rods are found, and the presumption is that these creatures are color-blind.

The Field of Perception of Red and Green Is Less Extensive than the Field of Perception of Blue and Yellow.— If we are looking straight ahead, and an object far out to one side travels toward our centre of vision, at first the rays reflected from this object will enter our eyes at an angle and fall upon the outer edges of the retina. As the object advances toward a position directly in front of us the rays from it will move toward the central portion of the retina. Experiments show that when the object first comes within the field of vision, if we do not turn our eyes toward it, but continue looking straight ahead, we shall detect first its motion and something of its form as a mass of light and dark without color. Then we shall see its color, but the color of a yellow or blue object can be detected at a wider angle than the color of a red or a green object. Have some one focus his eyes upon a spot directly in front of him on a table, at a short distance, say, eight inches. Now have some one select a disk of one spectrum color without letting it be known what color he has selected. Place it at a distance upon the table and move it slowly toward the person whose eyes are focussed upon the spot directly in front, until this person recognizes the color. Repeat this test with other colors. Usually it will be found that the movement of the disk will be perceived before its shape; its shape before its color; and the color of those which are yellow and blue before the color of those which are red and green. Moreover, a green or an orange disk will usually

give at first an impression of yellow, while violet will at first suggest blue.

Professor Lightner Witmer gives the accompanying diagram of the areas of color vision in the left eye (Fig. 5). Regarding it he says:*

FIG. 5. The fields of color perception of the left eye.
From *Analytical Psychology*, Lightner Witmer, p. 156.

"An object in the external field of vision, colored in red, green, yellow, and blue, can be perceived in all its actual variety of color, only when it lies within the area or part of the external field bounded by the smallest line, the one marked 'Green.' If the object lies beyond the area circumscribed by the line marked 'Red,' neither the red nor the green of such an object will produce the corresponding color sensations; these colors will appear as shades of gray.

* *Analytical Psychology*, pp. 156–158. Ginn & Co.

If such an object lies beyond the outermost line marked
'Yellow,' its yellow-and-blue coloration will also fail to pro-
duce sensations of these respective colors, and the object
will appear uncolored. The field of gray, or of white and
black, is coterminous with the field of monocular vision.

These external areas of the field of vision correspond to
sensitive areas of the retina. The color fields plotted by
careful experimentation are not usually so regular in out-
line as those represented in the diagram above; they vary
in extent with the size of the colored object, with the in-
tensity of illumination, and with other conditions. The
fact remains, however, that the retinal limits for red-green
vision are more restricted than those for yellow-blue vision,
and that both these areas are less extensive than the area
of sensitivity for black, white, or gray. It is inferred from
this fact that the perception of color must be dependent
upon retinal structures that are not uniformly distributed
throughout the retina. The contrasting retinal sensations,
red and green, yellow and blue, white and black, appear to
be associated in pairs. This fact is accounted for on the
supposition that there are three different retinal structures
or elements, one of which is distributed over the entire sen-
sitive area of the retina and when excited gives black and
white, another less widely distributed giving yellow and
blue, and a third restricted to a relatively small central area
giving red and green."

Theories of Color Vision.—Several theories have been ad-
vanced to account for color vision.* Prominent among
them is the Young-Helmholtz theory, published by Thomas
Young, in 1802, and amplified later by Helmholtz and Max-
well. It holds that there are three types of nerve fibres
concerned in vision, each capable of receiving and trans-
mitting three different color sensations. Regarding this
theory Rood says:

* A brief note on each of the principal theories will be found in *Color and
Its Application*, by M. Luckiesh, pp. 181–189.

"One set of these nerves is strongly acted on by long waves of light, and produces the sensation we call red; another set responds most powerfully to waves of medium length, producing the sensation which we call green; and finally, the third set is strongly stimulated by short waves, and generates the sensation known as violet. The red of the spectrum, then, acts powerfully on the first set of these nerves; but according to Young's theory, it also acts on the other sets, but with less energy. The same is true of the green and violet rays of the spectrum. They each act on all three sets of nerves, but most powerfully on those especially designed for their reception. . . . The next point in this theory is that, if all three sets of nerves are simultaneously stimulated to about the same degree, the sensation which we call white will be produced." *

According to this theory, hues intermediate between these three are produced by the combined stimulations of at least two of the three sets of nerve fibrils. Maxwell, as a result of experiments, decided upon the following as the hues which formed the three fundamental sensations: a red which corresponds closely to vermilion, a green approximating emerald-green, and instead of violet, a violet-blue not very different from ultra-marine blue.

According to another important theory called the Ladd-Franklin theory, yellow and blue sensations are produced by intimately associated processes, and the processes resulting in red and in green sensations are also closely related. Furthermore, red and green sensations are themselves due to elaborations of the processes which produce yellow. This is now the most generally accepted theory. Certain facts appear to support the grouping of color sensations into these two pairs, the blue and yellow, and the further division of yellow into red and a green similar to

* O. N. Rood, *Students Text Book of Colour*, p. 113.

what we call emerald-green. Color-blind persons confuse red with green, but they can usually distinguish between blue and yellow about as easily as do persons with normal eyes. When they look at the spectrum they see two colors as prominent, which they describe as yellow and blue. Maxwell is reported to have found that with black, white, and two colors, a bluish and a yellowish tone, he could match, for color-blind persons, any hue. This would indicate that in the most common form of color-blindness, namely red-green color-blindness, the person sees colors in terms of the amount of yellow or blue present in them. That is, he would probably see a brilliant yellow or blue about as the normal eye does, and a red or green as gray, but if the red was slightly orange, or the green a yellowish green, which would indicate a slight admixture of yellow, he would see each as a yellowish gray. If this theory is true, the ordinarily color-blind person, that is, one insensitive to red and green sensations, would see all nature's effects as varying intensities of yellow and blue, ranging from full color to practically neutral gray. Although he may miss certain important color experiences and effects, there is still some compensation for the color-blind person. Yellowish hues offset by blue and supported by varying values of light and dark not only constitute the fundamental elements of color vision, but we find also that a surprisingly large number of color combinations in art are based upon these two tones. The effects which he sees in nature may be more limited, but they are probably much more harmonious than the greater number of hues perceived by ordinary vision.*

* An interesting article on color-blindness by Edward A. Ayers, M.D., accompanied by illustrations in color intended to show the same scenes as they appear to a color-blind person and to the normal eye, appeared in *The Century Magazine* for April, 1907.

Certain Colors Seem More Individual than Others.— When we look at the various colors of the spectrum, some of the hues appeal to us as primary and individual, while the rest impress us as being compound, as if they were produced by a mixture of the others. When we look at orange we can easily imagine that we see red and yellow in it, and we can see violet as a mixture of red and blue. On the other hand we do not so readily see blue and red and yellow as compound colors. They usually appear at first sight to be individual and unmixed. A yellowish green impresses us so evidently as a mixture that we name it in terms of the two colors, yellow and green, that appear in it. On the other hand a strong emerald-green seems to be much more simple in character. In the spectrum, each hue has its particular wave-length, and in that sense is primary, but if the retina responds directly to only the two pairs of color sensations, the blue and yellow pair, and the red and green, then these are for us the simple individual colors, and others might well tend to appear compound or secondary because our consciousness of them actually depends upon the fusing of two or more sensations.

In addition to this fact that a few colors affect the nerves of sight more directly than others, perhaps somewhat as certain colors affect a photographic plate more quickly and strongly than others, it is likely also that some hues gain special attention because they are intimately associated with the primitive experiences of the human race. Yellow and orange were the colors of light and fire, and red of blood. Naturally colors which thus touched the experiences of primitive men would be the first to receive names, and be frequently mentioned in conversation. Hues observed later on which had less significance in human experience would naturally be described as far as possible by com-

bining names already in use, because it is our custom to describe new objects in terms that we have been accustomed to use in connection with familiar things which have some elements in common with the new objects or sensations. In attempting to describe a strange animal we do so by referring to features of familiar animals which are similar. Language has a special influence in shaping our thinking, and the fact that we have heard a color described in terms of two others, as for instance orange-yellow, makes us think of it as composed of those two colors, even though in the spectrum it has its own individual wave-length.

Colors Affect Vital Processes.—Light and heat are necessary to life. If the quality of sunlight is changed by subtracting certain rays so that what reaches a plant or animal is no longer white, but colored, some of the processes seem to change accordingly. Light falling upon certain nerve-cells appears to stimulate them into action. This action is due to photochemical changes which light produces in the substances sensitive to its influence.

The kind of chemical change produced seems to vary with the different wave-lengths of the light. Now because a change of wave-length in light corresponds to a change of color, this means that each color produces its specific chemical reaction and therefore its own particular stimulus to the nerves. Consequently, in the realm of our consciousness we can distinguish different hues and feel preferences for or aversions to them. We do not yet know what organic processes other than those of sight, and of which we are not conscious, may be set up by this transformation of the energy of light, with its various colors, into chemical reactions within us.

Colors Affect the Emotions.—The marked preferences which we feel for some colors and color combinations, and

the equally strong dislike for others, show that colors have an evident effect upon our emotions. Even animals make choices among colors. Doctor F. S. Breed has shown by careful experiments that chickens prefer red to blue.* Doctor S. O. Mast records that when the pupæ of ants were placed in the ultra-violet portion of a spectrum which was modified so that the intensity of the light was equal throughout, the behavior of mature ants in moving these pupæ showed a power of distinguishing colors and a great sensitiveness to violet, although probably their sensations of color are very different from those produced upon us. He writes:

"The ants began at once to remove them. At first many were deposited in the violet, some, however, being at once carried into the dark beyond the red. When all had been removed from the ultra-violet, they directed their attention to those in the violet, some being carried, as before, into the dark, some into the red and yellow. Again, when those in the violet had all been removed, they began on the pupæ in the red and yellow, and carried them also into the dark." †

Doctor Mast says also, page 352:

"Several pieces of paper which differed in color were pasted to glass slips, upon each of which a drop of honey was placed. A bee was then taken from a hive, marked and placed near the honey on one of the glass slips. After the bee had taken honey to the hive and returned several times the glass slip was removed to a distance of from one to three feet, and one of a different color was put in its place. When the bee now returned it seldom went to the honey over the new color in the old position; it usually re-

* "Reactions of Chicks to Optical Stimuli," *The Journal of Animal Behavior*, 1912, pp. 280–295.
† *Light and the Behavior of Organisms.* John Wiley & Sons, New York, 1911, p. 349.

turned to that over which it had been accustomed to collect honey, although it was now in a new position."

Any trustworthy classification of the color preferences of people on a basis of the direct appeal of a given color on the emotions, is difficult to obtain. Our responses to color are bound up with associations of other experiences. A child's attitude toward a color may be affected if he has seen it worn by a person whom he especially likes or dislikes, or if it has been prominently connected with experiences pleasant or otherwise. Nevertheless a preference for blue over other colors seems to be fairly general, while outside of the Orient few people prefer yellow unless they have given special study to color. Yellow is a hue that gains in charm as we study its qualities. A table of the color preferences of school children follows:

"The number of preferences given for each color by 2,000 subjects of the pre-adolescent period and by 2,000 who have passed their adolescent period."

		R.	O.	Y.	G.	B.	V.
Pre	Male............	149	83	92	133	462	79
	Female.........	120	79	116	122	439	151
Post	Male............	156	38	27	166	501	113
	Female.........	134	41	72	248	394	123

Regarding this table the experimenters write:

"A rough glance at this table will show that in every group the highest number of votes is given to blue. Over one-third of the total number of pupils, and in the case of one-half of the groups more than a half of such groups, preferred that color. Red is a poor second, with green a close third. The variation in the preference for these two latter colors is much greater than it is for blue. Violet oc-

cupies the middle position, with a considerable variation from grade to grade. Orange and yellow tie for the last place, with orange slightly in favor. Both of these colors are more often preferred in the lower grades than in the higher. Yellow is ahead of orange in the lower grades, while in the upper grades orange is more often preferred than yellow." *

Even in experiments of this sort the results are limited in significance because a change in value or intensity of a hue or in the background against which it is seen may change its place in the scale of preference. A hue unpleasant against white may be pleasing when seen against gray or black.

Even where it is not a favorite color, red appears to produce a more poignant emotional effect than any other hue. Scarlet has often been likened to the notes of a trumpet. On account of its strong emotional appeal it is among the first colors to be noticed and used for description. Havelock Ellis writes:

"It seems that in every country the words for the colors at the red end of the spectrum are of earlier appearance, more definite and more numerous than for those at the violet end. On the Niger it appears that there are only three color words, red, white, and black, and everything that is not white or black is called red. . . . The careful investigation of the natives of Torres Straits and New Guinea, by Doctor W. H. R. Rivers, of the Cambridge Anthropological Expedition, has shown that at Murray Island, Mabriag, and Kiwai there were definite names for red, less definite for yellow, still less so for green, while any definite name for blue could not be found. In this way as we pass from colors of long wave-length toward those of short wave-length we find the color nomenclature becoming regularly less definite."

* F. S. Breed and S. E. Katz, *A Study in Color Preference of School Children.*

He says that in many places the same word is used for blue and black, and adds:

"Here again we may trace similar phenomena in Europe; the same greater primitiveness, precision and copiousness of color vocabulary at the long-wave end of the spectrum has led to much controversy. Latin was especially rich in synonyms for red and yellow, very poor in synonyms for green and blue. The Latin tongue had even to borrow a word for blue from Teutonic speech. *Cæruleus* originally meant dark. . . . Modern English bears witness that our ancestors, like the Homeric poets, resembled the Australian aborigines in identifying the color of the short-wave end of the spectrum with entire absence of color, for 'blue' and 'black' appear to be etymologically the same word." *

This earlier use of words for red does not seem to be on account of lack of color perception for green, blue, and violet on the part of primitive men, but simply because of the stronger emotional appeal of colors at the red end of the spectrum, which brought these hues more vividly into their consciousness.

Something of the aggressive vigor of red is expressed in "Red Slippers," by Miss Amy Lowell:

"Red slippers in a shop-window, and outside in the street, flaws of gray, windy sleet!

"Behind the polished glass, the slippers hang in long threads of red, flooding the eyes of passers-by with dripping color, jamming their crimson reflections against the windows of cabs and tram-cars, screaming their claret and salmon into the teeth of the sleet, plopping their little round maroon lights upon the tops of umbrellas.

". . . Snap, snap, they are cracker-sparks of scarlet in the white, monotonous black of shops." †

* "Psychology of Red," *Popular Science Monthly*, 1900, pp. 365 and 367.
† Amy Lowell, *Men, Women and Ghosts*, p. 348. Houghton, Mifflin & Co.

If we look at nature through pieces of colored glass we see what a characteristic effect each different hue of glass gives to the landscape. Through blue glass it looks cold and wintry; through yellow it is sunny and like early autumn, through yellow-green it is spring-like in appearance, while through red it is as if a great conflagration was burning it up.

Each Hue Has Its Particular Traditional Significance.— Partly because of its direct emotional effect upon us and partly because of its associations with various experiences, each color has acquired a symbolism or mystic significance. Therefore its proper symbolic use in ancient art became an important matter. Usually each color had a wide range of significance, and frequently for everything good which it symbolized it had a corresponding sinister meaning. Some of the emblematic uses of color are the following:

White.—White symbolizes light, triumph, innocence, joy. It was easily the emblem of supreme divine power, probably because of the whiteness of the sun, and its triumph over darkness. In Egypt a white tiara decorated the head of Osiris. The priests of Jupiter wore white robes. On the first of the new year the Roman consul in a white robe ascended the Capitol on a white horse to celebrate the triumph of Jupiter, the god of light, over the spirit of darkness. The meanings of purity, innocence, and regeneration are akin to those of divine power and light. The phrase, whiter than snow, occurs in this connection. The Greek word for white carries a suggestion of happiness and gaiety. Romans marked auspicious days with white chalk and inauspicious days with charcoal. The sinister meaning of white is that of pallor and blankness, and the white gliding ghostliness of phantoms.

Black.—Because they indicate absence of light and color, black and neutral tones also, have a symbolism which is the

opposite of that of white. Black typifies the powers of darkness which are in conflict with those of light. It stands for defilement instead of innocence, and for mourning instead of gaiety. It is the color of error and annihilation. The Athenian expiatory ship that sailed every year first to Crete and then to Delos, hoisted black sails when it departed and white sails when it returned. In its good sense, black signifies a solid basic or structural strength, and also a deep restful quiet in contrast with the agitation of light.

Yellow.—Yellow, the lightest of colors, stands next to white in its brightness. It also typifies light, although a light of lesser purity and unity than white. It is used in some Christian services as an alternate of white. It is the emblem of gold. As yellow is the lightest of colors, so gold is the noblest of metals. Gold was said to be the son of the sun, and silver was to gold as the moon to the sun. Yellow signified divine love enlightening human understanding. In China it is the imperial color. Orange is regarded symbolically as a modified yellow. In its sinister sense, yellow signifies meanness, treason, deceit. The term, a yellow streak, is used in this sense.

Red.—Red, the most emotion-compelling color, denotes ardent love, valor, energy, fire, and fervor. In its bad sense it typifies cruelty, wrath, and also sin, as in the expression, "though your sins be as scarlet."

Blue.—Blue signifies truth and wisdom, divine eternity and human immortality. White symbolizes absolute truth, blue a truth which could be revealed to and understood by men. It is emblematic of a love less ardent than red, a cooler celestial fire. It is associated with the idea of constancy and loyalty. In its bad sense it signifies despondency. In China blue was attributed to the dead and red to the living.

Purple.—The ancient word translated purple probably refers to a color corresponding to our crimson. It denotes imperial sovereignty and royal dignity, as indicated by the expression, "born to the purple." The color which we term purple, which is a reddish violet, may denote love and wisdom united; that is, a mixture of red and blue. In its sinister sense it is an emblem of mourning, but of a grief not as recent nor deep as that indicated by black.

Green.—Green is closely allied to blue in its significance. In fact the ancients, in so far as we can judge, often used the same words for deep blue, green, and steel gray. In Japanese the same word may be used for blue and for green. Green, especially a green more yellowish than emerald, may also signify growth, life, and hope. In its bad sense green typifies jealousy.

Of color as a means of indicating different social levels, Professor E. B. Tylor says:

"In the history of the world, color has often been the sign by which nations accounting themselves the nobler have marked off their inferiors. The Sanskrit word for caste is *varna*, that is, 'color,' and this shows how their distinction of high and low caste arose." *

In connection with the expressiveness of colors, Professor DeWitt H. Parker writes:

"Thus every one would probably agree with Lipps and call a pure yellow happy, a deep blue quiet and earnest, red passionate, violet wistful; would perhaps feel that orange partakes at once of the happiness of yellow and the passion of red, while green partakes of the happiness of yellow and the quiet of blue; and in general that the brighter and warmer tones are joyful and exciting, the darker and colder, more inward and restful. . . .

* *Anthropology*, p. 69.

"To explain the expressiveness of color sensations is as difficult as to account for the parallel phenomenon in sounds. Here as there resort is had to the principle of association. Colors get, it is thought, their value for feeling either through some connection with emotionally toned objects, like vegetation, light, the sky, blood, darkness, and fire, or else through some relation to emotional situations, like mourning or danger, which they have come to symbolize. And there is little doubt that such associations play a part in determining the emotional meaning of colors—the reticence and distance of blue, the happiness of yellow, for example, are partly explained through the fact that blue is the color of the sky, yellow the color of sunlight; the meaning of black is due, partly at any rate, to association with mourning. Yet neither of these types of association seems sufficient to explain the full emotional meaning of colors. The conventional meanings of colors seem rather themselves to need explanation than to serve as explanations—why is red the sign of danger, purple royal, white a symbol of purity, black a symbol of mourning? Is it not because these colors had some native, original expressiveness which fashion and habit have only made more definite and turned to special uses? And if we can explain the reticence of blue through association with the sky, can we thus explain its quietness? Can the warmth of fire and the excitement of blood explain quite all the depth of passionate feeling in red? The factors enumerated play a part in the complex effect, but there seem to be elements still unaccounted for.

"In order to explain the total phenomenon we must admit, as in the case of tones, some direct effect of the sensory light stimulus upon the feelings. Rays of light affect not only the sensory apparatus, causing sensations of color; their influence is prolonged into the motor channels, causing a total attitude of the organism, the correlate of a feeling. It would be strange if any sensory stimulus were entirely cut off by itself and did not find its way into the motor stream. But these overflows are too diffuse to be noticed in ordinary experience; they are obscured through association, or are not given time to rise to the level of clear con-

sciousness, because we are preoccupied with the practical or cognitive significance of the colors; only in the quiet and isolation of contemplation can they come into the focus." *

Warm and Cool Colors.—Hues which approach red have almost universally been considered as warm colors and those which tend toward blue as cool. Two reasons have probably influenced this classification. In the first place, fire and sunlight and the glow of brisk circulation of blood are all associated with warmth. The colors through which these sources of warmth manifest themselves predominate in the range from red, through orange to yellow, and possibly yellow-green. The colors of the sky and distant mountains and cool waters are generally bluish. When the body is chilled its color tends toward a hue more bluish than the flush of warmth. Blue fire is a curiosity. These and other reasons naturally tend to make us associate red, orange, and yellow with warmth, and blue, blue-green, and blue-violet with coolness.

In the second place and apart from the more external associations, colors produce direct effects which are likely to give us impressions of warmth or coolness. In studying color sensations we learned that red apparently tends to arouse an emotional excitement stronger than that of other colors, while the influence of blue seems to be in the opposite direction. We find also that the colors in which red, orange, and yellow predominate have a greater luminosity; that is, they reflect more light than the colors in which mainly blue and green predominate. Some yellow pigments are surpassed only by white itself in the proportion of light which they reflect. From the white light which falls upon them they send back to our eyes not only the yellow rays, but

* *The Principles of Æsthetics*, pp. 256 and 257. Silver, Burdett and Co.

also the orange-yellow and greenish yellow, together with much of the orange, green, and red. All these hues unite to give us an impression of rich yellow. This capacity of the colors in which yellow predominates, to reflect so large a proportion of the light which falls upon them, probably increases the impression of warmth which we receive from them. Regarding the relative capacity of warm colors to reflect light, Rood writes:

"Artists are in the habit of dividing up colors into warm and cold. Now if we draw the dividing line so as to include among the warm colors, red, orange-red, orange, orange-yellow, yellow, greenish yellow, and yellowish green, then in white light the total luminosity of the warm colors will be rather more than three times as great as that of the cold colors. If we exclude from the list of warm colors yellowish green, then they will be only about twice as luminous as the cold." *

Green and violet have elements of both warmth and coolness. In the color circle they stand at the dividing lines between the decidedly warm and the decidedly cool colors.

Advancing and Retreating Colors.—That some hues, notably the warm colors, appear to advance toward the eye while cool colors appear to retreat, has been pretty generally accepted as a fact by artists. The fact that the warm colors are more frequently those of light, and the cool colors those of shadow, may have contributed toward this impression. Projecting objects or portions of objects catch and reflect the warm tones of light, while receding surfaces reflect the cooler shadow tones.

This effect of advancing and retreating colors may be partly due also to the ways in which rays of light of different wave-lengths are refracted or bent from their course

* *Modern Chromatics*, p. 42.

when they encounter a transparent medium the density of which is different from that of the air. The prism shows us that rays of short wave-length are deflected more than rays of longer waves. A certain amount of refraction occurs when rays pass through the lens of the eye; consequently, if we place at the same distance from our eyes spots of red and yellow and blue, the rays from all these, except the ones which strike the lens at right angles to its axis and therefore fall exactly upon the centre of the retina, will be deflected from their course. The yellow rays will be bent more than the red, but less than the blue. Therefore, if we accommodate our eyes to the yellow spots, the red and blue spots will be slightly indistinct as compared with the yellow spots. The red spots will be indistinct because the rays, by reason of lesser refraction, affect our eyes as if the red was nearer than the yellow. The blue will be indistinct because the blue rays, by reason of greater refraction, affect our eyes as if the blue was farther away than the yellow. In other words, although the three colors are all in the same plane, they affect our eyes exactly as they would if the yellow was a little farther away than the red, and the blue farther away than the yellow, but with no difference in the degree in which the rays of each were refracted as they pass into the eye.

Because of this difference in the refraction of the rays of each color, the result is that when our eyes are focussed upon the yellow spots we are slightly near-sighted for the blue, and to see it clearly must change the focus of our eyes as we would for an object farther away. On the other hand we are, at the same time, slightly far-sighted for the red, and to see it clearly must accommodate our eyes as if on a nearer object. It is probable that because the accommodation of our vision to different colors at the same distance

corresponds, because of their varying degree of refraction, to the accommodation required for colorless objects at different distances, the colors impress us as advancing or retreating in proportion as their wave-lengths are shorter or longer. This appearance of projection or recession of colors is more marked when either the design or the observer is moving slowly, just as actual differences in distance are then more evident. On this topic Professor Charles S. Hastings writes:

"The illusion described would appear of rather abstract scientific interest were I not convinced that the incomparable French artists of the thirteenth century had recognized it, and employed it for the purpose of artistic expression. Indeed, it was a casual inspection of the marvellous mediæval windows in the great cathedral at Bourges which first turned my attention to the studies embodied in these papers, and which persuaded me that the one essential distinction between these antique windows and their unsatisfactory modern imitations lies in the knowledge, possessed by the old artists, of the effect gained by an ordering of their vivid colors so that the resulting chromatic binocular relief should fit the composition of their pictures. As far as known to me, the most beautiful surviving examples of this lovely art, as well as the most convincing support for the views here presented, are contained in that unapproached collection; and not alone in the wonderful achievements of those forgotten artists but also in the instructive failure which has attended modern restorations." *

Professor Hastings adds a foot-note as follows:

"In two quadrifoils in the window given by the Guild of Tanners the artist has chosen a red background in place of the almost universal blue; but he has reversed the order of his colors throughout the composition so that the effect, to my eyes at least, was that of two charming little intaglios.

* *American Journal of Science*, vol. XIX, 1905, p. 411.

It was this which first suggested to me the distinction between ancient and modern mosaic windows described above, and which I thought abundantly verified by subsequent observations. Certain very puzzling contradictions to this theory—I have no means now of determining how many—were eliminated by a subsequent discovery that considerable areas of some of the windows are nineteenth-century substitutions for the original designs, which had been lost. There was no suggestion of this significant fact in my hands at the time of my visit."

Where strong lights of different colors are thrown in succession against a pattern of contrasting hues, as on a theatre curtain, effects of this apparent advance or recession of certain colors are sometimes plainly, and even startlingly, evident. As one colored light succeeds another, occasionally a pattern which in reality exists upon the curtain will appear to jump forward and to hang in the air at a distance of some inches in front of the curtain. When the light changes the pattern seems to retreat and to take its place again upon the curtain. This effect is evident only when we are observing the colors with both eyes. It disappears when one eye is closed.

Certain Colors Define Patterns More Clearly than Others.—Colors and colored lights differ in their defining power. At first thought it would seem that the clearest of all patterns would be those produced in black and white, and that the light which defines objects most clearly would be white light. However, we have just seen that our eyes cannot adjust themselves to a clear focus of all colors at the same time because of the different degrees of refraction for waves of different lengths. Now white is composed of rays of every length; therefore, our ability to focus upon its combinations of wave-lengths is not equal to our ability to focus upon rays which are of only one length, and con-

sequently of one color. On the other hand, some colored lights bring out objects less clearly than white light, perhaps because the eye-strain caused by their particular hue offsets the advantage of the fact that their rays are of a single length. Experiments indicate that for normal eyes a yellow light with rays of a single wave-length has more defining power than any other light of equal brightness. For this reason automobile lights are sometimes made yellow. Amber glasses are used to rest the eye; long-distance riflemen occasionally use a yellow glass to bring out a distant mark more clearly; and a pattern of black upon yellow is the combination which, other things being equal, seems to have greatest carrying power.

The relative carrying power of different color combinations has been listed as follows:

"Le Courrier du Livre reported the legibility of various combinations for reading at a considerable distance, the most legible print being black on a yellow background. The order of merit was found to be as follows:

1. Black on yellow	8. White on red
2. Green on white	9. White on green
3. Red on white	10. White on black
4. Blue on white	11. Red on yellow
5. White on blue	12. Green on red
6. Black on white	13. Red on green
7. Yellow on black	

"It is noteworthy that in this list the customary black-on-white combination is sixth on the list. These results are interesting, although perhaps not final, owing to the many variables that enter such a problem." *

The practical value of these results on the legibility of colored advertisements is apparent.

* M. Luckiesh, *Color and Its Applications*, p. 136. D. Van Nostrand Co.

QUESTIONS

1. What is meant by the hue of a color? by value? by intensity?

2. In the case of red, which of these qualities would be most changed by mixing with the red a little of (*a*) blue? (*b*) white? (*c*) gray of the same value as the blue? (*d*) black? (*e*) green?

3. What differences in rays of light cause differences in the color sensations which they produce?

4. Why do different objects in the same white light appear white? black? gray? red? blue? green? yellow? Explain each appearance.

5. Why is specular reflection the color of the light itself? What effect does it have upon the color of an object? Why?

6. Compare specular reflection with selective absorption.

7. Compare the quality of a transmitted color with that of a reflected color, for example, the color transmitted through yellow glass with that reflected from yellow paper of the same hue. Give reasons for the difference.

8. In a violet light which contained no green rays, what would be the appearance of disks of the following hues, and why? Red, orange, green, gray?

9. What colors in the color circle would be most intense and which least intense in a red light? a blue light? a yellow light?

10. How does the extent of the field of color perception in the eye differ from that of perception of form?

11. What colors are probably perceived by a "color-blind" person? How do the following colors appear to him and why? Yellow-green, orange-red, blue, green?

12. What are supposed to be the four fundamental color sensations?

13. What do the terms warm, cool, advancing, retreating, mean when applied to color? Name two or three combinations of colors which make patterns stand out most clearly.

II

COLOR VALUES AND INTENSITIES

Definitions.—We have learned that value is the term used by artists in describing the amount of light or of dark in a color, and that intensity refers to the degree of color purity or saturation. When a color is made lighter we say that it is higher in value. When it is made darker we say that its value is lowered. These changes in value correspond to what scientists call changes in brightness. In using oil-paints or opaque water-colors, we generally use white as a means of raising the value of a color. With the transparent water-colors, thinning the paint with water, if it is to be used on white paper, accomplishes the same purpose. The value of colors may be lowered by black. Many artists prefer to darken colors without using black, because black, unless skilfully handled, is likely to impart a gloomy quality to the color with which it is mixed. Our first experiments with low values will be carried on by mixing only black, white, or gray with the colors for the sake of making these mixtures as simple as possible.

A Scale of Neutral Values Gives a Basis for Studying Color Values.—It is easier to recognize any given value in neutral grays than in colors, because the peculiar stimulation which colors produce upon our eyes is likely to deceive us regarding the actual degree of light in the color. If we could photograph a yellow, a blue, and a gray of the same value, accurately, so that the variation in the chemical effects of the different hues were corrected, the result would be three grays alike in value. However, when we place

side by side a blue and a yellow, and a gray which photometric tests show to be of the same value, the blue is likely to appear to an untrained eye as the darker tone, and the yellow as the lighter. It requires considerable discrimination in the case of blue and yellow to determine when they are of the same value. This difficulty exists with other hues, but not to an equal degree. If we become thoroughly familiar first with the scale of neutrals graded from white to black, we will have taken the first step toward the ability to recognize corresponding values in colors.

We Perceive Readily about Five Steps in Value from White to Black.—Experiments show that, without training, our eyes perceive easily about five degrees of value, beginning with white and ending with black. We can distinguish more than these when the gradations are arranged in order, but five are about all that one unfamiliar with values can locate when each value is presented separately. With a little training we can recognize and assign to their correct places in the scale about twice as many.

Nature shows an indefinite number of gradations between her highest lights and her lowest darks, but for ordinary purposes of painting and design a thorough knowledge of five values from white to black is sufficient. When the scattered variations of light and dark which nature presents are massed into a few gradations, then our eyes are able to grasp the design easily and its pattern is not confused. We can produce this effect by half closing our eyes so that the innumerable slight variations of value are lost in a few important combinations of light and dark. If we wish to use a number of values greater than the five which form the more easily discernible intervals, a knowledge of the five helps us to relate the intervening steps to them in such a way that the design is not weakened unnecessarily.

The most useful scale of neutrals to begin with is the following: a white, a black, a middle gray lying half-way in value between white and black, and contrasting equally with both, a gray half-way in value between white and middle gray and which we call light, and a gray half-way between middle and black which we designate as dark. This gives us a scale of five values arranged in this order: white, light, middle, dark, black. The black, white, and three grays of our colored papers approximate these five tones. Light and dark in this scale are not general terms but are used to designate exact degrees of value. White is the note of highest value, and black the lowest that we can produce with paints. All the contrasts of light and dark which the painter can represent, lie between these extremes. This range of tones is much less than that of nature's contrasts even of reflected light. Under ordinary conditions pure white paint is about fifty times brighter than black paint, but light-colored objects in sunshine are often several hundred times brighter than deep shadows. Of course the specular reflection of sun on water or on polished objects is still brighter. All that the painter can do in representing nature's intervals of light and shadow is to make his intervals between the narrower range of black and white, proportionate to nature's greater steps between the illumination of sunlight and the gloom of shadow. The designer in stained glass can more nearly approach nature's scale of values because light can actually shine through his colors.

White and Black Have Unique Artistic Qualities.—The beginner in color is likely to regard black and white as negative in comparison with color. In reality, however, each is a distinctly positive element in a design, and an area of either is far from being a space of silence and emptiness. Pure white or black has a decorative effect in a design which

seems to differ essentially from that of any color however near the color may approach to black or white. Besides its own individual quality each affects the colors near which it is placed, by enhancing them, and in return each is modified by the reflections or after-images of near-by hues.

White light is the most vital thing in nature. When it passes through the prism it is separated into colors the waves of which are constant and regular in their motion, but the waves of white light are irregular and do not repeat themselves. Its stream is tumultuous. The colors which compose it seem hardly to be held in leash or concealed. Their energies are all visible. It pours on, ebullient and effervescing, ready upon meeting any obstacle to be shattered into its many possibilities of hue. In the white of objects this potency is more sudbued than in the case of light coming directly from the source of illumination, but it is still evident. The quality varies with the texture of the surface which reflects it. It reverberates from silk differently than from snow. Fine porcelain sends the light graciously to our eyes while cheap china returns harsh glints with knife-like, unmodulated edges. Thus the character of the play of light is often an assurance of the quality of the ware. A student of John La Farge, whose work was criticised because the white flowers in her picture did not take their place behind the frame, said: "I can't help painting very white—and the flowers look very white to me. I don't see how they can be whiter, but I think the frame doesn't suit." Mr. La Farge replied: "It is because they are white-lead color and not white-flower color, which is a very different thing, that they refuse to take their place behind the frame."

White is particularly subject to modification by reflected colors, so that white drapery gives hints of the colors which

are near it. Especially when it is surrounded by brightly
illuminated colors out of doors under a blue sky and amidst
foliage and flowers, does it become itself a surface of shift-
ing hues. White walls and expanses of snow are usually
full of delicate gradations of hue. What we term white
clouds show wide variations. Hold a piece of white paper
in the sunshine, so that beyond its edge you can see a white
cloud, and note the difference. If there are a series of
white clouds from near the zenith to the horizon, hold the
paper so that you see first one and then another behind it,
and the series of delicate hues can be plainly seen. On
days when the sky is soft blue, with cirro-stratus clouds,
the tint of these apparently white clouds is often most ac-
curately represented by mixing with white paint an almost
imperceptible amount of vermilion and yellow. Shelley's
line in the Witch of Atlas, "Of those high clouds, white,
golden and vermilion," well describes them. When we
study the apparent whites in paintings, the whites of clouds
and snow, of walls and drapery and sea-foam and flowers,
we see how full of color they are, and how the artist has
treated them to make them luminous. Compare in pic-
tures, white in light with white in shadow, and see how
seldom the shadows on drapery or snow or clouds, are merely
gray. Unless there are specially strong reflected hues,
white in shadow is well represented by mingled light tones
of vert emeraude, which is a blue-green, and venetian red,
which is a red-orange.

Even apart from the effect of reflected hues, blank white
seldom occurs in things which we see under ordinary con-
ditions. There are all degrees of selective absorption, so
that usually one or more hues are reflected out of propor-
tion to the others, even though to a slight degree. When
we collect and compare many examples of what passes for

white, feathers, fur, minerals, textiles, the petals of different flowers, we can see the distinctions in hue. Even where the material appears to be very white, but delicate in structure, as in white poppies, we get the impression as in light, of the chromatic vitality of white, as if the different colored rays which compose it jostled one another and were held together only in an unstable equilibrium.

Black stands at the end of the neutral scale, opposite to white. No paint reflects more light than white nor less than black. Consequently, in pigments white is our nearest approach to light, and black is as close as we can come to absolute darkness. Black is theoretically the absence of all color, but an absolute black is seldom found except in total darkness. What we call blacks usually reflect considerable light, and even color. If we paint a circle as black as paint will make it, and then place it beside a hole of the same size and shape which opens into a fairly large box lined with black, we see how much deeper is the darkness of the aperture than that of the paint.

Some surfaces which absorb most of the light, as in the case of certain velvets and furs and inks, produce striking effects when skilfully used in paintings or decorations or costumes. Chinese ink, which has been one of the important materials in Oriental painting, is made from the soot obtained by burning certain kinds of nuts. Occasionally the soot is of a texture which absorbs an unusually large proportion of the rays of light that fall upon it. When a stick of ink of this quality is discovered it is highly prized and is said to be kept for special uses from one generation to another, and while ordinary inks are used for grays, this stick is brought out when the picture demands some spot of splendid and light-absorbing black.

Blacks differ as whites do, and the student of color should

collect various so-called blacks and become familiar with their qualities. Each black textile, silk, wool, cotton, or velvet reflects light in its own way, so that a particular black may be becoming to one person and not to another, or more appropriate for one occasion than for another. Some are brilliant with flashing lights cutting into the black as in the case of several silks and satins. Others are rich and impressive in the depth of their tones.

Nature seldom produces a dead black, nor will our eyes allow us the impression of absolute blackness even when we close them in the dark. Pieces of charcoal, especially when fresh from the fire, have a brilliant, satin-like texture, and frequently show traces of brown and blue, and of iridescence. Black fur is lustrous, and the feathers of black birds are generally slightly iridescent. One of the most splendid blacks of birds is that on the head and neck of the loon, but when seen near by this shows itself to be many-colored. Black fruits are rich with colors. Attempts to produce black flowers, pansies or hollyhocks, result in surfaces which give the effect not so much of absence of color as of color held in suppression. As white can seldom hold in full subjection the vibrating colors which compose it, so black seems incapable of wholly submerging the hues which it is supposed to absorb. Some remnants remain and play in faint rainbow hints upon its surface. Black is also affected, as is white, by the reflection of colored surfaces about it.

When Black and White Follow Each Other at Certain Speeds an Illusion of Color is Produced.—When white light is suddenly cut off from the eye it is probable that the sensations of all the colors do not disappear at the same time. The blue rays seem to persist a fraction of a second longer. On the other hand, when white suddenly appears from be-

hind black, the red rays apparently affect the eye first. If we make a disk with black upon white, as in Fig. 6, which is one form of the Benham disk,* and then rotate it at a

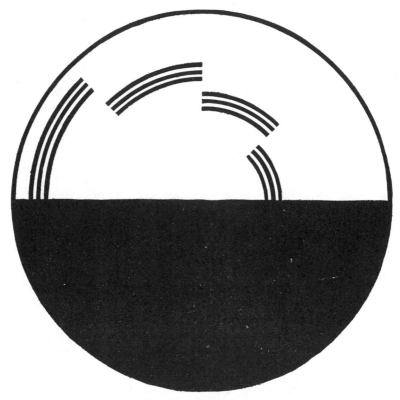

Fig. 6. Benham disk.
From *Color and Its Applications*, M. Luckiesh, p. 39. Van Nostrand Co.

certain speed, in one direction, the outer rings appear red and the inner ones blue, while those in between give intermediate hues. Now if we rotate the disk in the opposite direction the inner rings will appear red and the outer will

* A Benham disk is supplied with the Science Service color top (see p. 15).

be blue. If the rotation is very rapid the effects will be simply gray. It must be just rapid enough so that the impressions of the arcs merge in the eye into sensations of complete circles. The disk may be rotated upon the wheel, or with a pencil through the centre as a spindle it may be spun by hand. The disk should be about six inches in diameter. The colors appear most plainly when viewed from a distance of about six feet or less, and when the disk is held in a fairly strong light. The red has most intensity and becomes a deep maroon when the disk is held close to an artificial light.

A somewhat similar effect, but not so evident, occurs when the eye passes rapidly over a pattern of black and white. These color suggestions doubtless add to the brilliancy of certain black and white designs even when we do not see the colors.

Neutrals Contribute in Another Way to Increase the Apparent Intensity of Colors Which Lie Next to Them.—It has been found that when a color appears before our eyes its effect of greatest intensity occurs during the first fraction of a second. After this brief period, the intensity of the sensation rapidly decreases to about two-thirds or one-half. We can see something of this decrease if we place a neutral, gray or black, so that it covers part of a color area, as in Fig. 7, and after looking for a moment at the point C, remove the neutral. The uncovered portion of the color area will be much more brilliant for an instant than the part that has been in sight longer.

Because of this heightened intensity of color sensations during the first instant of visibility, it follows that when our eyes pass slowly over a pattern where neutral areas occur between color areas, the alternation of color with spaces devoid of any hue tends to keep the color sensations

at their greatest keenness. For this reason neutral areas in
a design increase the apparent intensity of adjoining color
areas. When a piece of color is so low in intensity that we
are not certain what the hue really is, if we place it beside
a neutral gray the contrast with a surface which is wholly

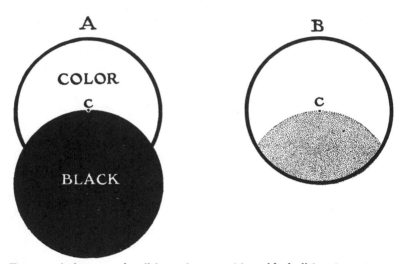

FIG. 7. *A* shows a color disk partly covered by a black disk. *C*, at the top
of the black disk, is the point at which the eye looks until fatigued. In
B, the shaded portion indicates the area of apparently heightened inten-
sity of the color disk after the black disk is removed.

devoid of color enables us to see quite clearly whatever of
color there is present. We recognize it at once as a greenish
or bluish or pinkish or yellowish gray. For this reason
areas of neutral in a design bring out all the possibilities of
very delicately tinted areas next to them.

**White or Black Areas in a Color Composition Are Likely
to Dominate the Design.**—White represents the brightest
level toward which all colors rise as illumination increases,
while black stands for the gloom into which they disappear

when all light has been cut off. There is, therefore, something absolute and supreme about the impression which white and black make upon us. Because of this tendency to dominate, pure white and black should be used with great skill, and when so used they are remarkably effective. Splendid combinations in costumes and in decorations can be produced by large areas of black or of white, with small areas of appropriate colors. Large areas of both black and white in costumes are seldom pleasing. In most cases one or the other of these absolutes should dominate decidedly, and the other merely enhance it or the colors with it.

Another instance of the decorative possibilities of white and of black is shown when the spaces of a composition are mostly colored, but when among their gradations appears a note of pure white or black, or both. The colors in all the other spaces may approach near to white or black, but by strictly limiting the actual white and black to one or two carefully chosen spots, the effectiveness of the gradations is increased. With regard to this use of white and black, John Ruskin wrote as follows:

"Next, respecting general tone. I said, just now, that, for the sake of students, my tax should not be laid on black or on white pigments; but if you mean to be a colorist, you must lay a tax on them yourself when you begin to use true color; that is to say, you must use them little, and make of them much. There is no better test of your color tones being good, than your having made the white in your picture precious, and the black conspicuous.

"I say, first, the white precious. I do not mean merely glittering or brilliant; it is easy to scratch white sea-gulls out of black clouds, and dot clumsy foliage with chalky dew; but, when white is well-managed, it ought to be strangely delicious—tender as well as bright—like inlaid mother-of-pearl, or white roses washed in milk. The eye

ought to see it for rest, brilliant though it may be; and to feel it as a space of strange, heavenly paleness in the midst of the flushing of the colors. This effect you can only reach by general depth of middle tint, by absolutely refusing to allow any white to exist except where you need it, and by keeping the white itself subdued by gray, except at a few points of chief lustre.

"Secondly, you must make the black conspicuous. However small a point of black may be, it ought to catch the eye, otherwise your work is too heavy in the shadow. All the ordinary shadows should be of some *color*—never black nor approaching black, they should be evidently and always of a luminous nature, and the black should look strange among them; never occurring except in a black object, or in small points indicative of intense shade in the very centre of masses of shadow. Shadows of absolutely negative gray, however, may be beautifully used with white, or with gold; but still, though the black thus, in subdued strength, becomes spacious, it should always be conspicuous; the spectator should notice this gray neutrality with some wonder, and enjoy, all the more intensely on account of it, the gold color and the white which it relieves. Of all the great colorists Velasquez is the greatest master of the black chords. His black is more precious than most other people's crimson." *

Black Appears to Have a Kinship with Colors of Long Wave-Length and White with Colors of Short Wave-Length. —The hues of the lower end of the spectrum, red and orange, have a peculiarly close relation to black, and can be used with it to great advantage. A design of red, orange-red, and orange in a large area of black, forms a striking combination. On the other hand, the colors of the upper end of the spectrum, blue-green, blue, and violet have an affinity for white. Blue-green shutters are generally chosen for white houses, and the blue-green oxidized copper for the

* *The Elements of Drawing*, pp. 158–159.

trimmings of white stone buildings. White and lavender form one of the most delicate of color combinations.

The reason for this close agreement of black with the colors of the lower end of the spectrum, and of white with those of the upper end is probably that red and orange are the first hues to emerge from darkness when the energy of the electromagnetic waves comes to the point of visibility, and consequently these colors lie close to black, while blue-green, blue, and violet are the last hues we can perceive before the rapidity of the light vibrations carries them to the point where our eyes can perceive color no longer. Therefore, especially in their high values, they seem like approaches to the absolute of white.

The relationships just described of the cool colors with white, and of the warm with black, may be the reason why white, notwithstanding the fact that it suggests light, is a cool tone, and black, although hinting at darkness, is usually a distinctly warm tone. White hints at the cool colors with their short wave-lengths, while black frequently seems about to emerge from its neutrality into the glow of the long-wave hues. Probably also association has much to do with it, because snow and frost are white. Then, too, white in sunshine is physically the coolest of tones, because it reflects the most light and heat, while black is, in fact, the hottest because it absorbs most. Also when white and black objects of the same material are raised to an equal temperature black radiates more heat than white, because the ability of an object to radiate heat when it is warmer than its surroundings is in exact relation to its ability to absorb heat when it is cooler than its surroundings. If two radiators are painted, one white and the other black, and heated to the same temperature, the black one will radiate more heat than the white.

Next to Black and White, Middle Gray is the Most Important Neutral Value.—Black and white, like colors, fatigue the eye, and consequently produce what are called after-images. Place a disk of black on a field of white and

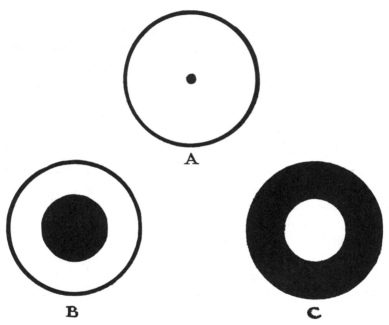

FIG. 8. To illustrate after-images of black and white.

gaze steadily at its centre for about twenty-five seconds. Then take it away but continue looking at the white ground. For a few seconds a shape like that of the black disk will be seen, but it will be whiter than the supposedly white ground. This effect can be seen by looking at *B* in Fig. 8 till the eye is fatigued, and then at *A*, to observe the after-image. Now place a white disk upon a black ground, as in *C*, and look at it steadily for the same length of time. Then remove it, and after a second or two the same shape will

appear, but blacker than the background. Try the effect
of black and of white disks upon gray, or upon colors, and
corresponding effects will be seen. The eye, fatigued with
the intensity of the extremes, tends to see them as reduced
toward a half-way point.

Similarly, when we look at a particular point in a scene,
all the contrasts outside of the area which is directly in
front of our eyes seem to be reduced. Colors beyond this
area appear somewhat neutralized. Extremely high values
are apparently lowered, and very low values are raised, and
everything is drawn a little toward a middle gray. It is
the solvent of all other colors and values, and seems to
mingle with them when they pass away from the centre
of vision, or whenever our eyes become wearied. For this
reason familiarity with middle value is of particular impor-
tance to a knowledge of tone relations, and should be well
established in mind. If possible we should know the middle
value so that our sense of it corresponds to what the mu-
sician terms, in music, a sense of absolute pitch.

Nature's grays, like her whites and blacks, are seldom
wholly neutral. Some color usually appears in them.
When the artist, in a design with colors, uses shapes of neu-
tral gray, these areas have an individuality which makes
them strikingly distinct from the hues. Ruskin remarks
that: "The other colors should be continually passing, one
into the other, being all evidently companions in the same
gay world; while the white, black, and neutral gray should
stand monkishly aloof in the midst of them."

**A Color Can Come to Its Full Intensity at Only One
Value.**—The six colors on the disks of our color top are sup-
posed to be about as intense as they can be made with the
colors available for printing. If we place them in a row
we find that some are higher in value than others, and

must be so in order to show the colors in their full purity.
If the yellow is made as dark as the blue it cannot be a
strong yellow. If the blue is made as light as the yellow it
cannot be an intense blue. In our color circle, in which we
made all the colors as pure as we could, we find the same
differences of value.

The level between light and dark where each color comes
to its full intensity is called its spectrum value. Yellow
has the highest spectrum value, that is to say, it is the
lightest of any of the colors at its full intensity. Violet is
lowest. Blue-green and the orange-red of vermilion come
to their spectrum value at about the middle point between
white and black. Orange and yellow-green find their spec-
trum value approximately half-way between yellow and the
middle value, while red and blue come to their fullest in-
tensity at about half-way between the middle value and
that of violet.

It is comparatively easy to darken a color of high spec-
trum value without producing an unpleasant tone, but the
result of lightening a color of low spectrum value merely by
adding white, or by diluting it with water, is likely to be a
thin and disagreeably weak tint. To produce a light blue
or red or violet, which has delicacy without weakness, we
must add to it its complement, or gray, or a little of each of
the colors which lie next to it in the color circle. In the
case of red, these added hues would be orange and violet.
These methods will be discussed in the chapter on Com-
posite Colors.

Colors Have Degrees of Both Value and Intensity.—In
studying neutral grays we have to consider only their values.
When we deal with a color we have to take into account
not only the amount of light and dark, but also the degree
of intensity of the hue, that is, whether it is a pure color or

whether it is grayed and thus reduced in color quality. The colors about us are subject to an infinite number of modifications by light and dark and by degrees of saturation and grayness, so that sometimes it is difficult to recognize in a subdued tone just what hue is actually present. An important step in training our perception of color is to be able to see in the so-called dull tones, that is in grayed or dark or otherwise obscured tones, the spectrum color which gives them whatever hue they have; in other words, to know just what spectrum hue in its full intensity, if mixed with a neutral, that is, with white or black or any intermediate gray, would most nearly match the given tone. Therefore, it is necessary to experiment with the six spectrum colors, mixing each of them with white and black and gray in various proportions, so that we may recognize each hue in any of its values and intensities, and can tell which one of the six colors is present to impart whatever hue the mixture has.

The Effect of Mixing Black and White and Gray with Colors.—It would seem to be a simple thing to recognize a dark or light or grayed tone of any one of the familiar spectrum colors, but surprises await us when we make experiments with some of them, especially with yellow, orange-yellow, orange, orange-red, and red. Very few people until they have experimented with these colors know the tones which result when these are mixed with neutrals of different values. In the variations of yellow are found all the olive tones which occur in many yellow birds. What we commonly call browns are found in the region of orange-yellow. Orange with black sinks toward red, red with black goes toward violet, while orange-red and red with a mixture of white and black give us, respectively, rosy and violet tints.

We can observe these mixtures in two ways. First, by

placing one of these hues on the color-top and spinning it with varying proportions of the black disk, then of the white disk, and then with both black and white disks in varying proportions. Secondly, we can make the mixtures by using water-colors and mixing the hue with black, and then with grays produced by diluting the black with more or less water. Of course many of Nature's softened or dark colors are composite, and can seldom be produced exactly by a mixture of one color and a neutral, but the mixture of one color with neutrals acquaints us with the simpler effects of varied values and intensities, and gives us a basis for understanding and enjoying more fully the complex tones when later we experiment with them. When we have actually seen the pure hue combine with the neutral and lose its intensity in darkness or in grayness, we shall be able to perceive more easily what the hues are that lie almost hidden in the so-called grays of stones and soil and tree bark and cloudy skies.

The Effect of Illumination and Gloom upon Colors.— The effect of varying degrees of illumination or of shadow upon colors is something like that which results when we mix the colors with different proportions of white or of black. Therefore, we can go far toward making colored objects in a painting appear as if light fell upon them, or shadows were thrown across them when we merely make the portions which are supposed to be in light, whiter, and darken those which are to appear as if in shadow. White alone, however, cannot fully represent the effect of light upon colors, because there is a palpitating energy in strong light which imparts a vibrant quality to the colors upon which it falls.

Strong Light Diminishes the Intensity of Colors upon Which It Falls.—We have learned that most colored sur-

faces owe their hue to the fact that they absorb part of the spectrum colors and reflect the remainder. In a moderately bright light these surfaces are able to swallow up the larger proportions of those rays which come within the range of their power of selective absorption. Consequently, the rays which they do reflect and which give them their color, are fairly pure and unaffected by those of other wave-lengths which would gray them if mixed with them. When the illumination becomes intense the deluge of light is so great that the absorptive capacity of the object is overtaxed and it can no longer take up all the rays of any single color. The flood of light is therefore largely reflected, and our eyes receive from the object not only the rays characteristic of its color but also a large number of all the other hues of the spectrum. If the color of the object is red, that hue is still likely to predominate, but it will be accompanied by so many other rays that the purity of the color will be lessened. The surface will be more brilliant because it reflects a greater amount of light than in low illumination, but any one particular color will be less pure because it is submerged in the white light.

If high illumination strikes the surface at an oblique angle, so much of the light will glance off in specular reflection that no one color will predominate. Any surface, however colored, may then appear white. We see this effect when we look at leaves which catch the sunshine at an angle such that the light is almost totally reflected, and green paint can no longer represent them. They are more nearly recorded by strokes of white. On the other hand, when very brilliant light passes through a transparent or translucent colored material, the transmitted color is usually more intense than in dull light. Even high illuminations are seldom powerful enough to overtax the capacity of

selective absorption to deal with the amount of light which actually passes through the translucent substance. This is illustrated by the intensity and purity of color where sunlight has passed through leaves in comparison with the bright but almost colorless light reflected from their surfaces in glancing sunlight. On the contrary, if a transparent substance like colored glass is placed in the path of very low illumination, for instance, that of moonlight, it is almost impossible to detect any color upon a piece of paper held so as to catch whatever light may pass through.

Because bright light decreases the degree of saturation of strong opaque colors, and tends to harmonize them by mingling the specularly reflected white rays with them all, it is probable that the reds, blues, and yellows with which the Egyptians and Greeks and other nations of early periods adorned their architecture were not unpleasant under the clear sunshine of those countries. Sunlight flooding even the crude colors of the most aggressive out-of-door modern advertisements can bring about a degree of relationship between the hues, so that they are less disagreeable than on a cloudy day.

In tropical sunshine where the powerful light glancing from foliage and objects fills the air with dancing prismatic radiance, brilliant butterflies, flitting about, seem to be part of the general scheme and merge themselves into it. Birds of bright plumage are inconspicuous among the trees. A peacock in the midst of sunlit foliage, even if his tail is spread, becomes almost invisible, and his feathers appear scarcely more resplendent than the leaves. In an important book on coloration occurs the following statement by the painter, Abbott H. Thayer:

"The peacock's splendor is the effect of a marvellous combination of 'obliterative' designs, in forest colors and

patterns. From the golden green of the forest's sunlight, through all its tints of violet-glossed leaves in shadow, and its coppery glimpses of sunlit bark or earth, all imaginable forest tones are to be found in this bird's costume; they melt .him into the scene to a degree past all human analysis.

"Up in the trees, seen from below, his neck is at its bluest, and when sunlit, perfectly represents blue sky seen through the leaves. Looked *down* on, in the bottom shades of the jungle, it has rich green sheens which 'melt' it into the surrounding foliage. His back, in all lights, represents golden-green foliage, and his wings picture tree bark, rock, etc., in sunlight and in shadow. His green-blue head is equipped with a crest which greatly helps it against revealing its contour when it moves. Accompanying its every motion, this crest is, as it were, a bit of background moving with it. The bare, white cheek patch, on the other hand, 'cuts a hole,' like a lighted foliage vista, in the bird's face. The tail, when spread—or even when shut—'mingles' in a thousand ways with its jungle surroundings. The ocelli, guaranteed by their forest-scenery colors, to vanish into the background at a short distance, have one peculiarly fantastic use. Smallest and dimmest near the body, and growing bigger and *brighter* in even progression toward the circumference of the tail, they inevitably lead the eye away from the bird, till it finds itself straying amid the foliage beyond the tail's evanescent border.

"The *spread* tail looks very much like a shrub bearing some kind of fruit or flower. Its coppery ground color (in a front view) represents perfectly that of the bare ground and tree trunks seen through the leaves. The very positiveness of the design in such details as an ocellus, works to conceal the wearer, on the principle explained in the introduction by a quotation from Stevenson. The forest is so full of highly individualized vegetable forms and of many-colored spots and streaks made by their confused outlines, that the predator's eye watching mainly for *motion*, doubtless gives but slight attention to any of them, *or to anything that looks like one of them.* In addition to all of

this, every changed point of view on the beholder's part makes all the bird's details assume new color and new correlations to each other and to the scene." *

Under Intense Light, Colored After-Images Add Their Hues to Those of the Actual Scene.—Sensations of intensely brilliant light do not die away immediately after the cause has been removed, but persist as color images, even when the light which produced them is white. These images overlay with their hues everything at which we look for several seconds afterward. Probably the most familiar example is the experience which follows looking at the sun. When we turn away we see sun-shaped disks wherever we look. These disks gradually change through a series of brilliant hues before they disappear. Even after they have faded so that we no longer notice them, we can sometimes see them again as faint but delicately colored patches if we look at some light background, as snow or white paper. When we shift our eyes to a very dark background, such as an opening into a gloomy room, the same disks instantly take on colors complementary to those which they showed against white. If we gaze at the flood of light reflected from the water at an oblique angle when the sun is fairly low, we will find that in a few minutes the scene becomes saturated with color, which changes gradually as the eye becomes increasingly fatigued, so that the effect is almost as if we looked through colored glass. Probably the play of these color images adds something to the chromatic effect of scenes under tropical sunshine, because some of the reflected lights are sufficiently intense to produce this overstimulation of the retina.

* Gerald H. Thayer, *Concealing Coloration in the Animal Kingdom.* Copyrighted, The Macmillan Co.

Under Varying Degrees of Illumination Colors Appear to Change in Hue as Well as in Value and Intensity.—If we carry our color circle from bright light into deep shadow we might naturally suppose that the hues would remain the same even though the values were lowered. In other words, we might expect that the red as it passed from illumination to shadow would merely become a darker value of the same hue. In fact, however, each color tends to appear more yellowish in strong light and to take on suggestions of violet in shadow. As they advance into light, red approaches orange in its appearance, and orange and green become slightly yellowish. Blue gives hints of green, while violet is somewhat bluer. On the contrary, as they pass into increasing shadow the hues are shifted somewhat toward violet or dark blue. Green becomes bluer; and orange redder, while red and blue show hints of violet. The changes in yellow are most elusive. In high illumination it may tend toward white or greenish white. In shadow, under some conditions, it suggests green, and under others, orange. At other times it is grayish, as if some of the complementary violet had been added. A yellow vase or flower or fabric will usually show these modifications.

The changes in hue just described are not very evident on the color circle itself as we move it from high light to shadow and back again, because each color is changing proportionately as the light varies, and therefore there are no constant hues with which to compare the changing ones. The differences show more plainly when we can see high light and deep shadow at the same time on a given color. Folds of drapery, flowers, and objects modelled so as to catch the light at various angles offer favorable conditions under which to see the changes. A red rose shows the effects in striking fashion. In a garden where flowers can

be seen, some in sunshine, some in subdued light, and some in deep shadows, or in a forest where the green of leaves appears under innumerable degrees of illumination, we may see some of the variations of hue, although under these conditions certain of the variations are due to causes other than the differences in intensity of light or depth of shadow. These variations of hue, due to different degrees of illumination, are important for the artist, and will be considered in more detail later.

The Colors of Night.—The tendency of colors to approach dark blue or violet-blue as illumination decreases is evident in the hues of night. Artificial lights, of course, furnish their own colors, but outside the range of these lights and their reflections, night tends to be bathed in deep blue and violet, and can seldom be truly represented in a painting by neutral grays or blacks. The softened radiance of moonlight produces elusive effects of color which are difficult to analyze. When the moon rises red through low-lying haze, its warm color accentuates the violet, so that the sky around the moon is graded from reddish to violet, and the shadowed sides of masses of foliage between us and the east are frequently deep purple. When the moon is high and clear, its yellowish white light appears to disintegrate the bluish color into which the green of grass and trees has passed, so that illuminated areas of green become a silvery gray. When we look at it we find difficulty in knowing how much of the suggestion of color which it brings is direct sensation and how much is recollection of the colors in daylight. Sometimes, when the air is full of moisture, the light of the moon is diffused through the atmosphere, which becomes luminous. At the same time the light subdued by the veil of mist becomes, as yellowish light usually does when its intensity is decreased, decidedly greenish. This

green radiance of vaporous moonlight has a peculiarly mystical beauty.

When moonlight is fairly clear and strong, if we stand so as to face away from the source of light we usually find the colors vibrating between green-blue and violet-blue. A remarkably fine rendering of this effect is presented in a painting called "The Urn," by Le Sidaner, which at the time of this writing hangs in the galleries of the Art Institute of Chicago. In this painting the whole atmosphere is pulsating with the bluish colors into which the hues of objects merge under low illumination. Where the moon shines directly upon light-colored surfaces as walls, the hue rises out of the blue toward luminous green. In shadow areas it sinks toward violet, while hints of both green and violet are woven into the general effect of blue.

Colors Do Not Always Retain Their Relative Values Under Changing Illumination.—Colors which are of the same value in a given light may appear as different in value when the intensity of the light is increased or decreased. For example, if an orange and a blue are of the same value under high illumination, when the illumination is greatly decreased the blue will appear lighter than the orange. As illumination decreases, colors of longer wave-lengths lose their power to reflect light more rapidly than do colors of shorter wave-length, so that blue with its short wave-lengths can reflect more light in very dim illumination, and thus appear lighter than a red or orange which in bright light was of the same value. An artist who just after sunset paints dim blue hills against a golden sky, so that the hills are slightly darker than the sky and make a silhouette against it, will find as twilight deepens that soon there is no difference in degree of light and dark between the hills and the sky in his picture. A little later still, when the light is very

dim, the hills which he painted darker than the sky are now apparently lighter. In the full light of the next day his hills will again be darker than the sky. Thus the light in which a picture is hung may change quite materially its pattern of light and dark, and consequently its intended effect.*

Intricate Gradations of Value and of Intensity Give Vibrancy to a Color.—A flat area of any color is usually repellent. We find the unrelieved monotony of sensation tiresome. As soon as we vary the surface with gradations of value and intensity, the color appears more alive. Even slight changes of surface will sometimes relieve the flatness and enliven the tones. Consequently, artists and artisans are always experimenting with their materials in order to discover and make use of delightful qualities of reflection. The weaver tries to produce surface textures upon which the light plays in pleasing fashion. Silk, linen, cotton, each reflects the light in a particular way. The right and wrong side of a piece of velvet may be identical in color, but the reflection from the reverse side is uninteresting. From the right side, however, part of the light comes back in the silvery brilliancy of specular reflection, while the rest of it penetrates more or less deeply into the pile of the surface. Here it is transmitted through the fibres and is reflected back and forth before it can emerge. These multiple reflections enrich the intensity of the color, so that we see all degrees from the silvery quality of the almost completely reflected light to the sumptuous darks where the absorption has been nearly total. The sense of increased richness and vitality of color when we look first at the reverse and then at the right side of a piece of velvet is marked. The range

* For scientific reasons for these changes, see *Color and Its Applications*, by M. Luckiesh, pp. 9–11, 165.

of values and intensities is further increased when the velvet is in folds.

Skilful workers in hammered metal often produce, by their hammer strokes, a complex surface which catches the light and reflects it in a way that contributes much to the beauty of the object, and is quite in contrast to the more flashy brightness of new tins. The painter works to give depth and beauty to his colors. The artist and artisan in every line try to avoid lifeless colors, and give to their products surfaces which reflect light and its colors with pleasing complexity.

Almost every variation in ways of handling colors gives its own quality of effect. For example, select any color in your paint-box and paint a small surface with it. Now paint another surface using as much water as will stay on the paper, and drop color into it till it is as intense as the color on the first surface. It may take this several hours to dry, so place it where it will not be disturbed. Now paint another surface with flat color as you did the first, and when it is dry hold it under the faucet and with a brush wash off what color can be removed easily. Repaint it and wash it again, so that after the washing it is about as dark and intense as the first surface. You will then have three surfaces painted with the same pigment, so that they are similar in hue, value, and intensity, but in texture they will be quite different. Probably the first will be flat and smooth and uninteresting; the second full of variety because of the way the paint has settled through the depth of the water; the third, washed into the paper, will have a surface texture caused by the grain of the paper that will be very different from either of the others. The projections caused by the grain of the paper will have lost most of their color, while the paint in the depression will remain practically un-

touched, unless the paper was washed too much. This breaking up of the paint surface into a mosaic of minute lights and darks gives it a complexity which often suggests that of some of the surfaces of natural objects or of textiles or pottery. If the washed and the unwashed pieces be placed beside woven material of the same hue, the piece that has been washed will be likely to resemble the fabric much more than the other piece does.

Compare three similar tones of dark red produced in different ways with water-colors: first, by mixing black and red and covering an area with the mixture; second, by painting a surface dark gray and when it dries overlaying it with a wash of red; third, by reversing this order and overlaying red with dark gray. This can be done so that the three tones will be of about the same color, but each will have a distinct character because of the different ways in which it catches the light and consequently exhibits different gradations of values and intensities.

Still more evident examples of the effects of vitality which result from gradations of value and intensity are seen when these gradations are on a larger scale. If we wet a surface of paper with water and then drop upon it bits of color and of neutral they will run together unevenly, and will mingle in endless variety of modulations. In places the color will fade softly into gray, and then emerge into fairly strong intensity. Dramatic effects of colored light disappearing into and emerging from gloom and giving the sense of depth and of cumulose volumes are possible from these flowings together of a color and neutrals.

By guiding the flow of the pigments and adding color or water here and there we can bring out any sort of delicate interweaving of color with grays, or of sharp contrasts of full color with black and white. Even in these minglings,

which require little skill, we shall find an unexpected variety of effect; indeed, individuality is curiously expressed in them, for if a number of people are at work on minglings of the same hues, one person will secure one style of contrast and texture, and another a still different effect, so that it is often difficult for one person to imitate the results of another.

Important Artistic Effects Are Possible with Only One Hue and Neutrals.—We have found that by mixing a single color with different amounts of black and white and grays, we can produce a remarkably wide range of color tones. Until we have actually made the mixtures it seems impossible that so great a variety can be produced by combinations of only one hue and neutrals.

Combinations of this type are frequently found in nature and in art. Sometimes these are strictly limited to one color and neutrals. In printing, especially of advertisements, it is a great saving of expense and labor if the desired effect can be obtained with the use of only one color and neutrals. A collection of examples of these effects is valuable to the student of color. Sometimes one color and neutrals form the general design in which appear a few contrasting spots of other colors. Usually these one-color patterns give the effect of being composed of a great variety of hues. It is only when we examine them after we have become familiar with the possibilities of one color and neutrals that we are able to see how few are the actual hues which enter into the combination. When we see a Cecropia or Polyphemus moth our first impression is likely to be similar to that which Keats expresses in "The Eve of St. Agnes":

"Innumerable of stains and splendid dyes
As are the tiger-moth's deep-damasked wings."

However, when we analyze the tones we find that if we place white, black, and orange-yellow paints upon a palette we can produce, from the various mixtures possible with these three pigments, a large proportion of the colors of these two moths, and of many of the tiger-moths as well. The impression of "innumerable stains" comes largely from the contrasts of the pattern of light and dark values and the apparent changes of hue which take place when the same color appears in various values and intensities.

In much fine painting the effect is due to the skilful use of light and dark tones with only a limited range of color. Laurence Binyon writes:

"But if we take the central tradition of Asian painting in its great periods and most typical form of expression, what do we find ? We find a type of painting in which color, so far from being predominant, is an always subordinate element, and is often entirely absent." *

He says that later, in the fourteenth century, came a change from the lofty idealism of the eleventh and twelfth centuries, and the ink sketch yielded to the sensuous charm of color, and adds regarding the work of the painter Korin, in the seventeenth century:

"The Genroku era in which Korin lived was one of unparalleled luxury and magnificence. New designs and patterns for stuffs and dresses were in continual request, and Korin delighted to improvise some novel idea in decoration for the dresses of fair women. We read of parties at which the ladies withdrew and returned seven or eight times, appearing each time with a different dress, always of the same color, but always with a new design." †

* Laurence Binyon, *Painting in the Far East*, p. 10. Dover Publications, Inc.
† *Ibid.*, p. 224.

Thus it appears that even in an era of magnificence, this artist was satisfied to depend for variety upon changing his patterns rather than his colors.

In considering how much we can express with only one color in its different values and intensities, and in combination with neutrals, we must take into account the purpose of our design, and select the color which is likely to awaken the mood most appropriate to this purpose.

We have found that given colors have general characteristics which affect the majority of people in the same way. Among these general characteristics are those of warmth and coolness, and of advancing and retreating qualities, and the traditional significance of colors, which have already been referred to. We have also to take into account the more individual ways in which the same color may impress different people. Some of us strongly prefer reds. Others like blues best. Some choose greens, and a few name yellow as their favorite hue. Consequently a color scheme that appeals to one temperament may not be attractive to another. The following are good illustrations of individual color preferences and responses.

Lafcadio Hearn, who was particularly sensitive to color, writes:

"In my own case the sight of vivid blue has always been accompanied by an emotion of vague delight—more or less strong according to the luminous intensity of the color. And in one experience of travel—sailing to the American tropics—this feeling rose into ecstasy. It was when I beheld for the first time the grandest vision of blue in this world—the glory of the Gulf Stream; a magical splendor that made me doubt my senses—a flaming azure that looked as if a million summer skies had been condensed into pure fluid color for the making of it." *

* Lafcadio Hearn, *Exotics and Retrospectives*, p. 232. Little, Brown & Co.

William Beebe thus describes greens:

"When I have left behind the world of inharmonious colors, of polluted waters, of soot-stained walls and smoke-tinged air, the green of jungle comes like a cooling bath of delicate tints and shades. I think of all the green things I have loved—of malachite in matrix and table-top; of jade, not factory-hewn baubles, but age-mellowed signets, fashioned by lovers of their craft, and seasoned by the toying yellow fingers of generations of forgotten Chinese emperors —jade, as Dunsany would say, of the exact shade of the right color. I think too, of dainty emerald scarves that are seen and lost in a flash at a dance; of the air-cooled, living green of curling breakers; of a lonely light that gleams to starboard of an unknown passing vessel, and of the transparent green of northern lights that flicker and play on winter nights high over the garish glare of Broadway.

"Now, in late afternoon, when I opened my eyes in the little gorge, the soft green vibrations merged insensibly with the longer waves of the doves' voices and with the dying odor. Soon the green alone was dominant; and when I had finished thinking of pleasant, far-off green things, the wonderful emerald of my great tree-frog of last year came to mind—Gawain the mysterious—and I wondered if I should ever solve his life." *

Louisa Fletcher, in "Mandarin Red," thus describes the color:

"I am the blood of Harlequin,
 The pulse of all things riotous and fleet.
 A deal of me and you have carnival;
 A little—and the heart must skip a beat!" †

Bliss Carman says:

"The scarlet of the maples can shake me like a cry
 Of bugles going by."

* *Atlantic Monthly*, March, 1921, p. 307.
†*Harper's*, May, 1921, p. 692.

A description in terms of music is given by Christopher L. Ward:

"From the faintest murmur of pearl-gray, through the fluttering of blue, the oboe note of violet, the cool, clear wood-wind of green, the mellow piping of yellow, the bass of brown, the bugle-call of scarlet, the sounding brass of orange, the colors are music."*

Some Ways of Using One Color and Neutrals so as to Bring out the Artistic Possibilities.—A design which is restricted to one color in its possible range of values and intensities, together with neutral tones, enables us to express in its simplest form the individual qualities of that particular hue and the mood which it tends to awaken in us. Among the items to which the artist gives attention in order to emphasize the effect he desires are:

1. **The Quality of the Color.**—This may be modified by the material. If the same red is used to color paper, cotton, silk, velvet, wood, porcelain, and metal, the character of surface texture will be different in each case. The quality of a hue in water-color is different from that of the same hue in oil-paints. Often the difference between a distinguished and a commonplace color effect is due not so much to the actual hue as to the skill with which its surface is handled.

2. **The Pattern of the Design.**—A color spread evenly over a surface is monotonous. The pattern of a design, with its gradations and contrasts, is the means by which we can bring out the full range of possibilities of our color tones. Typical among pattern effects of one hue and neutrals are the following:

First: Those which present powerful contrasts of intensities and values; a brilliant note of the color brought

* *The Yale Review*, April, 1921, p. 531.

sharply against black or white or both, as when a vermilion initial or ornament occurs in a piece of black-and-white printing, or when one note of strong color appears upon a rich, black costume.

Second: Those which present only slight contrasts, as when all the tones of a scene are subdued by haze so that there are no very strong lights or darks or intensities of color.

Third: Those in which the tones are gradated so that toward the centres of interest the intensity of the colors increases and the contrasts of value grow sharper. This arrangement makes an emphasis of interest toward the most important points of the design, as at sunset the colors are likely to increase in intensity or brilliancy toward the source of light.

Familiarity with the remarkable range of effects which can be produced by only one color in its various values and intensities and in combination with blacks, whites, and grays, is an important introduction to the enjoyment and discriminating use of color. Experimentation with mixtures of pigments in which we make an indefinite number of mixtures of one color with grays, blacks, and whites, the making of designs limited to these elements, and collecting examples from nature and art, all help to give us familiarity with the possibilities of these color schemes. In nature the monochromatic, or nearly monochromatic birds, butterflies, and moths furnish excellent examples. Partridges, blue-jays, some of the warblers, and almost innumerable butter-flies and moths show us striking patterns and endless grada-tions of one color and neutrals. In textiles and in printing we find excellent examples. Many magazine covers and book illustrations produce remarkable color effects by intro-ducing only one hue, pure in places, and in others mingled with different gradations of black.

QUESTIONS

1. How many steps in value from white to black can our eyes recognize readily?

2. How does the range of values in nature compare with that of pigments?

3. What are some of the characteristics of white? of black?

4. Collect white objects and compare the qualities of the different whites. Do the same with black objects. Arrange them in order of whiteness and of blackness.

5. What is the effect upon colors of placing neutrals next them?

6. What colors seem most closely related to black? to white? Why?

7. Why is the middle value of gray artistically important?

8. What is meant by the spectral value of a hue?

9. What is the approximate spectral value of the following colors as compared with the values of the neutral scale: yellow, orange, orange-red, red, blue, violet, green, blue-green?

10. Select a sample of what you consider to be brown. Match it with the top and disks to see what hues enter into it.

11. What is the effect of strong light upon colors as compared with the effect of dull light?

EXPERIMENTS

Experiment I.—To gain experience with some of the effects produced upon colors by changing their values and their intensities.

1. With your color-top and the black and yellow disks, see what effects are produced by varying the proportion of yellow and black, from a combination of a little black with the yellow to one where there is only a little yellow with the black. In what way does a dark yellow differ from what you would expect it to be?

To a fairly dark yellow, such as is produced by spinning the top when the black disk covers about two-thirds of the circle and the yellow one-third, add a little white by inserting the white disk so that it covers a quarter or a third of the visible portion of the yellow disk, leaving the black so that it still covers two-thirds of the circle. Notice the tone of the resulting grayed yellow. Vary the proportions of the disks and become familiar with the different grayed yellows.

2. Paint a series of seven or eight tones, the first of which is pure yellow, the next yellow with a little black so that the result is a little darker than the first. Make each successive tone darker than the one which precedes it by mixing an increasing proportion of black with the yellow. As a result you should have a series of yellows decreasing in value from pure yellow to a very dark value.

From these select five, one of which is pure yellow and one a tone that seems to you as dark as yellow can be made and still, at a distance of three or four feet, be unmistakably yellowish, and the others making graded steps between these, so that you have five values of yellow, the first of which is pure yellow, while the others form an even series from pure yellow to the darkest tone.

If a good gradation of values is not secured at first, you can lighten or darken any which you wish to change after the paint is dry, by washing them with water to remove some of the paint or by adding another coat of paint. Each of these should be about one and three-quarters by two and one-half inches in size. For convenience in working, make each sample larger than the final size and do not cut them out until the tones are just as you want them. Each should be as intense a yellow as may be, and yet be dark enough to take its place in the series. If any tone is too gray, washes of yellow can be carried over it after it is dry. Even in the darkest tone there should be enough color so that it will be evidently a very dark yellow, but not black. Sometimes a wash of pure yellow over the dark tones will give a richness of color that cannot be obtained by the first painting alone, where the black and yellow are mixed. Cut these

out and mount them on a sheet to show these different values of yellow.

3. With the color-top try the same experiments with orange and with red that were described for yellow in step 1. Use each of the colors first with varying proportions of black, and then with varying proportions of black and white. Are the results what you anticipated? Which mixture produces a tone nearest to your idea of brown? Experiment with the orange and yellow disks used together, with varying proportions of black, and of black and white. In a similar way observe the effects produced by the orange and red disks together with varying proportions of black and white. Can you tell what colors in the room could be exactly matched by any one of these colored disks with black or black and white?

4. With water-colors, make a series of tones with orange and red, similar to those described for yellow in step 2, and mount the five chosen to show gradation of values and intensities as in the case of yellow.

5. With the color-top try the same experiments with blue, violet, and green that were tried with yellow, orange, and red.

6. Make a dark blue in the same way that you made the darkest yellow in step 2, only substituting blue for yellow. Make a light blue about half-way in value between pure blue and white. Mount these together with a sample of pure blue, so that you have a series of three: light blue, blue, and the darkest blue that is still unmistakably blue.

7. With water-colors, make three tones of green, and also of violet in the same way as described for blue in step 6.

Mount and keep the five tones of yellow, orange, and red, and the three tones of blue, violet, and green, as illustrations of the effects produced by lowering the values of colors. We keep five tones of yellow, orange, and red, because these hues show more unexpected effects from changing values than do the colors from green to violet. The colors appear better when mounted on gray than when mounted on white.

In producing the dark tones of colors, experiment with

various ways of treating the colors, and note the differences in the results. For example, if we paint black over a red that has already dried, or red over black, or paint various successive washes, each of the different treatments gives a different effect. Usually by one of these methods we can produce a dark red that is more luminous and not so dead and flat as the red produced by mixing black and red thoroughly before the paint is put on the paper. What is true of the dark tones of red is, of course, true for those of the other colors. If we study paintings we find how much artists have experimented in the effort to make their colors vibrating and luminous instead of flat and lifeless.

Experiment II.—To show some of the various and complicated gradations that may be produced by mingling one hue with black, white, and gray.

When instead of mixing any color thoroughly with black or white or gray, so as to produce a flat tone, we mingle the pigments by letting them run together so that they are only partially mixed, we can produce within a small area a great variety of values and intensities, which illustrate a wide range of possible effects. The texture and various gradations produced by mingling instead of mixing, give a variety and vitality to the color, and help us to see that remarkable variety of color textures which we find in natural objects.

1. With a brush, wet a piece of paper about three by five inches in area. Make near the middle of this an irregular spot of bright yellow of full intensity. While this is still wet, paint around it with India ink, so that the yellow area shines out in the surrounding black. The paper should be wet enough so that the yellow merges into the black quite freely. The spots of pure yellow which still remain unmixed with the black will appear very brilliant in contrast. Colors surrounded by black seem more luminous and glowing than under any other conditions. If the gradations are skilfully made, the hue suggests a colored fire in the midst of deep gloom.

Try a similar experiment with orange, red, green, blue,

and violet. Cut these down to the proportions which best show the effect, and mount them. (Plate II, following p. 22.)

2. With a brush, wet a space of paper about three by five inches in area. Touch into this here and there, irregularly, spots of bright yellow as large as a brush filled with the color will make when its broad side is pressed upon the paper. With another brush filled with black water-color instead of ink, place spots of black in the spaces between the yellow patches. Let the two tones run together so that while in some places bits of pure yellow will be seen, and in others pure black, the spaces between will be filled by a mingling of the two. The flow of color may be facilitated and guided somewhat by holding the paper at an angle and turning it occasionally. If we make similar mixtures with India ink we will find that the ink gives a quality and texture quite different from what is produced when water-color is used. The effects produced by the ink are usually more brilliant and sparkling than those produced by black paint. The paint gives softer and more atmospheric mixtures.

Compare the yellows in this mixture with a flat tone of pure yellow and also with the yellow mixed thoroughly with black in Experiment I. What is the difference in effect? In which case does the yellow appear to be most brilliant and full of life?

3. In the same manner mingle a bright yellow with a gray of about middle value, made with black paint and water.

4. Carry successive minglings of yellow and gray over the same surface, letting each dry before the next is put on, until you have a tone which begins to approach flatness, but which still shows the slight variety resulting from the fact that the colors were mingled and not completely mixed. Compare this with the flat tone obtained in Experiment I, step 1. Which has the most pleasing texture and surface?

Repeat steps 2 and 3, using orange instead of yellow.

Do the same with red, green, blue, violet.

Try step 4 with red, and then with blue.

Place side by side the results of step 3 in all six colors.

Do the grays, even in spots where no color has run into them, look alike in each case?

Mount the results of your experiments, placing those of each hue together upon a single sheet, so that the various modifications of each hue may be seen together.

PROBLEM

Problem A.—To show the wide range of effects which may be produced by the use of only one color in its various intensities and values, together with areas of black, white, and gray.

General Directions Regarding Problems.—Problem A is the first of a series, planned to show how the color combinations with which we become acquainted in the experiments may be used practically in designs.

Various designs called for in household art, in decorative printing, colored illustrations, pottery, etc., will furnish excellent problems. When the same design can be used for a large part of the problems in this series, opportunity is given to compare the effects of different color combinations when applied to the same pattern. When the pattern has been chosen, make a number of tracings for use with various color combinations. Designs may be repeated by tracing, by transfer with carbon-paper, or by blacking the back of the original drawing with soft pencil, or by making a stencil. By placing the drawing against glass which has a light behind it, as, for example, against the window-pane, tracings may be made even on the thick drawing-paper on which the color is to be used. The experiments may be worked out on some good copied or traced design.

A design should be chosen which presents the best opportunity for free and varied experimentation with colors. Some of the characteristics of a design appropriate for this problem are:

1. The design should not be so large in area nor so intricate in pattern as to make the covering of the areas with tones of pleasing texture a time-consuming task. A pat-

tern about four inches square, or about three inches wide and five inches long is a good workable size, although, if the pattern is not too complex, smaller and larger sizes can be

FIG. 9. Designs showing the type of well-defined pattern suitable for coloring.

used without difficulty. Fig. 9 shows types of appropriate patterns.

2. The pattern should be perfectly definite and the areas clearly outlined, as are the patterns of a stained-glass window. If you outline the pattern strongly with waterproof India ink, you can lay in the colors freely and later

wash them and modify them without harming the outline. If black paint is used for outlining the pattern it will wash off or will mingle with the colors and destroy the clearness of pattern. On the other hand, black paint generally works better than India ink for producing areas of gray in the pattern and for mixing with the colors to vary their intensity.

In Problem A only one color is used, but it may be used with any combination of neutral tones; that is, with black, white, or grays of any value. It may be used not only in full intensity to contrast with the neutrals, but also it may be grayed to any number of degrees of intensity. The only limitation is that but one hue shall appear in the various combinations of values and intensities. Some fine effects in decorative and pictorial art are produced within these limitations. Start a collection of these effects and you will find good examples in both nature and decorative design. The various tones in the color schemes of the wings of several common moths and butterflies may be reproduced quite closely by using one color with neutrals. Illustrations in magazines and decorative effects in printing are frequently produced by these means.

In working out this problem we will find it worth while to keep in mind some things which tend to give decorative character to a design, among them the following:

1. The decorative effect of a pattern strongly outlined in black as compared with one the outline of which is thin and wiry.

2. The effect of strength and richness when in addition to the colored areas one or more of the areas of the pattern are pure black and others white.

3. The enriched color effect when the color in its full strength is limited to a small area, and the other varying intensities and values are arranged so that there is a crescendo of intensity toward this area.

4. The increased variety of color effects when at least one area of the pattern is a perfectly neutral gray. This gray takes on an appearance of color quite in contrast to the hue used in the rest of the design.

5. The added interest of texture when the colors are washed and repainted one or more times. By this process they become integrated with the texture of the paper and gain thereby a vibration and quality of depth.

III

COMPLEMENTARY COLORS

Each Color Is Closely Related to Another Called Its Complement.—If we gaze steadily at a color until our eyes are slightly fatigued, which takes about twenty or thirty seconds, and then look away at a white or grayish background, we shall see for a short time another and quite different hue. This appearance is called an after-image, and its hue is known as the complement of the original color. The after-image requires two or three seconds to attain its full intensity, so that for the best effects we should continue looking at the background until the image begins to fade. If we place the red disk of our color-top upon a white or gray surface and focus our eyes upon it for twenty or thirty seconds we shall find that a greenish color appears to "spill over" the edges of the disk. If now we look at a point a little to one side of the disk, we shall see somewhat faintly against the neutral background a form of the same shape and size as the disk, but emerald-green in color instead of red. This after-image grows stronger during the first three or four seconds and then gradually fades away. The after-image or complement of each color has its own particular hue, so that by looking at the after-images of all of our disks we can find the color that is the complement of each.

If the color which we look at is in dull light the after-image will be faint and will disappear quickly. If the color is in strong light the hue of the after-image will be more evident and will last longer. When the color is itself luminous as in the case of a colored light, then the after-

image will be still more intense. If at night we fix our
eyes steadily upon a colored light, or a light which has a
translucent shade of a brilliant color, and then look at a
darker, neutral background, a shaded portion of the ceil-
ing for instance, we shall see an after-image the color of
which is quite strong. The most startlingly brilliant color
of after-images occurs when a colored light behind a color-
less, translucent surface is followed immediately by a white
light, as when a red or green or violet light behind a ground
or opal glass is turned off and in its place a white light is
turned on at once.

The after-image is of the same shape as the original form
which produced it, but its color is that which comes oppo-
site in the color circle. It is like an elusive and trans-
parent phantom of the real form, similar to it in shape but
as far as possible from it in color. If we look for a short
time at scarlet geranium blossoms and then look steadily in
another direction where there are no blossoms, we will see
spots, shaped and arranged like the scarlet flowers, but
bright green in hue. After a few seconds these green spots
fade and entirely disappear.

We have already learned that a color appears less intense
after we have looked at it for a brief space of time. The
effect is almost as if the hue of the after-image of the color
had been mixed with it and had thus made it grayer. We
can see this effect if we place a small strip of colored paper in
a horizontal position upon a white or gray background, as
indicated by the dotted lines in Fig. 10, and after looking
at the centre of it for about a quarter of a minute, revolve
it so that it is at right angles to the first position, as shown
by the full lines in Fig. 10. Now, if we look at the centre
of it we shall see a band of the complementary color cross-
ing it and coinciding with the first position of the strip as

shown by the dotted lines. The space where the after-image crosses the paper, and forms a square about the centre, will appear much grayer or duller than the rest of the strip, because it is focussed upon a portion of the retina

Fig. 10. Two successive positions of a strip of colored paper, to show after-image.

which is already fatigued by looking at the original color. The rest of the strip is focussed upon portions not previously fatigued by that color and consequently appears stronger in color for a time than the centre. We can see the same phenomenon if we look at the centre of the strip, as we hold it about eighteen inches from the eye, and then, after the eye is somewhat fatigued, move the strip six inches nearer.

It is now focussed upon a larger area of the retina and consequently the outer edges occupy a part of the retina still fully sensitive to that hue. Therefore, we see upon the strip a smaller shape of dull color surrounded by a more brilliant border.

What Is the Cause of the Colors of These After-Images? —It will help us to understand the reason if we recall that a white surface in white light reflects rays of all colors in such proportions that no one color sensation predominates. If now we can dull our eyes to the rays of a particular color, and then look at a white surface, of course we shall see more strongly the remaining colors which go to make up white. The balance of hues is destroyed for a brief time. The portion of the retina on which the image of the red disk was focussed has become less sensitive to red and also in lesser degree to the orange and violet which adjoin red in the spectrum. Consequently, when we look at a white surface, that area of the retina which has become dulled to the red rays sees more clearly the other rays of white light, namely green, blue, and yellow, during the few seconds required for it to regain its sensitiveness to red. After that, it sees again equally well all the colors that constitute white, and therefore the after-image disappears.

When we gaze at a spot of the green which we found to be the hue of the after-image of red and then look away, the eye, now become somewhat insensitive to green and its adjoining colors, sees an after-image or complement of a pale red. In a similar way we can determine the complement of each hue of the spectrum. Complement means that which completes a deficiency. The complement of a given color is the residue which remains after the rays of that color have been subtracted from the total of the rays of white light. Roughly speaking, it is the color we would

produce if we mixed the hues of the remainder of the spectrum after the given color had been taken out. It is what would be necessary to add to the given color in order to produce white light.

The Result of Mixing Paints Differs from That of Combining Colored Lights.—If white light is composed of all colors of the spectrum, why is it that when we mix these same colors in the form of pigments, the result is never white, but a dark gray? The reason is that when we combine colored lights each adds its brightness to the result, and we have the sum of the energies of each light, a combination that is brighter than any one of them taken alone, but when we mix pigments and paint a surface with them, each pigment absorbs part of the white light and we see the result by only that portion of white light which escaped being absorbed.

Two lights of different hue concentrated upon the same area produce a genuine addition of rays, and a corresponding increase of brightness. On the other hand when two pigments of different colors are mixed, there is a double subtraction of rays from the white light which falls upon them, and the result in most cases is either duller or darker or both, than either of the two colors. When rays of light corresponding to all colors of the spectrum are concentrated upon a single area, the sum of the brightness is more than the brightness of any one of them taken alone, and the result is a white that is lighter than any of the colors which compose it. When, however, we paint all the colors of the spectrum mixed together upon the same surface each pigment absorbs something of the white light and only a dark gray escapes to be reflected to our eyes. If the colors of the pigment are in proper proportion we can produce a perfectly neutral gray and we may regard this as a weakened

white, from which so much has been taken away by the combined absorption of the various pigments that little of its original brightness is left.

We can see something of the darkening effect of the combined subtraction of mixed pigments by making a disk for the color-top as follows: take any two colors and paint half the outer border of a disk of white paper with one, and the other half with the other. Paint the portion inside the border with both the colors mixed in equal proportions (Fig. 11). The rays of light which fall upon its border are subjected to absorption from one or the other of the two colors, but not from both. As the disk revolves, the rays which escape absorption by the color on one half of the border alternate with those which escape absorption by the other. Each ray of the white light which falls upon the area within the border, however, undergoes absorption by both colors. Consequently, the centre will generally appear darker and duller than either color in the border. Although when the top is spinning, the two colors on the border appear to be mixed, yet the rays from each color are not mingled, but alternated. To our eyes they appear to be mixed because the sensation from one has not time to die away before the other ray arrives, and the sensations produced by the two overlap and we are conscious of only one color. But these sensations produced by rays that have undergone the subtraction of but one pigment have greater brightness than those of the centre, which are what remain of the original white after two pigments, each of which has the power to absorb particular ingredients of the light, have made their respective subtractions.

Colors Mutually Complementary as Lights May Not Be Mutually Complementary as Pigments.—We have seen that the result, when we mix lights of given colors, is different

from that obtained when we mix paints of corresponding hues. We find that when we have selected the two colors which as lights concentrated upon the same area will give

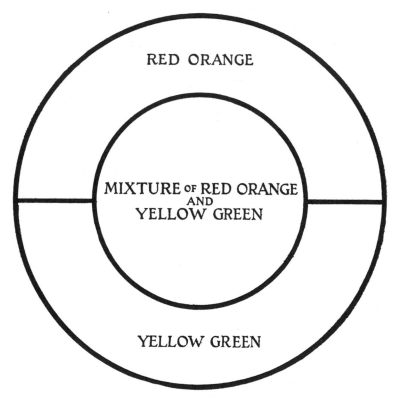

Fig. 11. Diagram of disk to show the greater intensity of two separate colors, those in the margin, mingled by rotation, as compared with the low intensity of a pigment mixture of the same hues in the same proportions, as shown in the centre.

white, it does not follow that two pigments of the same hue when mixed will produce gray, which is the nearest approach to white that is possible from the mixture of colored pig-

ments. In fact, we find that the color which with another
produces gray when mixed with paints, is seldom if ever
exactly the same hue that produces gray with it when the
mixture is made with disks on the color-top or with colored
lights.

We can experiment with some of these differences by
means of the top, because the apparent mixtures produced
by rotation of two or more disks resemble somewhat the
effects of mingled lights. When we spin the top we do not
get the sum of the brightness of each disk as we would
with lights, but we avoid the successive subtractions which
occur with the mixed pigments. We can use the same pig-
ments for painting different areas of the disks which are to
be mingled by rotation, that we employ in the mixtures,
and in this way make a close comparison of results.

We can arrange on our tops the green, blue, and red
disks in such proportions that the result when the disks are
revolved is a dark gray. If now, without changing the pro-
portions of the blue and green, we substitute a white disk
for the red, and revolve the disks the result is a light value
of the color which will give gray when its rays are added
to those of red. But this is not quite the same hue that
with red will produce gray when the mixture is made with
paints instead of with disks or with lights; it is slightly
bluer. This may be proved by matching this hue with
paints and then mixing it with a red pigment like the red
of the disk. The result will be slightly purplish, no matter
how carefully we try to adjust its proportions to those of the
red. If we add a small amount of yellow-green so that the
result is a little less blue, then by the mixture of the paints
we can produce a neutral gray. When we mix violet and yel-
low pigments we can approximate a neutral gray. When,
however, we spin the top with violet and yellow disks no

adjustment of their proportions will give us an exact neutral. The gray will be slightly pinkish. If now we introduce a little green we can produce a perfectly neutral gray.

Blue and Yellow in Light and in Pigments.—The greatest contrast between complementary colors in lights as compared with complementaries in pigments is seen in the case of the complement of blue. Blue and yellow as lights produce white. Blue and yellow disks produce gray when rotated. In pigments, however, blue and yellow produce green. With the color-top it is impossible with the yellow and blue disks to obtain even a suggestion of green. There will be a bluish or yellowish gray according as a larger proportion of the blue or the yellow disk is exposed. When the proportions are balanced a neutral gray results, corresponding in its neutrality to the white which occurs when lights are used for the mixtures. In order to produce gray with paints the color which must be mixed with blue is orange, but with the color-top the blue and orange disks give a violent purple.

The reason for this difference is as follows: When light rays, each of a different wave-length and rapidity, or, as we say for convenience, rays each of a different color, fall upon the same spot in the retina of the eye, the eye is unable to see them separately. Consequently, the sensation which we receive is a compromise between the different sensations which we would receive if we saw the various colors separately. For example, if yellow rays and green rays fall upon the eye together we see not yellow and green, but a hue which lies between them, namely yellowish green. The sensations produced by various rays differ so greatly that in some cases when they fall upon the retina together our eyes are unable to make any compromise and consequently we see no color, but see white or gray even if the rays pro-

ducing it are all very intense in hue. This is what occurs when blue and yellow rays are focussed upon the retina at the same time. Their color qualities counteract and offset each other and we see simply their brightnesses.

When, however, a beam of white light passes successively through a sheet of blue and a sheet of yellow glass, what

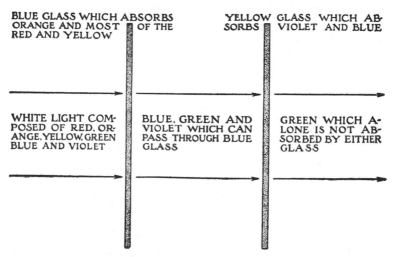

BLUE GLASS WHICH ABSORBS ORANGE AND MOST OF THE RED AND YELLOW

YELLOW GLASS WHICH AB- SORBS VIOLET AND BLUE

WHITE LIGHT COM- POSED OF RED, OR- ANGE, YELLOW, GREEN BLUE AND VIOLET

BLUE, GREEN AND VIOLET WHICH CAN PASS THROUGH BLUE GLASS

GREEN WHICH A- LONE IS NOT AB- SORBED BY EITHER GLASS

FIG. 12. Diagram of white light undergoing successive subtractions by absorption as it passes through blue glass and then through yellow glass.

finally emerges is green. Each sheet of glass, because of its power of absorption, subtracts a particular part of the beam of light and allows the rest to pass through. From the original white of the light, which was made up of red, orange, yellow, green, blue, and violet, the blue glass absorbs practically all of the orange and nearly all of the yellow and the red. The yellow glass, in turn, absorbs practically all of the violet, the remainder of the red, and nearly all of the blue. The only color which neither ab-

sorbs is green, which consequently passes through both pieces of glass (Fig. 12). What happens to the white light when it passes through the two sheets of glass is comparable to what happens when it falls upon a mixture of blue and yellow pigments. The mixture still consists of fine particles of blue and yellow. They have not changed color. Now, these particles have considerable transparency. Consequently, while part of the light is reflected directly back to our eyes, the larger proportion of it is not reflected back until its rays have passed successively through particles of blue and of yellow, and have thus undergone exactly the same sort of subtraction which occurred in the colored glasses.

If the particles of pigment were more opaque, so that rays of light could not pass successively through minute portions of blue and of yellow, then our eyes would receive yellow and blue rays separately from the mixture and it would probably appear gray, as do the revolving blue and yellow disks. We can approximate this effect if we take a package of white cards, such as are used for card catalogues, and holding them tightly together so that the color will not soak in very far, paint one end of the package yellow and the other end blue. When the cards are dry we can turn every other card end for end, so that a blue edge will alternate with a yellow. The result when seen at a distance of a few feet will be almost gray, although some green will appear because some white rays will pass successively through particles of blue and of yellow where the edges of the cards touch. A similar effect appears when we rule parallel lines alternately blue and yellow very close together.

Because of the differences in the results of minglings of lights and of minglings of pigments, some of nature's effects

due to lights cannot be imitated by the corresponding pigments. Often at sunset the sky is yellow near the horizon and blue higher up, while a luminous and delicate gray lies between where the two mingle. A painter who would represent the effect cannot produce this gray in pigments by the same means which nature has used, namely blue and yellow. He must use other colors, consequently his gray will be somewhat different in character and its elements not so intimately related to the blue and the yellow as is the case in nature.

One Who Uses Colors Should Know the Exact Hues of the More Important Pairs of Pigment Complements.—We shall consider the pigment complements, that is, the pairs of colors that mixed together give gray, rather than the colors which are complementary as lights, because the painter and designer work so largely with pigments. Therefore it is necessary for us, whether we are actually to work with colors as they do, or hope to develop the fullest appreciation of their productions, to become familiar with typical pairs of complementaries, and to recognize when the interval is exact, with much the same accuracy that we can recognize a given interval in music. When we have worked out by experimentation a few typical complements, and then have seen the way in which complementary colors behave when they are contrasted and when they are mingled in various proportions, we shall have an understanding of some of the effects in nature and in art that we cannot gain without this experience.

Roughly speaking, the complements of red, yellow, and blue are green, violet, and orange respectively. Place upon a white ground three disks of the color-top, red, yellow, and blue, arranged as in Fig. 23, page 187, so that they form a triangle and their edges touch but do not overlap. Look

steadily for a few seconds at the centre of this triangle and then shift the eyes to another portion of the white ground. The after-image will be a triangle of colors the hues of which are the opposites or complements of those of the original disks. In the place corresponding to that of the yellow disk an after-image of violet appears, and in place of the red and blue we see green and orange.

Try the same experiment with the orange, green, and violet disks. Against the white background we shall see a pale blue, red, and yellow, as after-images. If the pigment complement of a given color, that is, the hue which with it produced gray, was the same as the hue which in rotation with it on the top produced gray, we could determine the exact complements easily. For example, find on the color-top the proportions of blue and green which with red result in a neutral gray. When the neutral gray is produced, in order to determine exactly the hue which neutralizes red, remove the red from the top and readjust the remaining two colors so that their relative proportions, now that they occupy the whole circle, shall be the same as when they occupied only the part not covered by the red. The measuring disk provided with the Science Service top has twenty divisions. To find the space which one of the two colors, the green, for example, should occupy on the whole circle after the red is removed, multiply the number of points it occupied when the red was with it on the disk, by twenty, and divide the product by the number of points which the green and the blue together occupied. But this color, although it results in gray when mingled with red by rotation, does not give gray when it and red are mixed as pigments.

In determining the pigment complement of a given color its after-image will give us a clew to the hue, because the after-image of a color resembles its pigment complement

more nearly than it does the light complement. To be sure the after-image is always pale and soon vanishes, but we can renew it as often as we wish, and it is not difficult to match this pale hue with paints and then carry it to full intensity. We can then test it by mixing it with the original color, to see if the result is a neutral gray. In applying this test by mixture, for example with red and a green, which we have obtained by trying to match the after-image of red, if the first result of the mixture is pinkish or slightly green, that is, a hue like one of the two colors only grayer, the fault is merely with the relative proportions of the two in the mixture, and gray will result when the proportion of red to green is adjusted. If, however, the mixture is either brownish or purplish, then we know that the color is not the complement of red, but is too yellow-green or too blue. In the case of any two colors if the mixture is a subdued tone of either, the complement may be all right, and we need to experiment only with the proportions of the mixture in order to secure gray, for the addition of a true complement to a color merely grays it without changing its hue. But if the resulting hue is different from that of either color, then we have not the true complement, and no matter what proportions we use we can never produce a neutral gray. The troublesome hue, however, will furnish us with an indication as to where the error lies. It will be, in low intensity, the hue on that side of the color circle toward which the supposed complement is too much inclined. In the case of the complement of red, a brownish color indicates that the green hue leans too far toward the orange side of the circle, while the purple indicates that it has gone too far the other way. The mixtures of water-colors do not always produce satisfactorily neutral grays, because the colors tend to separate as they dry, but we can

secure fair approximations. The violet and yellow pair is the most difficult to balance on neutrality.

Of course every hue in the spectrum has its complement, and, therefore, there are an infinite number of complementary pairs. If we become familiar at first with the three pairs already mentioned, namely, red with green, violet with yellow, and blue with orange, and later with the hues which are complementary respectively to orange-yellow, to orange-red, and to violet-red, and which we can work out for ourselves, these six pairs will furnish us with the typical complementary combinations. In each case we should come to know the correct interval, not simply because we remember it, but because from many experiences we recognize the peculiar and characteristic impressions and responses which that relationship produces.

Because changes in color, as we have learned, depend upon variations of length of waves of light, theories have been advanced that a close relationship exists between color and music, since the latter is based upon sounds produced by waves or vibrations of air. Whatever analogies there may be between the emotional experiences of each, none that is very close appears to exist between their physical causes. No such fixed relation exists between the lengths of waves which produce sensations of complementary colors as have been found to exist between given intervals of musical sounds. The relation is not a fixed one for all the various pairs of complementary colors, and changes in color in different parts of the spectrum are not directly proportional to changes in wave-length.

Some Effects Which May Be Produced by Complementary Hues.—With two complementary colors together with neutral black, white, and gray, we can produce a surprisingly wide range of artistic effects, expressive of many

moods. Each pair of opposite hues has its peculiar qualities and possibilities. In order to appreciate the characteristic effects of each in nature and in art, it is important to experiment in various ways with a few complementary pairs until we are quite familiar with the two colors which compose each of them, and with the results of various contrasts and minglings of the colors with each other and with black, white, and gray. Playing with many mixtures by means of paints, collecting examples in nature, and in the arts, and noting pleasing combinations wherever we see them, will enlarge our acquaintance with the possibilities of beauty in complementary colors. After we are thoroughly familiar with the strictly complementary effects we shall have a basis for the variations that the artist employs when he breaks up one or both of the complements into its adjacents, or when he departs slightly from the complementary interval for the sake of the delicate color of the intermediate hues. In fact, the complementary pairs appear to be the basis for most of the more intricate color combinations. Consequently thorough familiarity with them will enable us later to elaborate them into more complicated groups without the danger that our color schemes will become disorganized and meaningless. Some of the typical effects possible with complementary colors are the following:

Contrasts in Which Each Hue Intensifies the Other.— We find examples of these contrasts in nature in the yellow and orange centres which so frequently occur in violet or blue-violet flowers, the red rose against its bluish-green leaves, and the golden sky of a clear twilight behind blue mountains. Even when the colors are very low in intensity each brings out whatever chromatic possibility there is in the other. On a gray day when the ocean or lake is a subdued green-blue, and the lowering sky against the

horizon has the slightly reddish hue which is sometimes seen when daylight has passed through masses of vapor, the color quality of each area is emphasized by the contrast.

When complementary colors are in motion so that they weave in and out or cross each other's paths upon the field of vision, then the contrasts between them are intensified far beyond what occurs when the colors are stationary. We can see this if we spin a top upon which two complementary disks have been placed so that each occupies half the space. When the top begins to slow up so that we can perceive the two hues separately, they seem like flashes of colored light whose brilliancy increases to an almost flame-like quality up to the time when the motion of the top ceases. A similarly splendid contrast can be produced by floating banners and by the costumes of dancers.

Minglings in Which Each Hue Softens the Other.— When complementary colors are mixed together each neutralizes or grays the other. This is the opposite of the effect just described where, placed side by side, each makes the other appear more brilliant. If the mixture is complete the gray will be neutral like that of mixed black and white, but in nature and in the artistic use of pigments and dyes the mixture is seldom complete. The result is a vibrating effect full of delicate, shifting, elusive hues. The difference in interest between a flat gray and a gray in which complementary hues are just discernible is evident when we compare a piece of a hornet's nest, where blue-gray alternates with orange-gray, with a piece of gray paper of flat tone.

We can produce combinations in which one or the other of the colors comes here and there to a fairly strong intensity and then is merged in and grayed by its complementary so that the whole surface becomes a series of more or less faint echoes of the stronger contrast. The tendency of

complements to gray each other is well illustrated in the effect produced in textiles by weaving a cloth of threads of complementary colors. A particularly delicate effect comes when sheer material of one color is placed over a ground of its complement. Some rays are reflected from the thin material and are therefore of its color, others pass through the interstices of its weave and fall upon the material underneath. When those not absorbed by the under material are reflected back, some pass again through the openings of the weave of the sheer material and are unaffected by it and are therefore the color of the under material. The rest are affected by the thin material and emerge having undergone absorption by both textiles. These are more or less gray. If the sheer fabric is yellow and the background is violet, some rays will be reflected from the yellow, which do not pass through the violet. Others will pass through and back unaffected by the yellow, because coming and going they escape through the net of its weave. Others have undergone absorption by both violet and yellow. Thus we have a combination of light mixtures corresponding to those produced by the disks of our top, together with double absorption as in the case of pigments. If the thin material is yellow, placed over blue, we have a particularly elusive result, because the cumulative effect of yellow and of blue rays is, as we found by experimenting with the rotating disks, gray, while the hue of those rays affected by both the yellow and blue is greenish.

Induced Colors Contribute to the Quality of Mixtures of Complementary Colors.—We have seen that wherever areas of neutrals occur near areas of color, the hue of the after-image of the color overlays and tinges the neutral. In combinations of complementary colors the after-images are themselves complementary. Consequently, they intensify

some areas and soften others. They lend color to gray areas, and they give a peculiarly opalescent and shimmering quality to spaces already grayed by the mingling of the two colors which compose the design. In these spaces the actual colors may be delicately balanced so as to appear and then disappear, so that in mingled red and green we detect a flush of rose in the gray, and then the coolness of green. Then to this is added the shifting veil of the after-images.

If we place a sample of pale pink upon a field of strong red, in a few seconds the green after-image of the red, superimposed upon the pink will make the latter appear gray. If now we place the sample of pink upon a green background the red after-image of the ground will double the apparent redness of the sample. Sometimes the effect of after-images is curiously intensified when a translucent material is placed over the colors. Rood describes this as follows:

"A small strip of gray paper is placed on a sheet of green paper. . . . It will be found that the tint of the gray paper scarcely changes, unless the experimenter sits and stares at the combination for some time. A sheet of thin, semi-transparent white paper is now to be placed over the whole, when it will instantly be perceived that the color of the small strip has been converted by contrast into a pale red. . . . Here we have an experiment showing that the contrast produced by strong, saturated tints is much feebler than with tints which are pale or mixed with much white light; for, by placing tissue-paper over the green sheet, the color of the latter is extraordinarily weakened and mixed with a large quantity of white light. In this experiment it often happens that the red which is due to contrast alone, seems actually stronger than the green ground itself. If, instead of using a slip of gray paper, we employ one of black, the contrast is less marked, and still less with one of white. . . . The strongest contrast will be produced in the case of red. orange, and yellow, when the gray slip is a little

darker than the color on which it is placed, the reverse being true of green, blue, violet, and purple; in every case the contrast is weaker if the gray slip is much lighter or much darker than the ground. . . . If now we reverse our method of proceeding, and place a small colored slip on a gray ground, and cover the whole with tissue-paper, it will be difficult, even with a green slip, to observe any effect of contrast. . . . This is another illustration of the fact that, for the production of strong effects of contrast, it is necessary that the active color should have a surface considerably larger than the one to be acted on; the former ought also to surround the latter." *

Colored Shadows.—Examples of contrasts intensified by induced colors occur when two lights complementary in color play from different angles upon the same scene. The most familiar instance is where the cool bluish light of early twilight vies with the yellowish light of a lamp. If both lights fall together upon a white table-cover, the portion of the cover nearer the window where daylight still predominates will be bluish, while that nearer the lamp will be yellowish. Where each light is of equal intensity they neutralize each other. If we place an object so that two shadows are cast, one by daylight and the other by the lamp, the yellowish rays will be cut off from the shadow cast by the lamp, but the bluish daylight rays will fall upon it. The opposite will be true of the shadow cast by the daylight. Consequently, one shadow will appear blue and the other yellowish, and the hue of each will be intensified by the after-images of the contrasting light.

When the lights are strongly colored the contrasting shadows are sometimes startlingly intense. Von Bezold describes the following experiment: Place a pane of blue glass so that daylight passes through it and falls upon a roll of

* Ogden N. Rood, *Modern Chromatics*, p. 260.

paper placed upon a white ground, as indicated in Fig. 13. The shadow of the roll of paper will be of an intense yellow. Modern systems of stage lighting offer opportunity for these plays of complementary lights, and the resulting colored

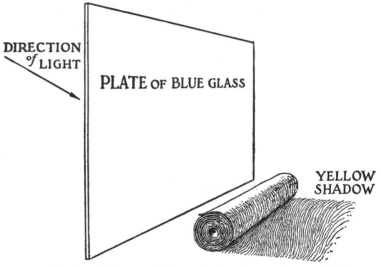

DIRECTION *of* LIGHT

PLATE OF BLUE GLASS

YELLOW SHADOW

FIG. 13. A colored light producing a shadow that tends toward the complementary hues.

shadows and intermediate shifting, indeterminate, but beautiful grays.

Each Pair of Complements Has Its Own Characteristic Range of Effects.—If we take three copies of the same design and use a different pair of complements in coloring each, we shall see how individual is the result in each case. When the colors of the designs are planned so as to bring out not only some amount of contrast but also the various intermediate tones of grayness produced by mingling the colors, each design suggests some particular mood of nature or quality of atmosphere.

Of all the complementary combinations in nature and in art, those of blue and orange, or yellow-orange, appear to be the most common. Blue and orange mingled in different degrees of intensity and used with black, white, or gray, give such a wide range of effects that often we do not notice the lack of other hues in decorative or pictorial designs worked out in these colors. The pigment called burnt sienna is a dark orange, almost exactly complementary to the blue in the paint-box. After experimenting with several minglings of these pigments, look at colored illustrations in books, for example, those of Arthur Rackham, of Edmund Dulac, of Maxfield Parrish, and of Jules Guerin, and notice how many of the effects are based upon blue and orange. See how nearly the brownish gray of withered leaves can be matched by these two colors. Many of nature's color effects have underlying them a variation, a movement from the warm of orange or orange-yellow to the cool of blue. Where there is little other color to interfere, as in snow shadows or on the white ceiling of a room, this movement from bluish to orange or orange-yellow can usually be seen. It pervades nearly all of nature's appearances, and over-lays more or less evidently a large proportion of the color schemes in art. The greatest contrast in the qualities known as warmth and coolness of colors is found in this pair of complements for the reason that blue impresses most people as the coldest of hues and orange as the warmest.

Because the difference between the light complement and the pigment complement of blue is greater than in the case of the complements of any other color, and ranges from yellow to orange, we can allow ourselves a greater freedom in the hue chosen, and may vary it from a yellowish orange to orange and still keep in our decoration or picture

the general atmosphere of a complementary combination. Then, too, there appears to be something elemental in the contrasts of these hues, because they are the first colors to appear when white light breaks up into colors. When the concentric black and white circles (Fig. 14) are held close to one eye and then gradually moved away, at a certain distance most people will find that the black lines assume a bluish hue, and the white lines become slightly yellowish. This effect is often more marked when the diagram is viewed obliquely. If in a dark room we turn a flash-light on a white wall, the sensation we receive from the wall is yellowish, then after a second or two it is bluish; then these sensations merge into white. We have found also that few people are at all color-blind to these hues. Blue and orange or yellow-orange, skilfully used, are satisfying color combinations, and can portray a remarkably wide range of appearances.

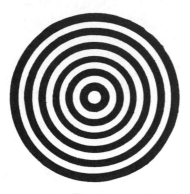

FIG. 14.

The range of effects which we can produce with red and green is more limited. These two colors give us a contrast of warm and cool tones but not those which appear so commonly in nature as blue and orange. If we use a considerable proportion of neutral in the areas of the painting or design we still find a surprising number of pictorial and decorative possibilities with red and green.

The results from yellow and violet are among the most delicate and elusive which it is possible to secure. Both of these hues lie half-way between the warm and the cold

group of colors, and consequently, since they lack that kind of contrast, they seem more closely related than the other pairs. Nevertheless, because yellow is a color suggestive of light and violet of shadow, a design with these colors will often present a delightful quality of subdued light and luminous shade.

When we become familiar with these pairs and their particular characteristics and possibilities, we shall find a group presenting somewhat different qualities, in the complements of the colors that lie between these in the color circle; namely, yellow-orange with blue-violet, red-orange with blue-green, and yellow-green with violet red. An artist in making a complementary combination seldom limits himself strictly to the two hues, but varies them slightly and produces a complementary balance. For example, he may offset a red in which hints of orange and violet appear, with a combination of greens, varying from yellow-green to blue-green. By this means he avoids the monotony of the exact notes, but preserves the general balance of opposites. A thorough familiarity with the exact complementary hues and their behavior in contrasts and minglings prepares us to understand and use the more complicated applications.

QUESTIONS

1. What is the reason of color after-images? Why, when seen against white or gray, is the after-image the complement of the color which produces it? If we look steadily at a color-disk, the lower half of which is covered by a disk of its complementary, and then remove the complementary disk, what will be the difference in the appearance of the upper and lower halves of the original disk, and why?

2. How would you proceed (a) to find the pigment complement of a given color, (b) to test the correctness of its hue?

3. How much of a suggestion of green can you produce by rotating on the top blue and yellow disks in any proportion? Why are mixtures of colored lights (or rotating disks) different from mixtures of pigments of corresponding hues?

4. Given a blue, if its mixture with a supposed complement has (a) a violet hue, what change should be made in the supposed complement to make it exactly complementary, and why? (b) What change if the mixture has a greenish hue? (c) What change if the mixture has a bluish color of the same hue as the given blue?

5. What is meant by induced colors? Given a red, if its mixture with a supposed complement has (a) a violet hue, what change should be made to correct the supposed complement to make it exactly complementary, and why? (b) What change, if the mixture has a brownish hue? (c) What change if the mixture has a reddish color of the same hue as the given red?

6. With what pair of complementary colors may the widest range of nature's effects be represented? Can you give any reason why this is so?

7. What two very different effects may complementary colors produce upon each other? Under what circumstances, and why?

EXPERIMENT

Experiment III.—To find the complementary hues of given colors, and to discover some of the different effects produced when complementary colors are mixed.

1. Place upon a sheet of white paper a spot of red; either the red disk of the color-top, or a spot of red paint about one inch in diameter. Look steadily at the centre of this for about twenty seconds. Then look at some one point on the white paper for a few seconds. What is the color of the after-image which you see when you turn from the red spot to the white paper? This color is the complement of the red. Is it a blue-green or a yellow-green? See if you can paint a spot of the strong color, of which this hue that you see on the white paper is the faint image.

Mix this color with the original red in such proportions that neither predominates. If the result is purplish, the color you have chosen for the complement of red is too blue. If it is brownish, the color is too yellow. If the result is a neutral gray, you have found approximately the complement of the red. Mount a sample of red and its complement, and between them a sample of the gray produced by mixing them in right proportions to balance and thus neutralize each other. Make the gray fairly dark.

2. Make a series of tones in the following manner, to show the effects of mixtures of complementary colors in varying proportions: Paint a sample of pure red; then another with red in which is mixed a little of the color which when tested proved to be the complement of red. Make other tones by gradually decreasing the proportion of red to its complement, until you have a series beginning with red and ending with the color which is complementary to red. Cut these out and select seven, of which the first is pure red, the last the pure complement of red, the fourth or middle a neutral produced by mixing proportions which exactly balance each other, and the others completing a series of evenly graded steps between the red and its complement. Mount these so as to show the series of tones between the color and its complement.

3. With a brush wet a space of paper about three by six inches in area. Near the centre of this place a spot of pure red about as large as the brush filled with color will make with one pressure. Surround this before it dries with a field of the exactly complementary green so that the green will mingle with the red spot at its edges. Aid the mingling by tipping the paper, but preserve somewhere a bit of the red that is not mingled with the green. The brilliancy of the spot of red will be heightened and made jewel-like by the contrast of the green. On another space of wet paper place a spot of green in a field of red, thus reversing the relative proportions of each which appeared in the previous step.

4. (a) On an area of wet paper place spots of red and of green so that they mingle freely until there are no pure

spots of either, although suggestions of one or the other appear in the grayish effect of the mingled colors.

(*b*) On another equal area of wet paper, place spots of red and of green and of black so that they mingle sufficiently to soften the edges of the spots but still present strong contrasts of the colors and black.

(*c*) On another equal area of wet paper place spots of red and of green, and of a middle gray made by diluting black paint, so that they mingle sufficiently to soften the edges of the spots, but still present areas of pure gray and of the two colors. Select and mount good examples of the results of mixing the complements in the different ways described in 3 and in 4, *a*, *b*, and *c*. Compare the variety of effects in these minglings with the effects in the evenly graded series of tones produced by the first and second steps of this experiment.

5. Repeat with blue and also with violet the experiments just described with red and its complement. First find the complement of each by matching the after-image and then testing this color to see if it produces an approximately neutral tone when mixed in about equal proportions with the original color. When the complementary hue is obtained, try with each pair the different effects of mingling suggested for red and its complement. (Plate III, following p. 22.) Select and mount on a sheet examples of blue and its complement and their various minglings, similar to those which you made for red. On another sheet mount samples of violet and its complement and their minglings. Because of the tendency of water-colors to separate somewhat in drying, it is not always possible to produce as pure a neutral as can be made with oil-paints, but something very near to a neutral can be made without much difficulty.

6. A supplementary experiment to show that the pairs of colors which produce neutral gray when mixed in pigments are not quite the same as those which produce neutral gray when mixed by rotation of colored disks.

Place on the color-top the red, green, and blue disks and vary the proportions of the three colors until when the top is spun they produce a neutral gray. When a neutral gray

results, in order to determine exactly the hue which neutralizes red, remove the red from the top and replace it with gray. This, of course, gives a blue-green, with its intensity much reduced. Match this color with water-color, and make a sample on paper. See how near you can come to producing a neutral by mixing this color with red in water-colors. Compare this color, and also the nearest approach to neutral, by mixing it with red, with the results obtained in Experiment III, step 1.

Similar supplementary experiments may be carried out with blue and also with violet.

We will find the differences as follows:

With paints, violet and yellow produce a neutral, but with the disks on the spinning top the result of violet and yellow is slightly reddish. Some green must be added in order to produce gray.

With the disks, the green which with red will produce gray, must be bluer than the green required when water-colors are used.

In the case of blue we shall find the greatest differences between the pigment which mixed with blue will give gray, and the disk which with blue will give gray on the spinning top. With the disks, blue and yellow produce gray, while with paints gray is produced by blue and orange. If we spin upon our tops the blue and orange which in paints give gray, the result is a powerful purple.

PROBLEM

Problem B.—To show in a design some of the various effects which may be produced by the use of two complementary colors with neutrals.

Almost any design for a project that calls for the use of color is suitable for this problem. If no project is at hand the same pattern that was used for Problem A may also serve here. Only two colors, and these exactly complementary, should be used, but with them may be included any neutral tones, that is, black, white, or any gray, either in separate areas or mixed with the colors, so that the hues may appear in several intensities.

Two typical and quite different effects are possible with complementary colors: (1) an effect of great contrast when the hues are placed side by side in quite strong intensity, for each then heightens the intensity of the other; (2) an effect of less contrast when the hues are mingled more or less thoroughly and do not appear in full intensity except perhaps in small areas. Where any mixture of the two occurs, each reduces the intensity of the other. Consequently we can secure very brilliant effects by placing the colors in our design so that each heightens the other, or we can produce subdued effects by mingling the colors. These results we can vary still more by black, white, and gray. In the following applications, any pair of complements may be used. Each pair has its own characteristic effects.

1. Fill in one pattern so that strong contrasts of color occur somewhere in the design. These strong contrasts can be supported by areas of subdued color or of gray. Have also at least one area of white and one of black.

2. Fill in the pattern so that the contrasts of color are subdued throughout by mingling with each hue some of its complementary. Let the stronger contrasts appear, if at all, in small areas. White, black, and any values of gray may be used.

IV

COMPOSITE COLORS

Colors in Nature Are Complex.—One characteristic of the colors of natural objects is their infinite variety of texture and of hue. They are seldom flat and monotonous. The tints are mingled and interwoven and are ever changing with infinitely gentle gradations, so that our eyes are constantly surprised with the shifting succession of hues.

Beside a nasturtium or pansy or poppy or fleur-de-lis, or any other brilliant flower, place a piece of paper of the same color. Some hue in your sample book will probably be near enough in tone to serve for comparison. The sample-book colors are about as intense as pigments can be made, but hold them beside flowers of similar hue and see how much richer and more glowing the colors of the flowers are. We might say that the color of one is dead while that of the other is alive. Place your finder on a leaf and put beside it a piece of paper painted with the same color. See how complicated the texture and color of the leaf surface are. In the first place, the surface of the leaf is seldom so flat and smooth as that of ordinary paper. It is broken up by the ribs, and still more finely by the veins, so that it is full of little projections and hollows. Over these the light plays in changes of value, some marked, and some very slight. A microscope will show how delicate the surface texture is. It is difficult to match with paints the surface quality of even very smooth leaves like those of orange-trees, oaks, laurel, and rubber plant, in which the variety and translucency of the surface add a richness to

the color. Sometimes besides this variation of surface there are suggestions of hues which are not seen at first. Hints of red are often found in green leaves. The color of a lilac leaf, held so that the sun glances from the surface, is full of sparkles of red. The under sides of leaves, as in the case of maple and elm and poplar leaves, often show a play of colors different from those of the upper surfaces.

This play of hues shows not only in the positive tones of brilliant flowers, but also in objects that are grayish and subdued. Withered leaves, lichen-covered rocks, and the bark of trees, things that at first glance appear to be brown or gray, often reveal remarkable variations of unexpected colors and surface textures. When we place a finder so as to enclose areas of bark of pine, cherry, poplar, apple, peach, and other trees, we find that the framed-in portions show varied and generally harmonious combinations. This intermingling of tints takes away the harshness which usually accompanies brilliant tones when they are flat and monotonous, and makes them rich and glowing. On the other hand, the interwoven hues of grayish objects give them a tremulous vibrancy, so that their grayness is that of suppressed color rather than of neutrality. The effect reminds us of that described by William Morris: "Whereof one scarce can say whether it be bright or gray, thousand-hued or all simple of color." *

Gradation of Related Hues Is an Important Element of Beauty.—This interweaving of related hues is an important factor in making colored surfaces pleasing to our eyes. For this reason artists are continually experimenting with the complexity and gradation which is almost universal in nature. The weaver of fine textiles, the maker of high-grade pottery, the painter and decorator, all try to intro-

* *The Water of the Wondrous Isles*, p. 464.

duce this element of beauty into their work. If we place a flat color beside a similar hue in a fine rug or piece of pottery or a painting, we will find a notable difference between the quality of our opaque paint and the carefully wrought surfaces of artistic color. The surfaces of polished wood appear translucent and full of shifting light. Try to match with paints the effect of a piece of polished oak or maple or mahogany, and you will find that, although you can produce the hue and value and intensity without much trouble, the translucent and varying character of the wood, which makes its surface so pleasing, is difficult to imitate with pigments. If now you hold your painted paper under running water and wash it lightly with a brush, and then while it is wet let more color run upon it so that it is unevenly distributed and is a mingling of slight variations of value and intensity, it will approach much nearer the quality of the textiles or pottery or polished wood.

Transparent substances which transmit light and color have a great range of brilliancies and intensities, and therefore their differences in character of tone are especially evident. Cheap colored glass and the finest examples of stained glass mark extremes of color qualities. Gems are superior in color to glass imitations largely because of their texture. Gems are crystalline in structure while glass is not. The crystalline gem reflects light the colors of which are interwoven in a way which gives us a higher degree of pleasure, if we are able to perceive the difference, than does the colored glass. One who from a group of precious stones and glass imitations can pick out the genuine gems because he recognizes the subtle quality of their color, is able to possess them æsthetically as well as materially.

When we move a finder about over the surface of a good painting the delicacies of gradation become more apparent

than when we see the picture as a whole. The little framed-in areas become surprisingly beautiful in themselves. In what we thought was a smooth area of color we discover gleams of unexpected, gem-like bits of color that impart a radiance to the whole. In his instructions to art students Ruskin writes:

"Whenever you lay on a mass of color, be sure that however large it may be, or however small, it shall be gradated. No color exists in Nature under ordinary circumstances without gradation. If you do not see this, it is the fault of your inexperience: you will see it in due time if you practise enough. . . . It is not indeed physically impossible to meet with an ungradated piece of color, but it is so supremely improbable, that you had better get into the habit of asking yourself invariably, when you are going to copy a tint, not: 'Is that gradated?' but 'Which way is it gradated?' and at least in ninety-nine out of a hundred instances, you will be able to answer decisively after a careful glance, though the gradation may have been so subtle that you did not see it at first. And it does not matter how small the touch of color may be, though not larger than the smallest pin's head, if one part of it is not darker than the rest, it is a bad touch; for it is not merely because the natural fact is so, that your color should be gradated; the preciousness and pleasantness of the color itself depends more on this than on any other of its qualities, for gradation is to color just what curvature is to lines. . . . What the difference is in mere beauty between a gradated and ungradated color, may be seen easily by laying an even tint of rose-color on paper, and putting a rose leaf beside it." *

By comparison and analysis and experimentation, we gradually discover some of the characteristics of good color, and we become able to distinguish a really beautiful tone from one that is commonplace. Our undeveloped prefer-

* *The Elements of Drawing*, p. 151.

ences for certain hues, as blue or red, merely as crude sensations, become secondary to preferences for subtler qualities of texture and vibration.

Beauty of color is entirely consistent with great brilliancy and power. It is texture and not intensity, nor lack of intensity, that determines quality. A note produced on a cheap violin by a student may have exactly the same pitch, duration and loudness as a note produced upon a superb violin by a master, but the two notes will differ in quality of resonance. Similarly, two colors may be alike in hue and value and intensity, but differ in quality of texture. We can develop an exact notation for degrees of hue, value, and intensity, and can arrive at them by rules and formulas. For the artistic qualities we have no exact definitions and terminology. To express them we use adjectives and phrases that suggest rather than define, as for example those expressions, full of intimations of the refinements and subtleties of beautiful tints, which Lafcadio Hearn uses in reference to types of Chinese porcelains.

Of these he says:

"All the azure porcelains called *You-kouo-thien-tsing;* brilliant as a mirror, thin as paper of rice, sonorous as the melodious stone *Khing*, and colored, in obedience to the mandate of the Emperor Chi-tsong, 'blue as the sky is after rain, when viewed through the rifts of the clouds.' These were, indeed, the first of all porcelains, likewise called *Tchai-yao*, which no man, howsoever wicked, could find courage to break, for they charmed the eye like jewels of price; . . .

"And the *Kouan-yao*, which are the Porcelains of Magistrates, and third in rank of merit among all wondrous porcelains, colored with colors of the morning,—skyey blueness, with the rose of a great dawn blushing and bursting through it, and long-limbed marsh-birds flying against the glow;

"Also the *Ko-yao*—fourth in rank among perfect por-celains—of fair, faint, changing colors, like the body of a living fish, or made in the likeness of opal substance, milk mixed with fire; . . .

"Also the porcelains called *Pi-se-yao*, whose colors are called 'hidden,' being alternately invisible and visible, like the tints of ice beneath the sun, . . .

"Also the *Kia-tsing*—fair cups pearl-white when empty, yet, by some incomprehensible witchcraft of construction, seeming to swarm with purple fish the moment they are filled with water; . . .

"Also the *Ki-tcheou-yao*, which are all violet as a summer's night; and the *Hing-yao* that sparkle with the sparklings of mingled silver and snow; . . . celestial azure sown with star-dust of gold . . . splendid in sable and silver as a fervid night that is flashed with lightnings."

Of the potter in the tale he says:

"Now Pu had discovered those witchcrafts of color, those surprises of grace, that make the art of the ceramist. He had found the secret of the *feng-hong*, the wizard flush of the Rose; of the *hoa-hong*, the delicious incarnadine; of the mountain-green called *chan-lou;* of the pale soft yellow termed *hiao-hoang-yeou;* and of the *hoang-kin*, which is the blazing beauty of gold. He had found those eel-tints, those serpent-greens, those pansy-violets, those furnace-crimsons, those carminates and lilacs, subtle as spirit-flame, which our enamellists of the Occident long sought without success to reproduce." *

Important Groups of Intermingled Colors.—However varied the hues of a natural object may be, usually they are all related, and therefore more or less harmonious. This is because the physical and chemical structure peculiar to each object, tends to make it absorb and reflect rays in some par-ticular order. Although sometimes the hues appear to be

* Lafcadio Hearn, *Some Chinese Ghosts*, pp. 147 ff. Little, Brown & Co.

inharmonious, yet in the larger number of cases the groups
of colors which occur together in nature are pleasing; so
much so indeed that they serve as suggestions to the de-
signer when he is searching for agreeable combinations to
use in his work.

When we analyze these combinations to classify the hues
which compose them, we find among the groups which occur
more frequently than others, the following:

1. Colors very similar in hue; usually with one color
predominating and supported by the two colors that lie
one each side of it in the color circle. For example, when
we examine a yellow jonquil we find yellow predominating,
with a tendency to orange-yellow toward the centre, and
to green-yellow where the petals approach the stem. The
blue of an indigo bunting shows the same type of move-
ment. It tends toward violet in the hues of the head and
toward green as it goes away from the head. For this rea-
son it appears quite iridescent in comparison with the blue
of a bluebird, which is really fully as intense.

2. Colors which are approximately complementary or
opposite to each other in the color circle. Blue or purple
flowers generally have orange or yellow centres. The under
sides of rose leaves are frequently blue-green, veined with
red. Where blue appears upon butterflies, we will usually
find orange also, sometimes sharply contrasted, as in the
yellow and black swallowtails and the common Antiopa
Vanessa.

3. Groups of three colors about equally distant in the
color circle. Combinations of this type, among which are
red, yellow, and blue, and the less aggressive orange, green,
and violet, appear in their full brilliance in sunrise and sun-
set effects. In far lesser intensity, orange, green, and violet
are woven into the grays of tree bark, lichens, and minerals.

We have already considered in some detail the pairs of complementary colors, and shall now examine the groups of similar or adjacent colors, and in a later chapter, the triads, or three colors taken at about equal distances apart upon the color circle.

Cause of the Frequency of the Combinations of Adjacent Colors.—Pure colors are seldom found in nature. Substances which reflect or transmit rays of only one wavelength are comparatively rare. Usually even brightly colored objects reflect not only the hue which is most evident, but also a considerable proportion of the hues which in the spectrum occur at each side of the dominant color of the object. The particular qualities which enable a surface to reflect light-waves of one length more readily than those of another, usually enable it to reflect also, but in a lesser degree, the other rays which most nearly approach this length. Therefore the capacity to reflect a given color is not usually sharply limited to that color, but extends with diminishing power to other hues the waves of which are similar in character. For this reason a red object almost always reflects considerable orange and violet. A yellow object reflects, also, much orange and green, while a blue object reflects rays of green and violet in addition to the blue.

The same thing is true in transmitted light. A red glass transmits some orange and violet in addition to the red. Thus, generally speaking, each colored object reflects the hues of half of the six spectrum colors; namely, its most evident hue and the two which lie one at each side of this hue in the color circle. In most cases any surface texture varies sufficiently in its capacity to reflect colors, so that if we look carefully we can see not only its dominant hue but the two which adjoin it. Where at first glance we think we see only a single hue, we frequently discover that we are look-

ing at a play of those colors which occur very near to each other in the spectrum circle. In an orange-colored nasturtium we can see suggestions of a reddish and a yellowish orange. In a red nasturtium or poppy we can usually see hints of violet and orange, the two colors which adjoin red in the color circle. When the petals of red poppies are pressed and dried the hues pass ·from red into delicate purples, and even to blue-violet. A red rose held in the sunlight will break into a play of hues that range from violet, or even blue-violet, through red to orange. If we look carefully at a portion that appears to be simply red, we can usually discover even here a variation, as if the red was made up of tiny particles, some of which are not red but are more or less orange or violet.

In iridescent colors this play of adjacent hues is easily seen. The surfaces of peacock feathers and of iridescent butterflies, when held at one angle will reflect green, at another blue, and at another purple. On some insects and birds, for example on certain humming-birds, are spots of iridescent red which flash gleams of orange and of violet when seen from different points of view, and areas of yellow which play from pure orange to pure green as they are turned to the light at various angles.

One reason why gold is highly prized for artistic uses is because of the very wide range of hues which it reflects or transmits. If we have recognized only its familiar orange-yellow, we have seen but a small part of the beauty which has made it a favorite metal for art work. Where surfaces of modelled gold project into the light they appear yellow-green. Where they form deep hollows the multiple reflections, sent back and forth, as in the hollow of a golden cup, gain a warmer tone with each reflection, until in some cases they are almost scarlet. Sometimes the reddish and green-

ish hues approach so nearly the complementary interval that they produce a subtle grayish tone very difficult to match with pigments. When gold is beaten thin it becomes translucent and transmits blue-green rays. If we mount gold-leaf on a piece of glass and hold it against the light we will see a clear blue-green.

By understanding the influence upon each other of hues adjacent in the color circle we are able to produce effects which are impossible by any other means. The following are some of the more important of these effects:

Great Brilliancy Is Obtainable by the Use of Adjacent Hues.—When similar hues are woven together they appear to reinforce each other. The oscillation through a range of colors of similar wave-length gives to the combination an effect of richness and depth.

When we first try to represent brightly colored flowers, and find our results dull in comparison, we are likely to feel that the fault is wholly with our materials. Our colors do not seem strong enough. Our paints, although intense in hue, do not produce anything approaching the richness of the hues reflected from the petals. Attempt to match a red nasturtium or poppy, and even the most powerful pigments fail if they are painted in flat tones. If, however, we do as nature has done and let orange and violet mingle with the red so that they are not thoroughly mixed but simply flow together and show gleams of red among suggestions of violet and orange, the resulting play of hues will often approach quite close to the effect of the flower.

Of course paints can never actually rival the sparkle of iridescent surfaces or the gleam of polished metal. Metallic substances can reflect nearly all the light which falls upon them, while white, which is our brightest pigment, reflects less than half. Nevertheless, painters who understand

colors can mingle green, blue, and violet so that the effect appears almost iridescent. If you examine pictures where objects with golden surfaces have been skilfully represented you will see how the painter has used not only yellow but green and orange, the two colors which adjoin yellow in the spectrum. Indeed, it is possible by using this play of adjoining hues to represent the shining quality of gold with pigments of quite low intensity. Other luminous yellowish surfaces of fine texture, like silken fabrics or hair, show a similar oscillation of hues, and when pictured are usually represented by a play of orange and green with the yellow. A yellow vase shows these colors vying with each other in its lights and shadows.

The Use of Adjacent Hues Gives Richness and Vibrancy to Color Combinations of Low Intensity.—Brilliancy is not the only result of a play of adjacent hues. Many delicate colors of low intensity owe their charm to the fact that they are not flat but composite tones. Quiet colors in nature often appear much stronger than they really are because the mingling of adjacent hues enlivens them and gives to them an effect of vitality and richness. Occasionally the blue of lake or ocean appears to be fairly intense. At such times green and purple are usually evident, mingled with the blue. It is somewhat surprising to match the color quite closely and see how low in intensity it frequently is. With oil-paints and a palette-knife, colors can be spread upon a card and then modified until the card held in front of the color in nature so nearly matches it that the difference is scarcely perceptible. With blue, green, and violet we can match almost exactly the color of the apparently blue water. Then we can transfer this color to some surface where its actual intensity can be seen, as, for example, when we place it beside pure blue paint. Its intensity will

usually be lower than we expect, but this is largely compensated for by the vitality which results from the play of the different hues, green, blue, and violet. The degree of pulsation depends upon the way in which they are mingled. If they are thoroughly mixed, so that the different tones cannot be distinguished, even by close inspection, the result will be comparatively dull. If the colors mingle so that threads or patches of each are woven together, but still visible upon close inspection, the impression at a little distance will be that of a single color, but a color that is sparkling and vibrant. Experimentation with various degrees of mingling will make us familiar with the character of the different possible effects.

In the arts, light blues and light reds are seldom pleasing if produced carelessly. The simplest way to produce a light value of these colors is to dilute the blue or red pigment with water or with white. The results are likely to be thin and unsatisfactory. But if faint suggestions of violet and green be made to play through the light blue, and hints of violet and orange to pervade the light red, we can produce delicate tones that are distinguished instead of commonplace, and we can avoid the distressing emptiness of the anæmic tints produced by mere dilution. If we look closely at the petals of a light-blue larkspur we will see that its color, which is one of nature's rare tints of blue, is composed of sparkling particles of blue, of green, and of violet. The petals of a wild rose, which are of an altogether pleasing pink, show traces of orange and of violet.

By Gradual Change from One Color to an Adjacent Color We Can Suggest Movement toward or away from Light.—We have seen that when we cover an area with adjacent colors so that they mingle without being thoroughly mixed the effect is much richer and more glowing

than where one color is painted evenly over the surface. That is to say, a space covered with an intermingling of red, orange, and violet will give an appearance of greater brilliancy than one painted with flat red, even though that red is of full intensity. If, now, we paint an area, say three by six inches in size, starting at one end with orange and gradually merging through red in the middle toward violet at the other end, we shall have an effect new in our experiments, and important. As our glance travels across the strip of graded color from violet toward orange, we feel as if we were approaching the source of light, and as if it would lie just beyond the orange if the paper should be extended. When we look from the orange through the red to the violet, the impression is of passing from illumination toward darkness and shadow. Thus the graded strip gives us a sensation of movement with a suggestion of continuation beyond what is actually recorded on the paper. Our imagination seizes upon this suggestion, and therefore we receive from the graded strip an impression of movement and space which an area of flat color cannot give. Sometimes these gradations may produce a highly dramatic crescendo, as when in a rift of dark cloud at sunset we see a wedge of clear sky where the color, as it approaches the setting sun, passes with swift change of hue from yellow-green to glowing gold.

These effects of movement are produced not only by the swift and marked changes of hue already described, but also by the gentlest of gradations. If we paint an area so that the hues change only slightly, as from orange-yellow to orange, it will still have a vitality lacking in flat color. We feel this vitality and movement even when the color modulations are too delicate to be evident. Regarding these inconsiderable variations, Professor Rood writes:

"Even if the surface employed be white and flat, still some portions of it are sure to be more highly illuminated than others, and hence to appear a little more yellowish or less grayish; and, besides this source of change, it is receiving colored light from all colored objects near it, and reflecting it variously from its different portions. If a painter represents a sheet of paper in a picture by a uniform white or gray patch, it will seem quite wrong, and cannot be made to look right till it is covered by delicate gradations of light and shade and color. We are in the habit of thinking of a sheet of paper as being quite uniform in tint, and yet instantly reject as insufficient such a representation of it. In this matter our unconscious education is enormously in advance of our conscious; our memory of sensations is immense, our recollections of the causes that produce them utterly insignificant; and we do not remember the causes mainly because we never knew them. It is one of the tasks of the artist to ascertain the causes that give rise to the highly complex sensations which he experiences, even in so simple a case as that just considered. From this it follows that his knowledge of the elements that go to make up chromatic sensations is very vast compared with that of ordinary persons; on the other hand, his recollection of mere chromatic sensations may or may not be more extensive than theirs. Hence it follows that it requires long training to acquire the power of consciously tracing fainter gradations of color, though much of the pleasure experienced by their passive reception can be enjoyed without previous labor." *

Of course any gradation from light to dark values, even in grays, suggests a passage from illumination to shadow, but when to the neutral and more abstract intimations of varying grays is added the emotional quality of color, the impression of movement from actual luminosity to gloom is greatly intensified. As we pass from any other color

* *Modern Chromatics*, p. 276.

toward yellow we usually seem to be nearing the light, and
as we move toward violet we seem to move toward gloom.
Yellow is the hue that is most suggestive of light. When
our gradation is from green through yellow to orange, the
impression is that of approaching the light from one direc-
tion, passing it, and going toward gloom on the other side.
On the other hand, violet is the hue that at its spectral value
hints most at darkness. Therefore, a gradation from blue
through violet to red gives the impression of approaching
deep shadow from one direction, passing it, and emerging
toward light on the other side. Gradations from green
through blue to violet give us effects of cool lights and
shadows in marked contrast with the warmth of movements
on the opposite side of the color circle.

In painting any expanse of color, the artist who would
represent nature has to take into account this fact: that
with every change of direction, the color of a surface tends
to change, not only in value and intensity, but also in hue,
and generally toward one or the other of the hues that lie
next to it in the color circle. If he neglects any of these
changes, however slight, he leaves out one of nature's
effects. To be sure, the artist does not always wish to rep-
resent nature. He may consciously omit from his produc-
tions this variation of hue and value and intensity, which
is almost universal in nature. Then it is curious to note,
if he does this understandingly, how far he can approach
the abstraction of certain decorative effects. In many
Oriental paintings the color areas are exquisite in texture
and pattern, but without those particular gradations which
appear in the colors of actual nature and are due to the
direction of the light and the modelling of surfaces. Some
manifestations of the third dimension have disappeared.
The picture exists in its own plane and thus gains a quality

of aloofness and impersonality. The artist who uses this effect needs, however, to know what he is eliminating. If he leaves out these gradations because he is ignorant that they exist, he is likely also to be ignorant of the possibilities of the elements which he retains.

If the sun is shining from directly in front upon a field of green grass, we shall see its light transmitted through more blades of grass as we look toward the direction of the light than at the sides. Consequently, the color of the grass directly in front will be yellow-green with something of the characteristic purity of transmitted light. When we look to right or left, the color grows cooler and less intense as it becomes more that which is reflected from the surface of the grass blades and not transmitted through them. Also as we look farther to either side our eyes receive an increased amount of reflection from the sky, and this adds to the coolness of color. The range of hue from directly in front to either side is from a strong yellow-green through green to a blue-green. Still different gradations will be seen if we look from the immediate foreground to the distance directly in front. The earth colors, ranging usually from orange-yellow to violet-red, now become an important factor in the foreground where they can be seen through the grass. When the light comes from one side the movement from warm to cool starts from the point nearest the light, which is now at the side of the scene. These gradations are always modified by the degree of clearness of the atmosphere and by the amount of specular reflection which varies with the angle of the light.

Roads, shadows at different distances, clouds at various elevations, expanses of water and of sky show evident gradations, all of which contribute to the effect of space and movement. On a very clear day the sky, which appears

at first sight merely blue of various degrees of value, will be found to be green-blue near the horizon, blue half-way to the zenith, and violet-blue overhead. This becomes apparent if we hold a piece of blue paper at arm's length, so that we see it in sunlight against the sky, and move it slowly up and down. In contrast with the constant blue of the paper the changes of hue in the sky become evident, and we see how swift they are. If we find a painting which represents a clear blue sky, and hold a piece of blue paper against the blue of the sky in the painting, we usually find when we move the paper from one portion to another that the same variation from blue to green-blue and violet-blue that we observed in the actual sky occurs in the painting. Often we find that in addition to the change of hue from the horizon toward the zenith in the painted sky, the artist has mingled some green and violet with his blue throughout the sky. This helps to produce an effect of depth and transparency. A sky which is painted with a flat, unvarying blue is usually dead and superficial. It gives us no feeling of approach to or recession from light, no sense that it is permeated with light.

Sometimes the painter will bring out very strongly the changes in hue and value of the blue of the sky. This swift passage from a color of one value and intensity to a color of another, as from light and greenish blue to dark and purplish blue, increases greatly the effect of brilliancy and depth. Some of the paintings of skies by Maxfield Parrish are good illustrations of the effects of this rapid change from one hue to another which adjoins it.

Effects of Modelling May Be Emphasized by Use of Adjacent Hues.—We can represent something of the roundness of a colored sphere by shading it from the light to the dark side without changing the hue. A blue sphere can

be painted light blue on the side toward the light and dark blue on the other side, and if our gradations of value and intensity are like those of nature, the painting will give the illusion of roundness. In our study of values, however, we learned that under varying degrees of illumination, colors appear to change in hue as well as in value and intensity, and that the variations in hue are generally toward the adjacents. We found that as the illumination increases, blue usually becomes greenish and red appears as orange-red. As the illumination decreases, both blue and red become purplish.

With this in mind, let us paint our picture of the blue sphere so that it will become slightly greenish and the red sphere slightly orange, as each approaches the light. We will give them both a hint of violet as they pass into shadow. When we compare these with the monochromatic representations we shall find that those with graded hues give an impression of more emphatic projection into light and recession into gloom. To be sure, the single-hued representations appear spherical, but not as convincingly so as do those where the color changes with the illumination. When there is no variation of hue, the painted spheres do not seem to receive and throw back the light quite as blue and red spheres in the world of reality do.

With these facts at hand, let us compare the appearance of three areas, one of flat color, say of red; a second of red, mingled with its adjacents, orange and violet; and a third where there is an even gradation from one adjacent, through the color, to the adjacent on the other side, that is, in the case of red, a gradation from orange through red to violet. When we contrast the second area, that of mingled hues, with the first, of flat color, we find that in addition to increased brilliancy, the mingled colors give an impression of

space and movement that is lacking in the flat color, but is different from the movement and space of the gradated colors which we have just been considering. In the mingled colors orange generally seems to reflect or transmit more light while the violet appears to absorb or obscure the light, so that the movement is one of depth, of projection toward and recession from the light by movements in the third dimension, rather than in the lateral direction of the gradated hues. The flat color is static. The mingled hues have depth and volume. They can hint of an alternation of thin places, where the light is breaking through, with opaque masses which obscure the lights, as where the sun is shining through vapors of changing density. An effect comparable to our minglings of red with orange and violet may frequently be seen when the setting sun is red but is veiled by purplish vapors. We will find the western sky hung with shifting hues of orange, red, and violet, in varying values and intensities.

Again, the adjacent colors can suggest the modelling of more solid masses which reflect rather than transmit the light, as when mountain crags at sunset project into and reflect the orange light while the ravines show their depths by the violet shadows cast over them. Two other effects result from the play of light over uneven colored surfaces and through transparent or translucent mediums of varying depth; namely, multiple reflections and unequal transmission.

Multiple Reflections Increase the Intensity and Modify the Hue of a Color.—When we color an irregular white surface evenly but very slightly the colors in the hollows will appear to be more intense than those on the projections and the hue will tend toward one of the adjacents of the color. If we wet white cloth or mix plaster of Paris with water in which there is sufficient bluing to tincture

the materials slightly, and have the cloth in folds and the plaster in projections and hollows, we shall find that the blue is much more intense in the hollows, and usually slightly more purplish than in the projections. Most of the rays reflected from the projections reach our eyes directly. The tincture of blue is so slight that it affects the light but little and consequently only a small excess of blue is visible. In the hollows, however, much of the light is reflected back and forth between the sides of the depression before it emerges. At each reflection the dye is able to absorb more of the rays that are not blue. Consequently, the blueness of what emerges is in proportion to the number of times it rebounded from the surrounding surfaces before it emerged. The inside of a gold cup, already referred to, and the depths of a pink rose, and the folds of drapery show the increased color intensity and modification of hue caused by multiple reflections.

The Rays of Light Passing through a Colored Medium Are Frequently Transmitted Unequally.—Some transparent or translucent colored substances transmit rays equally, so that where the substance is thicker the color is merely darker. Usually, however, the rays of long wave-length are transmitted more readily than those of short length. The rays approaching the violet end of the spectrum tend to be dispersed or reflected back more than the rays approaching the red end. The red rays tend to penetrate a thickness of substance that refuses to transmit the shorter wave-lengths. A common instance of this is seen when the sun is behind a veil of smoke. Where the smoke is very thin the light is merely yellowed, but where it is thick, only the red rays can penetrate. When the sun is setting behind a hazy atmosphere we can see the gradual elimination of rays in proportion to their wave-length, so that the color of

the sun changes from the white which comes through the upper transparent atmosphere, through yellow to the point where the sun appears as a red disk. Exactly the same cause produces the delicate sequences of hue which can be observed on comparatively clear days when "white" clouds float in a blue sky. The clouds nearly overhead appear almost white; those farther off which consequently seem lower down, are yellowish, while those farthest away, and which reflect their light through the greatest depth of atmosphere, are slightly rosy. The sky at the same time shows the changes already noted. It is violet-blue overhead because the fine particles in the upper atmosphere can reflect back and disperse only violet and blue rays. As it grows denser toward the horizon it can reflect colors of longer wave-length, even to green and yellow-green.

On the same principle the particles in the substance of an opal reflect back the short wave-lengths of violet, blue, and green, while the orange and red are transmitted. If, however, a cleft occurs deep in the stone the orange and red light which have penetrated that far are reflected back and we have the fire which comes only from the heart of the stone.

Some of the most vigorous impressions of color are produced by combining the effects of mingled hues with those of hues that are graded. We may not only mingle adjacent hues as orange, red, and violet so as to suggest depth, but we can paint them so that, although they are mingled over the whole area, one hue will predominate at one end and another at the other end. In the case of red and its adjacents, orange predominates at one end, red in the middle, and violet at the other end. In this way we secure both depth and lateral or vertical movement, and thus realize movement in all three dimensions.

Three Typical Ways of Reducing the Intensity of a Color without Changing Its Hue.—Our experiences with color mixtures will now enable us to discriminate between several types of subdued color tones, each with its individual quality. In the course of our experiments we have made use of three ways by which the intensity of a given color may be reduced and a softened tone of the same hue produced. These three methods produce results the qualities of which are typical of those of most of the subdued hues which we find in nature and in art. These methods are as follows:

1. The simplest way to reduce the intensity of a given hue is to add to it a neutral gray or black. A neutral has no active color quality, and therefore it reduces the intensity of the hue with which it is mixed by substituting grayness for color. It is like casting a gray shadow over the color.

2. A second way is to mix with a color some of its complementary hue. In Experiment III we found that if colors, exactly complementary in hue were mixed, they grayed each other without producing any change of hue. For example, if we mix with red a little of its complementary green, the green does not change the hue of the red, but introduces into it a slight grayness, and this grayness increases in proportion as the amount of the green in the mixture is increased, until the proportions are reached that produce neutral. Thus by mixing with a color, increasing proportions of its complement, we can produce all degrees of intensity, from the full color to neutral.

3. A third way of reducing the intensity of a color is by mixing with it the two colors which adjoin it in the spectrum. In a previous experiment we found that when we mixed the two hues which adjoined any given color in the

spectrum the result was similar in hue to the given color, although it was usually lower in intensity. That is, if we mix violet and orange, the two colors which adjoin red in the spectrum, the result is a red of low intensity. On the same principle, if we mix these two adjoining colors with pure red the result is a red of reduced intensity. Similarly, if we mix violet and green with blue we produce a subdued blue.

Consequently, if we choose the proportion of the different pigments carefully, we can make three mixtures with any given color, one a mixture of the color with neutral, one with its complementary, and one with the colors which adjoin it in the spectrum, so that the results will be almost alike. In the case of red, for example, the general appearance of the results will be about the same when we mix it with gray, with blue-green, and with orange and violet. To be quite alike the pigments must be thoroughly mixed. This can be done fairly well with water-colors, and still more completely with oil pigments, or with the disks. With oil pigments the three mixtures can be made almost indistinguishable. However, the only value in mixing them so thoroughly that they cannot be told apart, is in proving that the three processes actually may produce identical results. The artistic interest in the three processes is in observing the differences between the results when the pigments are not thoroughly mixed, but when we can still discern the original elements which enter into the combination; when we can see evident traces of the neutral or the green or the orange and violet, mingling but not completely united with the red. Under these circumstances on close examination the three mixtures will usually be found to differ each from the other in depth and vibrancy, and each will have its own peculiar quality. Our discrimination of many of the finer effects of color in nature and in art is

greatly helped when we are able to see what is the particular quality of tone which results from each of these mixtures. The chief differences are as follows:

1. Where the intensity of the color has been reduced by mixing with it a neutral gray or black the result is somewhat deadened as compared with the others. There is only one active color element in the mixture, namely the original hue. The other is negative. Consequently, the original hue is softened and veiled as if by a colorless gloom. This effect is sometimes seen in nature on certain gloomy days, although even the grays of cloudy days are usually suggestive of more color than the mere veiling of the actual hues by gray will produce. In art, black pigment is sometimes used, although most painters avoid it. Great skill is required to use it in a way that is not depressing. Oriental painters have used mixtures of black with beautiful results. Some western painters have also succeeded in doing this; for example, James McNeil Whistler. A number of our younger painters are now making use of the great decorative possibilities of colors with black.

2. Where the intensity of the color has been reduced by mixing it with its complementary there are two active, instead of one active and one neutral factor. The two when mixed produce a certain amount of grayness, but it is a grayness which the colors themselves unite to produce, and not an unrelated factor. It is the grayness of two positive colors which balance each other; two colors, neither of which has the color characteristics of the other, and between the contrasting sensations of which the eye is trying to effect a compromise. The result has, therefore, a greater degree of vitality. When the hues are not thoroughly mixed, fleeting hints of one or the other appear here and there and add to the beauty of the effect.

3. Where the intensity of the color has been reduced by mixing it with its adjacents, it is softened and deepened by two positive hues, both of which have elements which are similar to those of the original color, since they occur near to it in the spectrum. It is a mingling of three active and kindred colors. Consequently it is usually more luminous and vibrant than the mixture of one color with neutral, or one color with its complement. What grayness exists is due to the fact that each adjacent introduces an element complementary to the other. In the case of red with orange and violet, the orange contains yellow, which is complementary to violet, while the blue in the violet is complementary to orange. These complementary elements in the adjacents decrease the intensity of the mixture.

The Hue of Any Color May Be Reproduced by a Mixture of the Colors Adjacent to It in the Spectrum Circle.— We are all familiar with the fact that we can produce green by mixing the two colors that are next to it in the spectrum, namely yellow and blue; that with yellow and red we can produce orange; and that red and blue when mixed give us violet. Most of us, when we look at orange, even in a flat tone, can detect a hint of yellow and of red lurking in our sensation of orange. It seems to be a compound color ready to break up into the two colors, which if mixed together will produce it. Similarly, in looking at green we can see in it suggestions of blue and yellow, while violet seems to most of us to be evidently made up of red and blue.

Probably we are not so familiar with the fact that red, yellow, and blue can also be produced by mixing their adjacents. At first sight these three appear to most of us as primary and indivisible colors. We are not so likely to see in blues accompaniments of violet and green; nor orange

and green in yellows; nor violet and orange in reds. Probably the chief reason is that the majority of people have been taught that orange, green, and violet are secondary colors, which can be produced by mixtures. Also many of us have had actual experience in producing them by mixing paints. We have seen each of these hues made by the combination of two others, and consequently when we look at orange or green or violet the memory of having seen it produced by its adjacents in the spectrum enables us to see the two colors in it. But, on the other hand, because people have quite generally been taught that blue, yellow, and red are primary colors which cannot be produced by mixtures, and few have had experience in seeing them produced in this way, they have no memories to help them to see these colors as composite. It is true that with pigments it is easier and more common to produce orange, green, and violet by mixing for each the two colors that adjoin it in the spectrum than to produce yellow, red, and blue in this way, and the results are much more intense. Consequently this practical fact has determined most of our experiences with color mixtures.

Memories of these experiences exert a strong influence upon the way we see things. Nevertheless it is possible with pure pigments to produce unmistakable yellows, reds, and blues by mixing for each the two colors which lie adjacent to it in the spectrum, although the results are low in intensity. For instance, orange and violet mixed in right proportions produce a dull red. By varying the proportions of orange and violet we can match accurately the hue of any given red, but not always its intensity. That is, we can produce a hue which is similar to what would result if the given red is mixed with the necessary proportion of gray. In the same way, with violet and green we can match

the hue of any blue, and with green and orange the hue of any yellow. When these reds, yellows, and blues, produced by mixing the hues adjacent to them, are placed beside the brilliant hues of the disks, they appear very gray. At our first sight of them we are inclined to think that they are so dull as to be unpleasing, but when samples of them are placed side by side upon a neutral background they usually prove to be both pleasing in themselves and harmonious each with the others. If we compare them with the colors of pottery, textiles, paintings, Japanese prints, etc., we will often find that they match quite exactly the most delicate tones in these objects.

Let us compare with these mixtures of paints the results which we get with the revolving disks of our color-tops. Experiments will show us that with the top, as with the paints, we can produce yellow, red, and blue by using in each case disks of the two colors which occur in the spectrum, one at each side of the color we wish to obtain. The hue will be low in intensity, but usually more intense than the results obtained by mixing pigments. We can prove that the hues are the same as those of the brilliant colors, because if we try to produce yellow, red, or blue with the disks of the two adjacent colors, we can match exactly the disk of the desired color plus gray. For example, if we place upon the color wheel or top the larger disks of green and violet, and over them the smaller disks of blue and black and white, then by adjusting the proportions of the colors we can make the green and violet of the larger disks match exactly the blue, white, and black of the smaller. (Fig. 15.) In a similar way we can make a color with orange and violet which matches the red, with certain proportions of black and white, and a color with orange and green which matches yellow, with black and white.

If now we try to produce orange, green, and violet with the red, yellow, and blue disks of the color-top, we find some surprising results. Red and yellow will produce an

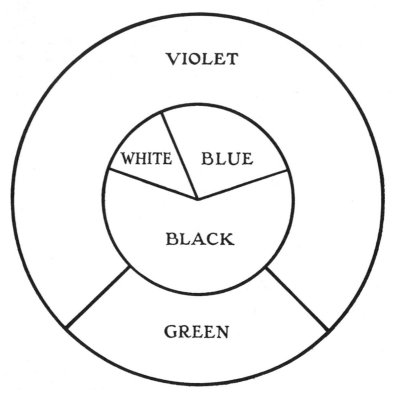

FIG. 15. Proportions of violet and green which when rotated approximately match a blue reduced in intensity by neutrals.

orange, but it is far duller than the orange disk. Yellow and blue, as we have already seen, produce not green but a neutral gray. It is impossible to obtain with them even a suggestion of green, while with paints the same colors will produce a fairly intense green. Red and blue disks, on the

contrary, will produce a purple of extraordinary intensity; more intense even than the pure violet disk.

The Intensity of the Hue Resulting from a Mixture of Two Colors Is Determined by Their Distance Apart upon the Color Circle.—In producing a hue by mixing its adjacents we have thus far discussed only the mixtures of colors at a certain fixed distance apart on the color circle. Of course there are intermediate hues, so that instead of mixing orange and violet to produce a dull red, we may take hues nearer the central red; for example, red-orange and red-violet. The resulting hue will be a much stronger red. Let us notice now the changes in intensity produced by varying the interval on the color circle at which the colors to be mixed are selected. The diagrams in Fig. 16 will illustrate the principle underlying these changes. In 1, the interval between the two hues, red-orange and red-violet, is slight. They have much in common with each other and are closely related to the red which lies between them. When this red-orange and red-violet are mixed they will produce a red of considerable intensity, although less strong than pure red. In 2, the interval at which the two hues, orange and violet, are selected is greater and they have less in common with each other and with the red that lies between them than did the colors in 1. When they are mixed they will produce a red of low intensity. In 3, the interval between the two hues, orange-yellow and blue-violet is as wide as can be. They are practically complementary and have therefore no similarity to each other. Consequently, when mixed they will produce gray.

Of course we may choose any number of intervals between those shown in the diagrams. Thus we may suppose a very acute angle with its sides ending in the circumference of the color circle close to red, and we may imagine this

angle to widen gradually through the position in 1, and
then in 2, until its sides become a straight line, as in 3. If
we mix in right proportions the two hues indicated at each
successive widening of the angle the results will be reds of
decreasing intensity but of the same hue, until neutrality
results from mixing the colors at the widest possible angle,
where they are complementary. If the sides are moved
still farther from red, and beyond the straight angle, they

Fig. 16. To show reduction of intensity resulting from mixing hues taken at
increasing intervals on the color circle.

begin to approach each other on the opposite side of the
color circle, and the result of the mixture of the hues which
they indicate in the color circle will now be the color which
lies between them on that side; namely, a green.

These mixtures of two colors to produce an intermediate
give results somewhat similar in character to those we pre-
viously obtained by mixing a color with its adjacents. We
are simply omitting the original color and using only its
adjacents. In the case of red, for example, instead of mix-
ing violet and orange with red, we are omitting red and
using only violet and orange. If instead of mixing the two
colors we mingle them so that we can detect each in the
mixture, we usually produce a softer and more delicate

but somewhat less rich and glowing tone than where thread-
ings or particles of the central hue appear more or less dis-
tinctly in the combination. For example, we may mingle
red with orange and violet, and beside it place a mingling
of reddish orange and reddish violet chosen at an inter-
val such that the resulting general red tone will be the same
in hue, value, and intensity as the mixture of the three
colors. The mixture of the three colors will, however, have
more depth and glow, while that of the two colors will be
more delicate.

These differences in quality are important to the artist
and artisan. Two textiles may be woven, one of reddish-
orange and reddish-violet threads, and the other of orange,
red, and violet threads, and the hues may be so chosen
that the actual amounts of red, orange, and violet are the
same in each case, although where reddish orange and red-
dish violet are used, the red is in combination with these
two hues and does not appear separately. The results of
the weaving will be practically alike in hue, value, and in-
tensity, but the color textures and vibrations will be differ-
ent. A wide field of experimentation in weaving is open
in the production of varied and lovely qualities of yellows,
reds, and blues by weaving the colors with their adjacents,
and also the adjacents without the intermediate hue. Dif-
ferent degrees of irregularity of mixture will give endlessly
varying textures and qualities to our results. By varying
the distance apart at which the two outlying hues are
chosen for mixtures, we may produce all degrees of intensity
of any given color from full saturation to complete neu-
trality.

**Actual Mixing of Colors Is an Important Aid to Percep-
tion of Composite Effects.**—In order to understand and
appreciate any kind of complexity, it is generally true that

we must first be acquainted with the separate factors which go to make it up and must have watched them while they were actually mingling and fusing into the resulting combination.

There are physical reasons why this is particularly true of composite colors, because when we mix two colors at all thoroughly the product appears at first sight to be a simple hue located somewhere between the two original tones. In music when several notes mingle in a chord the result does not resemble a single note struck midway between the extremes, or at a point where all the vibrations balance. The sound is many-voiced and our ears detect in it all the factors which contribute to its volume. But we find that our eyes are not so analytical as our ears. We do not easily perceive the composite character which contributes to the charm of some of the most dainty and baffling, as well as of the most magnificent, color effects in nature and in art unless we have had experience with the separate hues and have watched their behavior as they combine. We are not likely to understand the tonal possibilities of those three particularly splendid colors, reds, yellows, and blues, unless we have followed our experiments with their more brilliant effects, by producing them from mixtures of their adjacents, and have actually observed the behavior of these adjacent hues as they unite into subdued images of these colors. Our perception of color, which seems due wholly to the impressions of the moment, is based to a surprising degree upon our past experiences and their interpretation of the present sensations.

QUESTIONS

1. How does the color quality of a leaf or flower petal differ from that of colored sample-book paper of the same hue?

2. Describe some factors that contribute to the beauty of a color tone.

3. Describe the three groups of colors the intermingled hues of one or another of which appear most commonly in natural objects.

4. Why are combinations of adjacent hues especially common?

5. In natural objects what hues are most likely to accompany red? yellow? blue?

6. Why is a color of strong intensity in nature likely to be accompanied by the hues adjacent to it in the spectrum?

7. Can you find in colored prints in magazines or elsewhere examples of blues, reds, and yellows made composite by the introduction, in each, of the two colors adjacent to it in the spectrum?

8. Name three different ways in which colors may be reduced in intensity, so that the resulting tones are theoretically alike. State in detail what colors would be used in each of these three processes in the case of yellow, of red, of blue. How can processes so different produce similar results?

9. How can adjacent hues be used (a) so that they add brilliancy to a color? (b) so that they reduce the intensity of a color?

10. Describe some typical artistic effects made possible by the use of adjacent color combinations.

11. Describe the use of adjacent color hues to heighten the effect of the modelling of curved surfaces. Why should this effect of modelling result?

12. What are multiple reflections? Why do they increase the apparent intensity of colors?

13. As a translucent medium increases in thickness, what colors tend to predominate in whatever light is transmitted through it, and why?

14. When any two hues are mixed, what relation is there between the degree of color intensity in the mixtures and the distance apart of the two hues in the color circle?

EXPERIMENTS

Experiment IV.—To discover how nearly we can produce any color by mixing the two hues which lie next to it in the color circle.

1. Place the disks of the six spectrum colors side by side in the following order: red, orange, yellow, green, blue, violet. Do any of them appear to be made up of other colors, or as if they might be produced by a mixture of other colors? Can you see in red any suggestions of other colors which enter into its composition, or does it appear to be a single hue? Can you see in orange a suggestion that it might be made of other colors, or does that appear to be a single hue? Place in one group the disks the colors of which appear as if they might be produced by a mixture of two other colors, and in another group those in which you can see no suggestions of other colors, and which, therefore, look as if they could not be produced by mixtures.

2. We learned that if two rays of light, each of a different color, for example, a red ray and a yellow ray, fall upon the same part of the retina of the eye at the same time, we cannot see the red and yellow as separate colors. The eye makes a compromise between them, and we usually receive a sensation somewhat similar to that of the color which lies between the two in the spectrum. In the case of red and yellow, the compromise results in a sensation of orange. With your water-colors make mixtures to see how near you can come to producing orange, green, and violet by a mixture of the two colors which adjoin each of these hues in the color circle. In other words, see if you can produce an orange by mixing red and yellow, a green by mixing blue and yellow, and a violet by mixing red and blue. Make samples of the mixtures and place them beside the corresponding disks. In which cases have you been able to approach most nearly the hue and intensity of the disks by mixtures of adjoining hues? Make a list of the three results, placing, as number one, the mixture that is most nearly like the disk, and the other two in the order of their likeness to the disks they were to imitate.

3. Try a similar experiment, using the red, yellow, and blue disks instead of the corresponding paints, and spinning them upon the top to produce the mixtures. Compare the orange which results when you spin the red and yellow disks with that which you secured with paints. How nearly can you match violet by the blue and red disks? How nearly can you approach green with the blue and yellow disks? Compare these with the corresponding mixtures of paints. Make a list of the results obtained with the disks, placing first, as in the list of paint mixtures, the one that most nearly resembled the hue that in the spectrum lies between the two colors that were mixed, and the others in the order of the similarity of each to the color which we would expect it to resemble. Is the order in this list of mixtures of spinning disks the same as that of the paint mixtures? What mixture in paints is nearest like those of the spinning disks, and what one is most different?

4. With the disks see how near you can come to producing red, yellow, and blue, by using for each of these hues the colors that lie upon each side of it in the color circle. In other words, see how near you can come to producing a blue tone with the green and violet disks, a red with the orange and violet disks, and a yellow with the green and orange disks.

5. Try a similar experiment, using your water-colors instead of the disks, and see how near you can come with green and violet to producing a blue, with orange and violet a red, and with orange and green a yellow. Make samples of the resulting tones. At first sight they will probably appear very low in intensity. Place them side by side upon a neutral gray background of middle value or darker. This gray will help in bringing out whatever color the mixtures have. Place the samples upon the colors of Japanese prints or of textiles of soft tones and see how nearly they match these. The tones of red, yellow, and blue, produced by mixing the colors that adjoin them in the spectrum, are not so intense as the orange, green, and violet which we can make by mixing the hues that adjoin them, but if the mixtures are carefully made the red, yellow, and blue which

result have a peculiarly delicate quality. Making them helps us to see the many similar tones in nature and in art.

6. Place upon the color-top the green and violet disks of the larger size, and over these the blue and black and white disks of the smaller size. Experiment by adjusting the proportions of the disks, to see if with the violet and green disks you can produce a tone which will match exactly that made by the blue, black, and white disks, so that when you spin the top the two sets of disks look just alike in hue, value, and intensity. Try the same experiment, using the larger-sized disks of orange and green with which you tried to produce yellow, and over them the smaller yellow, black, and white disks. Try also the orange and violet disks to see if they can be adjusted to match some combination of the red, black, and white disks. The black and white with one color do not alter its hue, although they may change its intensity. That is, red with black and white still remains a red, although its intensity may be decreased and its value raised or lowered. Consequently, if with certain proportions of orange and violet we can match a combination of red, black, and white, we have succeeded in producing a hue of true red, even though we have not produced it in full intensity. Our experiments with the six mixtures with colors and the six mixtures with disks will show whether in any case we can approach not only the hue but also the intensity of a color by a mixture of the colors adjoining it in the color circle. In the cases of our mixtures of paints the hue in each instance can be that of the color we tried to match, although the intensity may differ. That is, we can produce with paints a given hue by mixing the colors that adjoin it in the color circle, but it may be so reduced in intensity that it looks as the spectrum hue would if it was mixed with gray.

Experiment V.—To reduce the intensity of a given color by three different methods so that the results are similar in hue, value, and intensity, but different in texture and quality.

In this experiment two tones, a light and a dark tone of

blue, of yellow, and of red, in reduced intensity, are worked out each in three different ways, so that as a result we will have three light and three dark tones of each of the three colors. The light tones of each color are to be similar in hue, value, and intensity, although produced by different methods, and so also are the dark tones. At a distance of six or eight feet they should be nearly alike in general appearance, but a close examination should show the different ways in which they are produced. In the first attempt the tones are likely to vary, but by washing to lighten the value, or painting over to darken the value or to change the intensity, the results may be made more nearly alike.

1. On one area mingle blue with gray, as in Experiment II, so as to produce a light tone of gray-blue, and on another a dark tone of gray-blue. The mingling should not be so complete as to be perfectly flat, nor should it be spotted in areas of gray and blue. If it is too spotted after it is dry, go over the surface again until the gray and blue are fairly even. If the result is too dark, wash it, and, if necessary, paint it over again.

2. Mingle blue with its complementary orange until you have a light tone and a dark tone which in value and intensity are similar to the tones just produced by mingling blue and neutral. The use of burnt sienna as orange will give approximately a complement to the blue. Handle this as you did the blue and gray. The result should be a light and a dark blue which at a distance of ten or fifteen feet are fairly similar in appearance to the blues produced by blue and gray. When they are viewed at a distance of two or three feet, however, a difference in quality is evident because the blues mixed with orange are softened or made less intense by an active color which balances the blue, instead of by a neutral which dilutes it as in the case of the first step. Look at the two samples closely in a strong light, and the difference in texture of hue will be still more apparent. In one there will be a pleasing variation between the blue and the neutral, in the other a variation pleasing in a different way between the warm glow of the orange and the coolness of the blue.

3. We have learned that nature's colors are usually complex. One of the most pleasing types of complexity occurs when a color is accompanied by traces of the two hues which lie one at each side of it in the spectrum. Blue merges into green on one side, and into violet on the other. See if by mingling blue with green and with violet you can produce a blue which at a distance is similar in hue, value, and intensity to the blues just produced, one by mingling blue with black and the other by mingling blue with its complementary orange. See if those blues softened by the addition of green and violet have any suggestion of iridescence like that of peacock feathers. With yellow and also with red, try experiments similar to those you have tried with blue. In the third step the two colors with which yellow will be mingled are green and orange, and those with which red will be mingled are orange and violet.

Experiment VI.—To see how mingling a hue with its adjacents may give an effect of both brilliancy and softness.

1. Wet an area of white paper about six inches long and three inches wide with water. Into this run irregular brush strokes of brilliant red and of pure orange and violet, so that the whole surface is mottled with these three hues. While these are still wet, guide them with the brush till they merge so that at a distance of ten feet the surface appears red, but when held more closely, all three hues are visible. If the mottling is too evident at a distance, carry a wash of red over the whole when it has dried. Cut off half the area and wash it with water, so as to make it a light pink.

We now have a dark red and a light red, each made up of red with its adjacents. Do the same with yellow and with blue. (Plate IV, following p. 22.) Compare the results with the colors of flowers. See how similar the dark and the light blue are to the dark and light blue larkspur and iris, in which the adjacent greens and violets are almost always evident. Compare the light blue with an equally light blue made by diluting plain blue with water. Note how com-

monplace the diluted blue is in comparison. Place the yellows and reds beside flowers of similar hues. Compare them also with light and dark colors in paintings, colored illustrations, and textiles.

2. Find a dried autumn leaf the hues of which are golden or rosy and of very low intensity. Decide upon its hue and then try to match it by mingling the colors which lie upon each side of it in the spectrum circle at a wide angle.

PROBLEM

Problem C.—To show in a design some of the effects which may be produced by a color with its adjacents.

Almost any design that calls for the use of color can be used to advantage. Only three hues, namely a color with the two hues which are adjacent to it, should appear, but with them may be used any neutral tones, either in separate areas or mixed with the colors. The two adjacent hues should not be as strong in intensity as the central color. They are to support the central color but not to compete with it.

Fill in the pattern of the design with areas of blue and of its adjacents, green and violet. Modify these by guiding the colors and by washing them so that the blue is dominant in intensity, although it need not occupy the larger areas. Strikingly iridescent effects can be obtained by subdividing the areas of the design so that it becomes a mosaic of blue with green and violet, and white, gray, and black. On a similar pattern experiment with yellow, with its adjacents, green and orange; and in still another, try red with its adjacents, orange and violet.

Delightfully vibrant and luminous effects can be produced by a pattern in which the areas change gradually in color from one hue to its adjacent, thus forming a sequence of color. In weaving or embroidery, any color can be enriched by weaving threads of its adjacents into it.

V

NEAR–COMPLEMENTS AND TRIADS

The Relations between Colors Nearly but Not Quite Complementary.—In our experiments with pairs of colors which were exactly complementary, we found that if we mixed a little of one with the other, there was a change of intensity but no change of hue. When we mixed a little orange with its complementary blue the orange simply grayed the blue. The orange had no more effect upon the hue of the blue than would have been produced by mixing a little gray with the blue. Similarly, a little blue mixed with the orange merely grayed the orange. Consequently, when we make a design using only complementary colors, we can produce all degrees of intensity, from the two colors in their purity, through successive proportions of grayness, to neutrality. We cannot, however, change the hue of either color if we limit ourselves strictly to complementaries. If the two complementaries are blue and orange, all the mixtures that are not neutral will be various intensities of blue or of orange.

If, now, we mix two colors that are nearly but not quite complementary, we can produce a result that is very low in intensity, but it can never be exactly neutral. Moreover, the hue of the mixture of these two colors will not be a reduced intensity of either of them, as is the case in mixtures of complementary colors. (Fig. 17.) Each combination of these two nearly but not quite complementary colors will have a hue of its own which will lie somewhere in the

color circle between the two hues used for the mixing. The proportions in which these two hues are mixed will

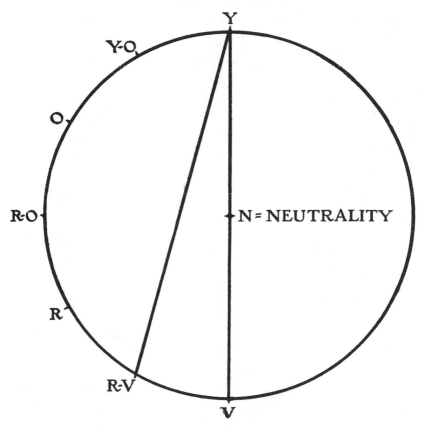

FIG. 17. The line between complements passing through neutrality compared with the line between near-complements which never quite reaches neutrality.

determine where in the color circle the hue of the result will occur.

When equal proportions of nearly, but not quite, complementary colors are mixed together, the hue of the mix-

ture is about half-way between them on the color circle and will be grayer or lower in intensity than either. If more of one is used than of the other the hue of the mixture will be nearer the hue of the color which occurs in the

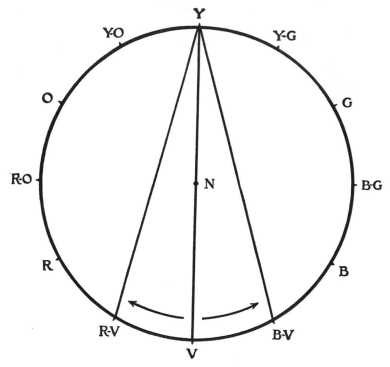

FIG. 18. Yellow and its two near-complements, red-violet and blue-violet.

greater proportion, and its intensity will be greater, because there is less of modification by the other and nearly complementary color. Thus by mixing in different proportions colors which are nearly but not quite complementary, we can produce a range of tones varying in hue as well as in intensity. When the two colors are mingled instead of

being thoroughly mixed, the resulting tones are usually of great delicacy and full of shifting hues. Some of the obscure colors of nature, the hues of faded leaves, of stones, of the bark of trees, can often be produced by minglings of these nearly complementary colors.

For each color there are, of course, two hues that are nearly complementary, one at each side of the actual complement. On the diagram, Fig. 18, we find yellow at one end of the diameter of the color circle and violet, its complement, at the other. At each side of violet lie the two colors which are nearly complementary to yellow, namely, red-violet and blue-violet. With successive mixtures of red-violet in increasing amounts, yellow will pass through the following changes: A slight amount of red-violet will change yellow to orange-yellow of slightly less intensity than the yellow. A greater proportion of red-violet will change the yellow to orange of still less intensity. Equal proportions of each will produce a somewhat reddish orange of the lowest intensity of any mixture of the two. Larger proportions of red-violet will carry the mixture through red-orange and red, as far as we please, toward red-violet, with continual increase of intensity.

Fig. 19 will indicate the general principle of these changes in hue and intensity when the two originals are at full intensity. $Y-V$ represents the line from yellow to its complement violet. N is the point of neutrality where the violet and yellow mixed give neutral gray. Any other points placed on this diameter will indicate different intensities of yellow or violet. The line $Y-RV$ is the line from yellow to one of its near-complements, and points on this line represent mixtures of yellow with different proportions of red-violet. None of these mixtures can touch the point N of absolute neutrality. The variation of the suc-

cessive mixtures, from neutral gray, in other words the degree of saturation or intensity of the mixtures, is indicated by the lengths of the radii from N to the points where they intersect the line $Y-RV$. The points where the radii touch the circumference indicate the hues of the mixtures. Full saturation or pure color is indicated by S^5. At this point, no red-violet has been mixed with the yellow. Therefore the line $N-S^5$ extends to the full length of the radius to pure yellow. A mixture of a certain proportion of red-violet carries the hue to a point on the circumference between O and $O-Y$, and reduces the intensity to NS^4. When the amounts of yellow and red-violet are equal we find that the intensity is reduced to $N-S^3$, the point nearest to neutrality on the line of mixtures, and that the hue has passed nearly to red-orange. From there on the intensity increases with added amounts of red-violet while the hue changes as indicated where the radii touch the circumference. In the same way we can plot the intermediates between yellow and its other near-complement, blue-violet, on the other half of the circle. Similarly we can diagram the results of mixtures of any color with the two hues that are nearly complementary to it. We have only to consider the circumference of the circle upon which the spectrum hues are indicated in Fig. 19 as being stationary, while the diagram within is made upon a separate surface which, like a superimposed circular card, can be revolved about a pin through the centre N. As we revolve this card, one end of the line which is now $Y-V$ will successively indicate all the possible hues, while the opposite end is pointing out the complement of each. At the same time the other lines of the diagram are indicating the hues and intensities of various mixtures of each hue with one nearly complementary to it. To become familiar with the

actual qualities and relationships of these tones we need to mix them with pigments so that we can actually see the changes. Nevertheless, acquaintance with the diagram

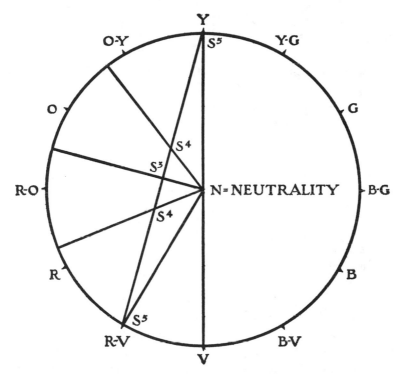

FIG. 19. Diagram showing the relative intensities of three mixtures of the near-complements yellow and red-violet in varying proportions.

enables us to think out the changes and to visualize the relationships of the mixtures to each other and to neutrality, so that we understand the principles involved and can predict the results.

We can now see that two colors nearly complementary give us, in their various mixtures with each other, a chro-

matic scheme extending between the extremes of two tones of full intensity, through a range of intermediates of great delicacy and variety of hue and all intimately related to the two original colors. When we add to these, black, white, and gray, we have the materials for a color scheme of great beauty and one which is of especial value in the arts.

Colors Which Are Nearly Complementary Introduce Us to the Triads or Three-Color Combinations.—We have seen that while each color has only one exact complementary, there are two hues which are nearly complementary to it, namely the hues that occur one at each side of its complement. If we use in a design a color with both of these near-complements, the balance of color qualities is equivalent to the balance of the color and its complement, because it consists of the color and the two hues which when mixed together produce its complement. In Fig. 20 we have yellow with the two hues that occur close to its complement V. If the triangle is revolved on the centre of the circle, while the circumference remains stationary, the points of the triangle will indicate successively each hue of the spectrum and its two near-complements.

If we use in a design these three colors or any mixtures of them we have two ranges of hues intermediate between yellow and its near-complements, one at the right and the other at the left side of the circle, but all these intermediate hues are softened and subdued because the mixtures which produce them are of colors very nearly complementary. Only those hues which approach the near-complements used unmixed can be intense. Moreover, we can have mixtures which result in neutrals if we use all three colors in certain proportions, because with two of them we can produce the exact complement of the third. Consequently

we have a combination which gives us greater variety than any we have considered before, and yet insures close relationship between the hues and all their intermixtures. We

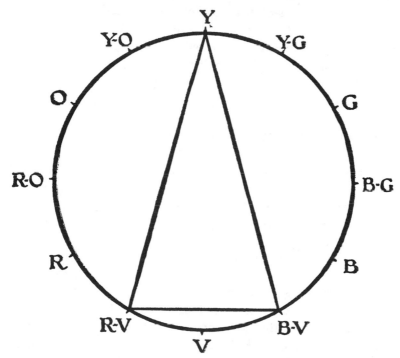

Fig. 20. Diagram for finding the near-complements of any hue.

can also imitate some of the most baffling of nature's tones without having our results lifeless and muddy.

For instance, it is true that by putting a little color with gray we can roughly approximate the tones of withered leaves in late autumn, but when we place the colors which we have produced in this way beside the leaves we usually find a silvery quality in the leaf surfaces and faint hints of

hues with varying color suggestions which are not found in our mixtures of one color with a neutral. If, now, instead of mixing gray with the color which is nearest like the leaf we find on the color-circle the hue approaching that of the leaf, and then select the two other colors that are nearly complementary to this hue, a mingling of these three will usually be very nearly the color of the leaf. If the leaf is a dull red, a mixture of red with its two near complements, yellow-green and blue-green, will gray the red and yet give delicate intermediate hues which avoid actual neutrality.

A Considerable Interval May Exist between the Hues of the Divided Complement.—In a three-color group consisting of a color and the two hues which when mixed will produce its complement, we can often allow a considerable arc between the two hues of the divided complement without losing the complementary relationship between a mixture of these two hues and the first color. Usually this arc may extend to about one-third of the circumference. In Fig. 21, the dotted radii show the near-complements of yellow. When we extend the arc to blue and red we still have hues which when mixed produce violet, the complement of yellow. But they are so far from the actual complement that the intermediate hues produced by mixing either of them with yellow have considerable intensity. We can prove that the blue and red still maintain the complementary balance with yellow, because when mixed in certain proportions with it, the result is a neutral gray such as we obtain when we mix violet with yellow.

If now we make the arc wider than the distance between blue and red, so that it approximates a half circle, and the two hues, blue and red, are pushed still farther from violet, these hues lose any close affinity with violet but have not

yet been swung around far enough to become adjacents of yellow. The unifying elements based upon complementary

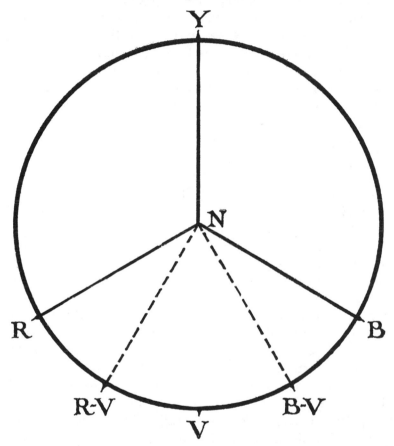

Fig. 21. Development of near-complements to triads by widening the angle between the near-complements.

balance with yellow are lost. We can no longer produce a neutral gray by any mixture of the colors in anything suggesting equal representation of all three. Even if the

two colors which we have arrived at by increasing the distance from violet are not quite complementary, a mixture of them is so near to gray that only the slightest addition of yellow is necessary to produce an absolute neutral. Their relation to yellow is different from any with which we have yet experimented. If they are to be brought into agreement with yellow, it must be by bonds of unification other than those of complementary or adjacent relationships. They occupy a position on the color circle midway between these two possibilities. How hues thus dissociated may be harmoniously composed will be considered in the chapter on Color Harmonies.

Balanced Groups of Three Colors Selected at About Equal Intervals on the Color Circle.—The triad which we have just been considering, namely, yellow with blue and red, the two colors into which violet, the complement of yellow, may be divided, is typical of an indefinite number of groups selected on the same principles. In these groups the division of the complement of one of the colors is carried as far as may be and yet retain a marked complementary balance to the other color. The limits of this balance extend to the point where a mixture of two of the colors still requires the addition of something approaching an equally important amount of the third to produce neutral. This limit is approximated when the hues are located at about equal intervals on the color circle.

In order to simplify our first study of triads we will omit any detailed discussion of the many possible modifications of the intervals between the hues, and consider the characteristics of a few, in which the hues are located about equally distant one from another on the color circle. These will acquaint us with typical effects and provide a starting-point for as many experiments as we care to try in modify-

ing the intervals. Fig. 22 will indicate a way to find all of
the triads of equal intervals. Suppose the equilateral tri-
angle, the corners of which now point to yellow, red, and
blue, to be a card separate from the circle. When we re-

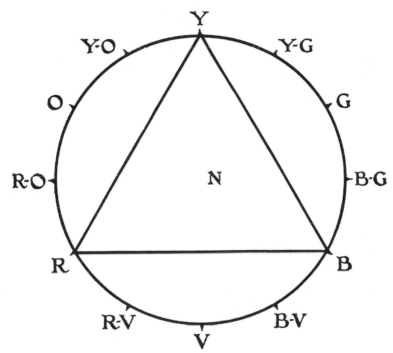

FIG. 22. Diagram for finding various triads on the color circle.

volve this card upon the centre N, its three corners will in-
dicate successive triads of colors at equal intervals on the
circumference. In a circle where the colors are imper-
ceptibly graded, as in the spectrum, there will, of course,
be an indefinite number of these equal-angled triads. We
will consider some of the qualities of four, which will be
typical of all the others.

The Triad of Red, Yellow, and Blue.—This is a triad of strong and aggressive color sensations. If they are used in full strength they must be skilfully handled or the results will be crude and disagreeable. Where they are used in a masterly way, as in some of the mediæval stained glass, the effects are sumptuous and peculiarly satisfying. When we contemplate them they affect us as if they were primal and authoritative hues to which all others were subservient, standing in the relation of modified and intermingled echoes. Even in subdued form something elemental lurks in the appeal of these three hues. This may be the reason why red, yellow, and blue were the dominating colors in ancient art. We find them in Egyptian decorations. They are the colors chiefly used by the Greeks in the ornamentation of their temples and statues. The traditions of their use are continued in mediæval design and painting.

In addition to the potency of the three hues, any two of them when mixed together result in intermediate tones of great intensity. Yellow and red produce a strong orange. Blue and yellow pigments give us a bright green. Red and blue combined form an intense violet. Therefore, incomplete minglings of red, yellow, and blue, as when the colors run together on a surface of wet paper, are likely not only to give unpleasant contrasts but also to produce so many other hues where they mix that we have not a group of three colors only but a confused mingling of all colors of the spectrum. Nevertheless, many of the richest and most beautiful color combinations are those in which these three hues are dominant.

If we mingle them so as to avoid crude contrasts and too many strong intermediate hues, we shall have suggestions of some of the more important effects which their use makes possible. When we let very light tones of red,

yellow, and blue flow together, extremely luminous effects result, hinting at brilliantly lighted vapors in high altitudes of sky, or what Keats, in "Orpheus," has described as

"The vaporous spray
Which the sun clothes in hues of Iris light."

When we mingle them in full intensity, but so as to keep the intermediate fringes of orange, green, and violet which occur, subordinate, the effects often suggest great richness and splendor. Sometimes they call to mind bright flowers in the sun, as when scarlet and yellow poppies are seen against a background of blue water. Or they suggest effects of tropical sunsets. The hues are so powerful in themselves that they are likely to compete unpleasantly in any accidental mixture, but we can unify the results somewhat by making one or another of the three colors dominant, or we may subdue all three by the addition of gray or by mingling them till grays result from complementary balance. In this way we can avoid having these mixtures wholly accidental. The minglings may not be very enjoyable as combinations, but they will illustrate for us many facts regarding the behavior of these three colors under various modifications of value and intensity. Out of a large number of minglings, we shall probably find a few that are pleasing and worth preserving as notes.

The Effect of the Red, Yellow, and Blue Triad When Veiled with Yellow.—An effect of peculiar richness and depth results when patterns of strong red, yellow, and blue are washed over with yellow. It may be that the reason why the effect of toning this triad throughout with yellow is particularly pleasing to many of us is because such a large proportion of the paintings and decorations and tapestries of earlier periods, as for example paintings of the

Italian Renaissance, employ these three colors prominently in rich patterns over which the combined effects of time and of varnish have laid a golden film. These older works of art are widely familiar in their original form or through reproductions, and have furnished us with a more or less unconscious standard of tonality for that triad. Apart from the influence of association, however, this major triad of colors appears to give us a direct and particularly strong and pleasing color experience when its hues are veiled with yellow, as if permeated with a golden light.

The Triad of Orange, Green, and Violet.—Let us revolve the equilateral triangle within the circle in Fig. 22 until the angle that was at yellow now points to orange. The other two angles, one of which indicated red and the other blue, will now point respectively to violet and green. This group of colors is complementary to that of red, yellow, and blue. This is surprisingly well illustrated if we place our red, yellow, and blue disks close together, as indicated in Fig. 23 and look steadily for about twenty seconds at some one point in the group and then glance at white paper. The after-images of the three disks will appear respectively as green, violet, and orange. We can reverse this effect by using the green, violet, and orange disks.

Not only are the colors of this triad, orange, violet, and green, complementary to, and therefore opposite in, the color circle to red, yellow, and blue, but the effects which they produce and the moods to which they appeal are correspondingly different. Combinations of orange, violet, and green occur much more frequently in modern paintings and decorations than in those which date back more than a hundred years. If in an art museum we pass from a room of paintings of the period of the Renaissance to a room of paintings by contemporary artists, we will find that

although all colors of the spectrum appear, reds, blues, and yellows are likely to predominate in the older canvases, while tones of violet and of orange, together with green, hold a correspondingly important place in modern art. The reds, yellows, and blues have by no means been crowded out of modern art, but they no longer dominate. The

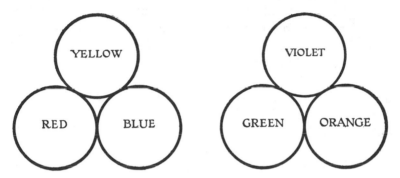

FIG. 23. Diagram showing that the after-image of a triad is another complementary triad.

difference in general color effect of the new paintings as compared with the old, especially the prominence of violet and green in the new, is marked.

When we mingle orange, green, and violet, we find the results quite dissimilar in general effect from what is produced by mingling red, yellow, and blue. The hues seem to be more subdued. The combinations have greater unity because the intermediate tones where the colors run together are much reduced in intensity and never compete with the original colors. Each hue modulates into the next through an intermediate, which in its quiet grayness is quite in contrast with the lively fringes that occur where the edges of wet areas of red, yellow, and blue pigments have run together.

An Indefinite Number of Triads May Be Found upon the Color Circle.—Of course it is possible to select any number of triads of colors equidistant upon the color circle by taking any three points which divide the circumference into three equal parts. In other words, when the equilateral triangle in the circle in Fig. 22 is revolved, its points will indicate a triad wherever they happen to lie. Out of this indefinite number of possible triads, however, two others will be sufficient to illustrate for us the other more important three-color mixtures. One of these, our third triad, is found when the points of the equilateral triangle lie at red-orange, yellow-green, and blue-violet respectively, and the fourth triad occurs when the hues indicated are yellow-orange, red-violet, and blue-green.

The third triad is a combination not pleasing to most people when the colors are presented in strong intensities. The minglings of these colors have, however, their own characteristic qualities, which cannot be exactly matched by combinations of other hues unless the mixtures are so complete as to destroy any vibration of the original colors used. When we mingle red-orange with varying proportions of yellow-green, so that the two colors maintain indications of their presence in the mixture, we have a range of very warm golden hues of great richness. The red-orange with the blue-violet give purplish tones which vary from glowing warmth of light to cool shadows. We can represent the furrows of a ploughed field of dark earth, across which the setting sun shines, by using subdued tones of red-orange and of blue-violet. In the sun the red-orange will predominate, while in the shadow the proportion of blue-violet will be greater. We will have an effect of sharp contrast of light and shadows if the predominance of one hue in the light and the other in the shadow is marked.

Our light will appear to be softer if the proportions of the
two colors in each mixture vary but slightly. The effect
is still more subdued if into the combinations of red-orange
and blue-violet we cut a little of the third member of this
triad—namely, yellow-green. By mixtures of blue-violet
and yellow-green we can produce a series of greens passing
from warm to cool tones.

The fourth triad, yellow-orange, red-violet, and blue-
green, is perhaps the least common of the four combinations,
but one that in its various modifications, where we let the
colors run together to observe their interminglings, is gen-
erally pleasing. Its tones continually hint at red, yellow,
and blue without ever actually imitating them. There is a
quality of distinction and unusualness in the hues, and in
the minglings of any two of them in varying proportions or
with a slight admixture of the third. This triad often car-
ries a suggestion of remoteness from the ordinary run of
color effects in nature, as if its function was to express ex-
ceptional and peculiar moods.

These Four Triads Are Typical of All Others.—Of course
there are innumerable intermediate triads, but the four
which we have been considering are about all that our eyes
can distinguish readily. Acquaintance with them will in-
troduce us to a large proportion of the combinations of three
colors, taken at wide intervals in the spectrum. The hues
of a triad are not necessarily beautiful when put together,
but each group is individual in character and seems capable
of representing some particular atmosphere or tonality;
some characteristic mood or æsthetic experience.

When we mingle the orange and green of the second triad,
taking care not to let the two colors wholly lose their iden-
tity in the mixture, we find that the resulting yellowish
tones differ in quality from those which we can produce by

mingling the orange-red and yellow-green of the third triad, and these in turn are distinct in quality from the yellowish tones which grow out of a mingling of the yellow-orange and green-blue of the fourth triad. If we paint sunlight across a ploughed field, using as the chief hues the orange-red and blue-violet of the third triad, as has been already described, and then paint the same effect twice more in a similar manner, using in one case the orange and violet of the second triad and in the other the yellow-orange and red-violet of the fourth triad, we shall find that our ploughed field appears in each case as if it existed in an atmosphere different from that of the others. Although the hues are similar, the sunshine is that of different days. Sometimes the bark of old pine-trees will hint at one triad at noon, another at sunset, and still a third when the sun strikes it after it has been soaked with rain.

Familiarity with the various possible minglings of the colors of each triad will acquaint us with the behavior of its hues in varying proportions. We thus learn what tones can be produced by mingling all of its colors, or any two of them, or any two with some addition of the third. We see how different are the effects when one or another color dominates and is merely modified and balanced by the others, or when all three appear in considerable importance. When we become thoroughly familiar with the triads we shall distinguish one or another of them in a design, not so much by analyzing the combination in order to discover what hues have entered into it, as by recognizing the totality of impression which is characteristic of each. Of course it is possible to introduce a great variety of modifications of the colors which occur in any one of these triads and still preserve the general principle of complementary balance. We can vary somewhat the intervals at which they are selected

on the color circle. By mixing them we can obtain inter-
mediate hues. We can even make a design in which occurs
a miscellaneous group of colors, but by interweaving the
colors of a given triad we can give to the whole the general
impression characteristic of that triad, so that this impres-
sion will dominate while the other colors play through it
with a subordinate influence. The four triads as here de-
scribed, however, will serve as an introduction to the endless
number of possible modifications.

A Summary of the Color Groups thus Far Presented.—
The combinations of colors which we have been considering
may be divided into two main classes; namely, colors that
are similar, so that one general tonality pervades the com-
bination, and colors that present a marked difference of
hue, so that there is a balance of contrasting colors.

In combinations of the first type we experimented first
with one color together with neutrals. Some sort of con-
trast appears to be a necessary factor in producing pleasure
in any pattern. In this case the contrasts were provided
by the differences in the values and intensities of a single
hue and in the neutrals which entered into the pattern.
Later we experimented with a color and the two hues which
adjoined it in the color circle. Here the slight differences
between the hues were sufficient to add some variety of
hue while still preserving the general color tonality of the
design.

In combinations of the second type, we experimented
first with one color and its exact complementary. In this
we had the greatest possible contrast of hue. We varied
this slightly by taking a color with another nearly but not
quite complementary, and thus secured contrast with sof-
tened intermediate hues. We then greatly increased the
variety of hues, while still preserving the complementary

balance, by using one hue with two others which, if mixed together, would produce the complementary of the first. This gave us the wide range of hues found in the triads. This classification may be set forth in a brief list as follows:

I. Similar hues which give a likeness in color tonality:
 (*a*) A single color.
 (*b*) A color and its adjacent hues.

II. Contrasting hues which give a balanced color tonality:
 (*a*) A color and its complement.
 (*b*) A color and its near-complement.
 (*c*) A color and the two hues which when mixed produce its complement.

In each case the pattern may include the colors in any intensity and value and with neutrals.

These Groups Are Interpretative of a Wide Range of Combinations in Nature and in Art.—These groups of hues are by no means all that nature and art present. Nevertheless they are sufficiently typical to give us a practical introduction to a wide range of color effects, because they illustrate some of the more important ways in which white light is broken up into its component colors under various conditions of reflection, transmission, and absorption and different textures and degrees of transparency and opacity of materials. They also illustrate some of the ways in which our minds, in their reactions to color, relate the various sensations, as in the case of after-images. These objective processes of light and the subjective types of behavior of our minds in response to them are probably at the basis of our preferences for certain hues and combinations, and thus are directly related to our enjoyment of color in nature and our tastes in art.

Sometimes we find these particular color groupings presented in almost unmodified form in nature, as when the patterns of the Cecropia moth or of the yellow warblers show only one hue in varying values and intensities, or when mountains and the sunset sky against which they are seen show, as they frequently do, exactly complementary tones, and again when adjacent hues or triads of color appear in reflections on water or in skies. We also find that not infrequently they are frankly presented in the arts. More often, however, they are not set forth quite so clearly, but are merely dominant color tendencies in the patterns of nature and art.

The colors of these particular groups, moreover, are not necessarily pleasing merely because they happen to be together in a combination. Therefore a knowledge of them does not constitute a recipe for the production of color harmony. But they do appear to be the ingredients of a surprisingly wide range of nature's color effects, and each group seems to furnish the factors which produce better than any others some characteristic mood of nature. Each of these combinations may be considered as raw materials, already related by the laws of physics and optics to outside nature and to our own ways of seeing, but awaiting a further organization and modification by the artist. His experience and sensitivity can carry the adjustment and relationship of tones to a point which analysis has not yet reached.

QUESTIONS

1. Compare the intermediate hues which it is possible to produce by mixing complementary colors with those which can be produced by mixing two colors nearly but not quite complementary, and give reasons for the differences. Give two specific examples, naming in each case the hue and its complement and near-complements, and the suc-

cessive intermediate hues which result from the mixtures (a) of the color with varying proportions of its complement; (b) and (c) of the color with varying proportions of each of its near-complements.

2. In what sense are triads based on complementary color relations?

3. In mixtures of near-complements what proportions of each produce the lowest intensity? Why?

4. Compare the characteristics of the triad of red, yellow, and blue with those of the triad of orange, green, and violet.

5. Summarize the various groups of colors which we have studied. Into what two general classes can they be divided?

EXPERIMENTS AND PROBLEMS

Experiment VII.—To show the effects of mixing two colors which are nearly but not quite complementary in hue.

For purposes of comparison of successive steps, one or two color-tops should retain the combinations of each step while others make the changes for the next step.

1. Place on your color-top the violet disk, and over it the yellow and orange disks, so arranged that the orange is covered by the yellow. Adjust the amount of yellow and violet so that when you spin the top the resulting tone is as near a neutral as you can secure.

2. Without changing the amount of violet move the yellow disk so it shall cover only half the space which it previously occupied, and let the orange fill the other half. The top now shows the same amount of violet as at first, with half as much yellow, the remaining space being occupied by the orange. Compare the result of this combination when revolved with that of a top with yellow and violet, arranged as at first. What hue begins to appear where orange enters the combination?

3. Shift the disks so that no yellow shows, but orange covers all the space which yellow occupied at first. Compare the hue produced by revolving this with that pro-

duced in steps 1 and 2. With each change of disks, what change has taken place in the effect (a) of hue? (b) of intensity?

4. What hue would have appeared if, instead of orange with the yellow and violet, we had used green? See first if you can tell by looking at the color circle, then try the experiment beginning as in step 1 with areas of yellow and violet producing as nearly a neutral gray as possible, but decrease the yellow space by areas of green instead of orange.

5. See if you can tell as a result of these experiments and by looking at the color circle what hue will result in each case if you mix the following pairs of colors, and what the intensity will be, and why. Write out what you calculate that the results will be:

Orange and blue-violet; green and red-violet; orange and green; blue and yellow-orange; yellow-green and red.

Try them with water-colors, preparing the colors carefully for mixing, and see how near they come to what you have written down. Make several samples of mixtures of each of the first three pairs, showing them in different values and intensities in order to become thoroughly familiar with them. Compare these samples with objects the colors of which sometimes seem uncertain and difficult to match with paints; for example, stones, dead leaves, the bark of trees and twigs, bare ground, as in roadways and gardens. Collect some objects which you find to correspond in color to any of these mixtures.

6. With your samples of mixtures make and mount a series of five graded steps from (a) orange to blue-violet, (b) yellow-green to violet, (c) orange to blue-green.

Problem D.—To show in a design some of the effects which may be produced by using near-complements. Only two hues at nearly but not quite the complementary interval should be used. They may appear in mixtures of any proportions and with areas of white, black, or gray.

Fill in the pattern of a design with areas of orange-yellow, of violet, and of any mixtures of these two. Use also areas of black, white, and gray. Let the two original hues in

their full intensity occupy only small areas and be supported by the mixtures, and by black, white, and gray. In two or three other designs use other pairs of near-complements. (Plate V, following p. 22.)

Experiment VIII.—To show the effects produced by mingling balanced groups of three colors taken at equal intervals on the color circle.

1. Moisten with water a space about three or four inches long and two or three inches wide, on a piece of paper, and paint on the wet surface areas of pure red, of pure yellow, and of pure blue. These colors will run together at the edges because the paper is wet, but the spaces of yellow, red, and blue will probably dominate even though the edges where the colors have mingled show considerable orange, green, and violet. Make several of these minglings to get different arrangements and greater or less degrees of mingling.

The combination of these three colors mingled in this way are usually too crude to be beautiful, but they suggest great brilliancy, sometimes like that of full sunshine on colored objects, as on bright flowers in a garden, and again like glowing fire or sunset. Notice particularly the edges where one color blends with another. Wash over, with water, one or two of these combinations, so that part of the color is removed, and only light tones remain. No washing should be done until the colors have once dried. Select and mount one or two of the most interesting from the dark and from the light groups.

2. Choose a mingling of red, yellow, and blue, in which the hues are fairly intense, and carry a wash of strong yellow over it. Do this as lightly as possible, so as not to disturb the color underneath more than is necessary. Notice how much richer in effect the red, yellow, and blue appear through the coating of yellow, even though they are somewhat reduced in intensity. When this is dry, carry over it still another wash of yellow, so that the red, yellow, and blue of the original mingling become almost submerged in yellow. Mount a sample of this combination.

3. In the same manner mingle red, yellow, blue, and black. Notice how the black increases the glow of the colors, even though it decreases their intensity somewhat. When only one or two small spots of pure color happen to be left they will sometimes gleam like jewels or lights in contrast with the darkened colors about them. Wash one or two of these minglings so that the colors and blacks are lightened. If the colors are dulled too much, make other washes of color over the first while the paper is still wet.

4. Make with orange, green, and violet, and with orange, green, violet, and black the same kinds of minglings that have just been made with red, yellow, and blue, and black.

Place two or three of the combinations containing red, yellow, and blue beside corresponding combinations containing orange, green, and violet. Besides the plain differences in hues, do you find other differences sufficiently evident so that you can describe them? For example, do the minglings of red, yellow, and blue awaken impressions or suggest effects in nature different from those hinted at by the orange, green, and violet combinations? Are any of the suggestions or impressions which you receive from your color samples sufficiently definite so that you can give titles to any of the combinations, as if they were pictures or designs?

Compare them with colored prints, with minerals, with moths and butterflies, with textiles and pictures in the art galleries; for example, with Italian paintings of the Renaissance period and with modern impressionistic paintings. See if among this material there are some examples with which one or more of your red, yellow, and blue combinations seem to belong, and others which give an impression more like that of your orange, green, and violet combinations, even though the colors may not be exactly the same as yours in any case.

5. Make similar minglings with following groups of colors, using the colors alone and then the colors with black:

(a) R–O, Y–G, B–V.
(b) Y–O, B–G, R–V.

Compare these with the other minglings. Are they sufficiently different to be readily recognized? (Plate VI, following p. 22.)

Can you find prints or paintings, minerals, plant colors, butterflies, moths, etc., which are more like one of these combinations than like either of those previously made? Which of the four groups do you like best?

Problem E.—To show in a design some of the effects which may be produced by using triads composed of three hues selected at about equal distances from each other on the color circle. With them may be used areas of black, white, or gray.

Fill in the pattern of a design with areas of red, yellow, and blue. Let the colors in their full intensity occupy only small areas. The intensity of the hues in larger areas may be reduced by addition of gray to the colors. Another method of reducing intensities is to paint with strong color all the areas except those which are to be black, white, and gray, and then lightly wash the whole design with water. This tends to mingle all the hues slightly and thus to reduce their intensity. The hues may then be strengthened in areas where greater intensity is desired. Gray can be added to areas that are still too intense. Some of the best effects with this triad are obtained by repeated washings and repaintings.

If a rich, golden color scheme is appropriate to the design, wash the colors with yellow instead of with plain water.

Fill in a pattern with one of the other triads, handling the colors in the same way that the red, yellow, and blue were used in the previous pattern.

VI

COLOR HARMONIES

The Colors of a Design Should Be in Harmony with the Subject and with Each Other.—In order that the colors of our designs shall be harmonious we need first to select hues which are in accord with the emotional mood which we wish to declare. The decorations by Puvis de Chavannes would lose something of their impressive solemnity if painted in the sparkling colors of a Monet landscape. The Monet landscape, in turn, would lose much of its atmosphere and dancing sunlight if rendered in the subdued tones which Chavannes used in his mural decorations. The realistic colors of a painting by Sorolla could not support the devotional quality of a picture by Fra Angelico. But we have gone only part way toward producing a harmonious whole when we have picked out appropriate hues. By adjustment of proportions and of qualities we must introduce common bonds of relationship which will give to the various hues, however different they may be, a tendency to approach and combine in a single united scheme.

How shall we make these finer adjustments and convergences which will compose our colors into complete harmony? A few general suggestions can be given which will help us to bring colors together into consistent groups, and then to relate them still more closely and, consequently, more harmoniously. However, there seem to be no exact rules which we can follow with any assurance that our color effects will be fine in quality. It appears to be impossible to classify what is artistically excellent in any terms that

do not apply equally well to what is good but just falls short of being superior. We have to depend finally upon our own sensibilities to tell us when the color qualities and combinations are good. The degree of our discrimination marks the extent of our power to use colors artistically, or to enjoy them. The actual standard of our discrimination is what we really prefer. Under the influence of well-directed experimentation and of familiarity with good examples we usually find our color preferences changing from what is crude and commonplace to what is excellent in the sense that the latter gives us greater and more permanent enjoyment and satisfaction.

Artistic Preferences Have Some Points in Common with Principles of Physics and Optics.—When we try to discover why some color tones are pleasing while others are not, and why we like certain combinations of hues and dislike others, we find that the combinations with which we have experimented thus far offer some explanations. When we have related colors according to physical and optical laws, we have gone part way toward fulfilling the demands of artistic preference. For example, when we study the particular ways in which natural objects which we find to be pleasing in color, flowers, or gems, or the varied surface effects of water, absorb and reflect light, we find that if we handle our materials, our paints and textile dyes and glazes, so that they act upon light in similar ways, they are more pleasing in quality than flat tones would be. We discover, in the play of adjacent hues, or the interweaving of complementary or of neutral tones, some of the more common ways by which the restful or stimulating complexity of nature's colors are produced. We thus come into possession of some methods of making color tones agreeable.

Again when we study the combinations of hues which

result from reflection and transmission of light under different conditions, we find that the groups of colors usually vary consistently with the varying textures or densities of the materials, or angle of the illumination. Thus we can often predict from the colors of a sunset at a given moment approximately what group of hues will follow within a specified time, and what other combination will later succeed that. These groups are closely related to those with which we have already been experimenting.

These physical facts which spell consistency for the scientist, produce in us distinct æsthetic experiences, each correspondingly consistent and integral in its emotional tonality. The correspondence between the external world and the response of our own moods is probably due in part to the fact that certain color qualities and combinations are closely associated in our experience with particular aspects of nature, as the colors of springtime and autumn, and noonday and twilight. The behavior of our eyes themselves, in the processes of fatigue or relief, is also doubtless an important factor in determining our preferences for certain colors, tones, and combinations.

Thus when we are to select and harmonize the hues for a design, and to elaborate the color tones until they are of fine quality, we find that nature does give us valuable suggestions regarding the consistent grouping of hues and the refinement of their texture. But nature goes only part way in furnishing what art demands in color harmonies. We must take what is there hinted at but seldom clearly set forth, and work over it, rejecting what does not accord with our main purposes, and perfecting the rest until it satisfies our æsthetic demands. How far we can go depends upon the degree of our own experience and sensitivity. There is a curious difference between what we consider

beautiful in nature and what satisfies us in a work of art. Even nature's most complete presentations stand in need of an inward assimilation and a further adjustment before they are beautiful as art. Some of the suggestions which physics and optics can give us regarding the artistic use of colors are the following:

Mere Color Sensations as Such Are Usually Pleasing if Not Too Strong or Too Weak.—We have found that color makes it easier for us to see objects and to hold them in vision. Colored objects seem to stand in closer emotional relation to us than do objects which are neutral in tone. The added quality of color helps to attract our attention and to hold it longer. We are better able to distinguish areas when each has a different hue, as in the case of colored maps or charts. This augmented stimulation of the incoming nerves and consequent increase in the elements of perception give a degree of pleasure in themselves. Consequently a colored surface has a decided æsthetic advantage over one that is uncolored.

We have already noted some attempts which have been made to discover whether any universal preferences exist for particular colors; whether blue is generally better liked than red, or red better than green, and also to discover what color combinations are most widely pleasing. Most of these experiments deal with conditions too simple to be of noticeable value to the designer. Usually the colors presented are flat in texture, of full intensity, and in shapes that have no special interest, so that the element of mere chromatic sensation may be separated so far as possible from the other influences. Even then the preferences vary if the background against which the colors are seen is changed. Then, too, even under these elementary conditions it is doubtful if we make our choices on a basis of mere sensa-

tion, because color, which might be abstractly regarded as a sort of life without form, has been so closely related in our experience with numberless forms and situations, that when we see any specified hue, some of these innumerable associations pour in and blend their own emotional tone with that of the color as such.

Equally inadequate are the formulas as to what combinations of colors are pleasing; for example, the familiar statement that red and green go well together. They may be pleasing and again they may be a most disagreeable pair. The problem of the colorist is not one of mere hues. It is by no means as simple as that. Each hue has its endless possibilities of variety in value, intensity, and qualities of texture. Our pleasure in any combination is affected by the arrangement of the areas of the pattern, and the mutual relations of all the qualities of the hues.

Hues Need Not Be Dull to Be Pleasing and Harmonious. —Lovers of brilliant color who have the courage of their preferences, are frequently confronted with the theory that all refined colors are necessarily of greatly reduced intensity. The implication seems to be that colors must be dull in order to be "good" artistically. Of course it is true that in appropriate circumstances grays and grayed colors are beautiful. They have their own intrinsic charm. On the other hand, it is equally true that grayness may be the refuge of the inefficient colorist. Moreover, to produce a grayed color of fine quality is a complex process; it is not the result of so simple a device as mixing the color with a neutral.

Crude colors of full strength may be pleasing to some people because their eyes lack sensitiveness in perceiving hues, and consequently a tone of powerful intensity is needed to awaken any noticeable sensation. It may be that

jaded and inactive senses have something to do with futuristic color preferences. But this does not imply that strong and brilliant colors are necessarily crude, nor that a liking for splendid hues is evidence of a barbaric taste. The old theological doctrine of the total depravity of the unregenerate has been revived in much of our art teaching, so that the natural untrained preferences in the arts are frequently regarded as something to be wholly discarded in order to make an entirely new beginning. Some of these preferences, however, should be considered rather as the best starting-points for development toward a taste for what is more permanently satisfying, and as indications of the main direction which that development should take. Regarding the somewhat general attitude toward the brilliant color which educators have taken during the past few generations Leigh Hunt wrote as follows:

"And we have a favorite epithet of vituperation, *gaudy*, which we bestow upon all colors that do not suit our melancholy. It is sheer want of heart and animal spirits. . . . Reds, and yellows, and bright blues are 'gaudy'; we must have nothing but browns, and blacks, and drab-color, or stone. Earth is not of this opinion; nor the heavens either. Gardens do not think so; nor the fields, nor the skies, nor the mountains, nor dawn, nor sunset, nor light itself, which is made of colors, and holds them always ready in its crystal quiver, to shoot forth and divide into loveliness." *

Much great art has been produced with very little addition of color. Some Chinese painting of the best periods seems to have been almost without color. On the other hand, the Chinese and other nations which attained a high level of art expression have often delighted in a wealth of color, not only in small areas, as in gems and textiles, but

* *Essays and Sketches*, p. 304.

even over the large surfaces of sculpture and architecture. The buildings and sculpture of Egyptian and classical periods appear to have been overlaid with bright hues of red and blue and yellow or gold to a degree of brilliancy that we would question.

In mediæval times still greater splendor was obtained by mosaic and stained glass. Until the close of the fifteenth century the façades of the chief palaces of Venice were covered with colored marble. In addition to the magnificent wealth of hues which these provided, the sculptured ornament was frequently overlaid with thick gold-leaf, while the flat grounds were colored a deep ultra-marine in such a way as greatly to enhance the brilliancy of the gold. The decorations of St. Mark's Cathedral were elaborated until the walls were completely faced with glass mosaics in a gold ground or with colored marble and porphyry. Plain white marble was used only for sculpture, and even then was thickly covered with gold. The surfaces outside were splendid in the sun, while within, the glowing mosaics enriched the gloom. In *Stones of Venice*, volume II, paragraphs 10 to 16, John Ruskin pictures the remarkable contrast between the grayness of the impression which an English cathedral gives us when we approach it and the colorful vision that breaks upon us at the sight of St. Mark's. He describes it as "a multitude of pillars and white domes, clustered into a long low pyramid of colored light; a treasure-heap, it seems, partly of gold and partly of opal and mother-of-pearl, hollowed beneath into five great vaulted porches, ceiled with fair mosaic, and beset with sculpture of alabaster, clear as amber and delicate as ivory."

Time, through the energy of external forces, has dimmed and in many cases destroyed much of the magnificent color of the past, while other agencies have changed our prefer-

ences, or at least those which we feel free to express, until now a single gilded dome or statue in a metropolis can call forth a storm of protest. Fortunately, however, we are returning to a use of richer color schemes.

Brilliancy of color is not necessarily crude any more than is a strong volume of sound. Whether the latter is harmony or mere noise depends upon its polyphonic character rather than upon the power of its vibrations. It is not essentially less refined than more attenuated strains. If a powerful hue is flat and without quality of texture, it may be painful to our eyes. In that case it can, of course, be rendered less actively unpleasant to the eye by veiling its insistence with gray, and this is a simple process, a sort of first aid requiring no skill. On the other hand, by gradations and contrasts, reinforcements and reliefs, the skilful colorist can preserve and apparently enhance the flame and vitality of his color and at the same time make it a delightful thing upon which our eyes dwell without fatigue.

When we examine samples of nature's most brilliant and scintillating colors we usually find good examples of counterpoise and gradation of hues. Place an opal under a strong magnifying-glass. The flashes of light which seemed to occupy the whole area of the stone now appear fewer and more widely separated. Between them is an area of grayness produced by the balance of the blues and greens with the complementary flame color which comes from the depths of the stone. This grayness is not a negative neutral but the balance of the complementary radiances. As seen under the magnifying power of the glass these gray areas reveal their importance as reinforcements of the color. Moreover the brilliancy of the actual hues is enhanced by their gradation toward adjacent colors. The greens play from yellow-green into blue. The flame color varies from yellow to

rose. Even within the small areas of most flashing color
we discover gradations of hue and intensity. The flaming
blue of a polished surface of azurite is also a marvel of gra-
dation and of intricate texture.

We find then that beauty of color depends upon character
of texture and counterpoise of hues rather than upon de-
gree of intensity. These pleasure-giving qualities may
exist in tones of all degrees of intensity. Flatness and dead-
ness whether of strong or subdued tones is the sign of the
commonplace. Of peculiar insipidity are smooth ungra-
dated areas of color dulled indiscriminatingly with neutral
gray. Their harmony is rather the non-belligerency of
anæmia than the delicate adjustments of positive forces.

Naturally if each of the different areas of color in a de-
sign is intrinsically fine in quality the effect of the whole
will be more pleasing than as if each was commonplace,
even if the colors are not closely related. But if, in refining
the tones, we use for all the areas similar methods of grada-
tion or of infiltration of balancing tones, then this consis-
tency in method of treatment will of itself introduce an ele-
ment of unity into the whole effect. How brilliant any one
color in the design, or the design as a whole shall be, we
must determine by our own sensibility and discrimination.
If we are to adopt any precept in the matter, perhaps it
might well be that the hues should be made as colorful as
they may be, and yet be appropriate to the mood and pur-
pose and place of the design. There are occasions to which
grays, sombre or silvery, are suitable and completely satis-
fying. There are other times when our mood cries out for
something as powerful as the blaze of scarlet poppies in the
sunshine, viewed against a background of azure sea.

Some Lines of Experimentation in Harmonizing Colors.
—When we examine pleasing color combinations in nature

and art we find that there is no one way of satisfactorily harmonizing a group of colors. A number of influences may contribute each its part, so that while one kind of treatment may relate the hues to a certain extent, another may introduce one more element of unity, and a third may draw them still closer into concord. The setting sun may tinge with gold all the colors of a landscape. A slight haze may give them still more of common character. The lines of innumerable lengthened shadows may weave cool darks all extending in the same general direction across the scene. Each of these factors has contributed its part toward enabling the scene to produce upon the spectator a single emotional effect. Thus we see that there may be various degrees of relationship. When we become acquainted with some of the influences that are most potent in giving a pleasing unity to a combination of colors, and have experimented with each separately, we shall then come to know what each can contribute and how and when it will be useful for our purposes. After we have selected our hues to accord with the mood of the design (and these selections will in general be based upon our groups already studied, namely groups of similar colors and groups of contrasted colors which are complements or present a complementary balance, as the triads do), then we shall find that some of the factors which tend to relate them still more closely are the following:

Veiling a Group of Colors with One Tone.—A simple experiment will show how remarkably the effect of a diversified group of colors will be unified by veiling them all with a single tone. Across a sheet of white drawing paper, about nine by twelve inches in size, paint three bands of strong color. Make the upper band yellow, the middle one **blue,** and the lower one red, as indicated in Fig. 24, *A.*

Let the outlines of the bands be somewhat uneven, and let the colors merge a little, just enough to soften the edges. After these bands of color are entirely dry, draw vertical lines dividing the sheet into six areas, as in Fig. 24, *B*. Now paint over the first vertical area with a wash of red, carrying the color lightly, so as not to disturb the hues underneath. This can be done by laying the red on with a full

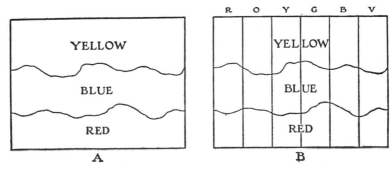

FIG. 24. Diagram for the experiment of relating three hues by veiling them with a fourth.

brush and leading the wet color down over the surface, which should be held at a slight inclination to aid the flow of the red. Over the next division carry a wash of orange, over the third a wash of yellow, and so on with green, blue, and violet, as indicated in Fig. 24, *B*. After the colors are dry, cut the sheet on the vertical lines, so that each strip shows the original yellow, blue, and red washed with some one hue. Trim these and mount them on gray or tinted paper. On comparing them we shall find that each gives some peculiar atmospheric effect. In fact, if our colors are rich and transparent, and we have adjusted the proportions in a pleasing fashion by modifying the areas of yellow, blue, and red so that the spaces of the three original colors are

not monotonously similar, we shall probably find that the effects will be fairly pleasing in their pictorial suggestions. We have a series of suggestions of sunset effects. In each strip where the overlay of hue corresponded to one of the colors underneath, one color in the final result has been greatly intensified by the double wash of that hue, while the others have been somewhat softened and at the same time changed to adjacents of the hue which has been reinforced. For example, the red wash has increased the brilliancy of the original red and has changed the yellow to orange and the blue to violet. In the cases of the three strips washed with orange, green, and violet respectively, one of the original colors is complementary to the superimposed color, and is consequently grayed. The orange wash grays its complementary blue, and changes the red and yellow to the adjacent orange-red and orange-yellow.

We can elaborate this experiment by varying the strength of the hue which we carry over the original colors. Even when it is comparatively weak it is still a unifying factor and affects perceptibly the relations of the colors. We come to realize how remarkably a group of colors in a landscape may be brought into unity by varying conditions of atmosphere. Each day has its peculiar color veil. How much unity of hue is imparted by apparently transparent mediums, to objects seen through them, becomes apparent when we look through pieces of glass which are very slightly colored, so that the hue is scarcely perceptible. We find that each gives its own effect to the scene. We can see that this difference, although slight, may still produce a definite effect if on a gray winter day, when there is little color in the landscape, we stand at some distance from a window and look at the sky or snow, as seen through different panes of ordinary glass. Usually, although the glass is

supposed to be clear, we can see quite plainly that the hues of gray vary a little with each pane of glass. Similar variation may be observed by looking at reflections in different mirrors. The contrast in tonality in different positions of a landscape may sometimes be seen when a mirror is placed so as to show a reflection of one part of a scene, set into a different portion—for instance, when a reflection of the eastern sky is seen against a western view. The mirrors near the windows in a Pullman car frequently show these contrasting tonalities of reflections from one side of the train with direct window views from the other. Comparable effects of difference may be seen in the mirror by which the driver of an automobile is enabled to see what is on the road behind his car.

This overlaying of a group of colors with some one hue is perhaps the simplest method of bringing them into closely related tonality. There are many ways of applying this principle of introducing a common tone, some of which admit of more variety in the result than where a film of a single color covers all the surface. Instead of washing one or another color over yellow, blue, and red, as in our previous experiment, let us reverse the process. Take six strips of colored paper corresponding in hue to the six pigments with which we painted over the original colors, and on each of these paint yellow, blue, and red, to correspond in pattern with those colors in our first experiment. These three colors are now related by an underlying instead of superimposed hue. Any undertone in prints or stencilled fabrics or painting or glazing exerts its unifying influence through the colors placed over it. Sometimes a color print which is crude on white paper will be pleasing and harmonious on a paper slightly colored.

The skilled worker in fabrics understands the peculiar

quality of color which results when a material which is translucent is placed over one of another color. A beginner will be surprised to see the modifications which appear when one pure colored thin material is placed over another of different but equally strong hue. Take pieces of silk showing the spectrum hues in full intensity and place over each a thin piece complementary in color, so that you have yellow over violet and violet over yellow, red over green and green over red, and so on through any number of complementaries. On comparing the combinations with the separate fabrics we find it hard to realize that the results can be secured by these means.

Instead of overlaying or underlaying a group of colors with an extended area of a single hue, in a textile pattern we can weave in threads of some one hue so that lines or gleams of it, recurring throughout the pattern, will give unity. In a painting a tonality can be effected by brush strokes throughout of some one tone. We can also relate a group of colors by introducing into each some hints of the others. In a pattern of blue and orange some interweaving of threads of blue with the orange, and of orange with the blue will often give them a highly pleasing unity. When colors show strong contrasts in hue, introducing into each the two hues which are adjacent to it in the spectrum will frequently give them a charming relationship. In a pattern of rose and blue an introduction into the red of its adjacents orange and violet, and into the blue of its adjacents green and violet, will give to each the common adjacent, violet. This method is especially effective in the case of hues which are members of the same triad or group of three balanced colors, because any two of these colors will have one adjacent in common. When we mingle each with its adjacents, two changes occur: first, each color is

softened and enriched, and secondly, there appears in each, one hue which occurs in the others. This method of relating colors gives excellent effects in painting where, as in luminist pictures, the colors are broken into their adjacents and painted by means of small dots or brush strokes, or in weaving, where threads of various colors furnish the opportunity for introducing into each of two colors the hue adjacent and thus common to each.

Harmonizing Effect of Reflections and Induced Hues.— The colors of a group of objects in nature tend to mingle and thus to relate their hues because of the reflections which they cast one upon another. Each adds something of its own hue to its neighbor, as when children in the country hold buttercups under the chins of their playmates to see if they like butter. A highly colored vehicle moving along a sunlit street will invest everything opposite its illuminated side—houses, costumes, and faces—with a veil of its own complexion as it passes. A red wall in the sunlight sheds a rosy hue over everything near it. The blue of the sky is reflected not only from the surface of water but also from ground and foliage. Smooth, oiled roads as they stretch away under a clear sky are only a little less blue and purple than rivers.

Sir Alfred East's book on *Landscape Painting* contains a chapter on reflections which is full of the observations of a close student of nature. Among his statements are the following:

"The reflection of sunlit grass on the under parts of a white cow, combined with that of the sky on its back, is a puzzling thing in paint; but it is far worthier your brush than the exercise of painting the cow in the shadow of a fold-yard, uncomplicated by reflected lights. . . . Note the reflection of the grass upon the trunks of trees near the

ground. By painting this reflection you will at once get
rid of the hardness which most amateurs betray.

"Do what Corot did. Walk round your tree and ex-
amine it narrowly, and learn to know it thoroughly before
attempting to paint it. Note that not only is the color of
the trunk altered by reflected light, but every leaf, while
always in color in sympathy with the sky, reflects light and
color according to its surfaces. For example, leaves with
an absorbent surface, as the elm, do not reflect the sky as
brightly as those with a smoother surface. And always
remember that the color of a tree is built up by the aggre-
gate of the color of its leaves. You will have noticed how
within the shadow of a white-washed wall across a sun lit
street, there gleams the reflection of the shining road.
The light is reflected and re-reflected like an echo. . . .
Upon the same factor of sky reflection depends the just
modelling of a tree and its branches, and you should not
set out to reproduce foliage before you have conscientiously
studied the action of reflected light. . . . It vivifies your
subject, and gives a soul to your picture. It should always
manifest its presence. It is easily forgotten in the studio,
but not so readily when one faces Nature." *

The designer and decorator as well as the painter find that
this dispersion of hues by reflection is an important factor
in bringing the various colors of their schemes into harmony.
Under certain conditions the effect of reflections is sufficient
to harmonize the violently contrasting hues. Paint a fairly
large surface with a strong color and another surface of
equal area with the complementary color. Place them face
to face and then separate them slightly at one end as you
would open the covers of a book. Hold them so that the
light shines into the opening and see how the reflections of
the two surfaces upon each other almost neutralize the
colors in some areas. Vary the width of the opening and

* *Landscape Painting*, pp. 77 and 82. J. B. Lippincott Co., American pub-
lishers.

the angle of the light and its intensity, from full sunshine to low illumination, and note the wide range of effects of one surface upon the other.

Try a similar experiment with two surfaces painted with the same hue and see how the colors are now intensified as each by its reflection reinforces the other. This is shown in striking fashion if we paint each surface with white into which a very slight proportion of color has been mixed. If the surfaces are quite large, fifteen or twenty inches square, the amount of color added to the white may be almost imperceptible and still show in the reflections. For instance, if the added color is blue, the light reflected many times back and forth will become a fairly deep blue. Further experiments with various colors will show us how by reflections the hue of one surface may be made to merge gradually into that of another placed at an angle to it, and thus avoid what might be a disagreeable contrast. What is seen in the case of the flat surfaces just described occurs in more subtle fashion in the case of rounded objects like most of those in nature. In the folds of draperies it is evident. Even when very highly colored surfaces, such as those of the spherical glass baubles used to ornament Christmas-trees, are placed together, the reflections of any two that happen to touch mingle their colors near the points of contact and thus give elements in common. These form areas of transition from one hue to the other.

By taking advantage of this echoing of colors we can see how some seemingly irreconcilable combinations may be rendered pleasing. A low, well-lighted room may even have a blue ceiling, white walls, and a red-orange floor covering, so arranged that the reciprocal reflections of floor and ceiling bring the two into harmony and make each much less assertive than it would be alone, while the white

walls, over which play the dispersed hues of both colors, form a connection between the two.

We are all accustomed to notice reflections in water because there the facts are too apparent to escape our attention. When water is still, not only the colors but the forms of the reflected objects are seen. This repetition of both form and color lends a decorative character to the effect. How elusive and shifting these effects are, becomes apparent when we focus our vision alternately upon the reflections in the water and upon a bubble or ripple upon the surface in the midst of the reflections. When we look at either, the other usually becomes much less evident.

Uneven surfaces may repeat forms as well as colors, so that upon wet streets we see distorted mimicry of actual objects. These erratic and whimsical patterns do not repeat exactly the shapes which they reflect, yet hint at them sufficiently so that we readily recognize them. They introduce a caricatured iteration which often imparts a unity, delightful in its variation from the uniformity of complete repetition.

Probably the fact that polished surfaces reflect form, attracts our attention more than the fact that they also reflect color. We notice the color when it is unusually prominent, but the images reproduced exactly or in distorted form seem to make the strongest appeal. Consequently we are less likely to see the reflections of colors which come from surfaces too uneven to repeat forms, but which nevertheless do show in a marked degree the veils of hues from surrounding objects. Thus the process for harmonizing a group of colors, which was previously described, namely, by adding to each color in the combination something in common with one or more of the others, corresponds exactly to what is always going on in nature. Because of reflec-

tions, colors are echoed and re-echoed from one surface to another until the rays are mingled and the tones brought into sympathy. The color of each thing in a group of many-hued objects appears quite different and much more complex than when the object is taken out of the range of reflections from its neighbors, and away from the consequent interplay of colors.

The Influence of Complementary After-Images.—Under some circumstances, after-images help to relate colors. When one hue in a combination is stronger than any of the others, then its after-image tends to give to the whole area a tone slightly complementary to the dominant hue. If the strong color is in gray surroundings, the after-image is apparent and gives a tinge of complementary color to the gray. If the surroundings have hues of low intensity, the after-image of the strong color tends to unify them. In a combination of intense colors under high illumination, the after-images sometimes heighten adjoining colors so as to make the effect restless and unpleasant. Even then, however, they add a certain complexity and vibration which help to take away the monotony of flat hues. After-images appear like transparent screens of color overlaying and mingling with the hues underneath. Actually, however, they are probably subtractions or neutralizations of portions of the rays, due to fatigue of portions of the retina, and not additions as at first they seem to be. These after-images tend to promote a complementary relationship in the effect which any group of colors produces upon us.

The Character of the Pattern of a Design Affects the Relations of the Colors.—Big, bold patterns tend to emphasize the hues of a design. In a finely divided and intricate pattern, on the contrary, the small areas of color, even though they are brilliant, seem to mingle and thus to

lose their individual assertiveness. Colors which are complementary offer the greatest possible optical contrast. When one field of full color in a bold pattern comes abruptly against another which is complementary to it, the hue of each seems to spill over into the other. There is a restless chromatic flutter along the border which is often distressing. We may see this if we place our blue disk so as to cover half of the orange disk and then look along the edge between the two colors. In a design of minute areas these same colors appear to mingle and thus to neutralize rather than to intensify each other. Even in a design of large pattern, however, it is surprising to note how the competition of hues may be decreased by separating the colors with a border of neutral around each area. This lessens the rivalry of the tones and strengthens their relationship and at the same time enriches the design. The broad neutral lines produced by the leading of stained-glass windows accomplish this result, and so also does the outline of white and of black which the Egyptians used around their brilliant colors. Even in complicated patterns of small areas the interlining with neutral appears to increase the mutual affinity of the colors. These colorless portions become playgrounds for the after-images and also, where conditions allow, for the reflection of the different colors.

In a broad simple pattern we can secure variety without competition, even in complementary colors, by subduing the intensity of one of the hues, as in the case of a representation of a golden moon in a dark, gray-blue sky. If both the yellow-orange of the moon and the blue of the sky were of full intensity, the effect of their competition might be unpleasant. What is true of the relation of the scale of the pattern to the brilliancy of complementary colors that may be used to advantage in it is also true of almost any

group of colors. Intense tones and strongly contrasting colors are usually most pleasing in designs of small area, and even there appear richer when there is an interplay of neutrals, as in the case of the opals previously mentioned.

An interesting correlation exists between the character of lines in a design and the quality of colors that should be used. Fig. 25 shows two patterns of trees against a twilight sky. The linear character of one is quite different

FIG. 25. Particular arrangements of line frequently suggest appropriate color schemes.

from that of the other. Have in mind two schemes of sunset color, one rich and glowing with gorgeous hues, the other cool and quiet. Look for a moment at *A* and then at *B*. Does the character of line in each seem to you to ally itself with one of these schemes of color more than with the other?

It is probable that each type of line structure in a design hints at an appropriate combination of hues, and that the color suggestions of a pattern of sharply acute angles will differ from those of a rectangular pattern. These in turn will be unlike those called for by a web of full round curves or by one of delicately modulated sweeps of line. While the purpose and position of objects and the materials used probably offer the most definite suggestions regarding suita-

ble colors, yet when other conditions are equal there appears
to be, in addition, some correspondence between the purely
lineal character of a design and the qualities of certain
colors. Our experiments have not gone far enough to allow
us to say how specific these correspondences are. We find
some general correlations however. For example, in Fig.
25 the majority of people associate a cool scheme of color
with *A* and a warm one with *B*, and think that gorgeous
hues go better with *B* than with *A*.

**The Values of the Colors in a Combination Affect the
Harmony of Their Relations.**—In the chapter on Values and
Intensities we discussed the artistic importance of the
middle value of gray as the place where the eye most readily
comes to rest, and also as the tone which all values and
colors tend more or less to approach as they pass away from
the centre of our vision or as the eye becomes fatigued by
looking steadily at them.

Look at the color circle and you will see that brilliant
yellow is in its value nearest of all colors to white, while
violet is nearest to black. If we wish a yellow or a violet
of middle value we must darken one or lighten the other,
and thus reduce the intensity of each. It is impossible to
have a violet or yellow at middle value and yet of full in-
tensity. In fact the only two hues which can be in full
strength at middle value are blue-green and orange-red.
All other hues lose some of their strength when we bring
them to that level.

Usually if the colors of any group have all been brought
to middle value, the point of brightness which our eyes find
to be most restful, they are thereby sufficiently related so
as not to be strikingly inharmonious. If their intensities
as well as their values are equalized, so that all are of equal
value and of the same intensity, they are usually pleasing;

so that when we outline a design or picture, and then fill in the areas with different colors, all of middle value and of the same intensity, the result will seldom be actively disagreeable.

We can, however, preserve a balance of light and dark if, instead of having our colors all on middle value, we modify them so that some are as far above the middle point as the others are below. If we use red and blue, each at its spectrum value and fairly intense, they seldom look well together. But if we make the red as much lighter than middle as the blue is darker, the effect is much more pleasing and is frequently used with good results in costumes. The light red or orange-red of coral against dark blue is a far more agreeable combination than would result if the red was as dark as the blue. Similarly three colors may be balanced simply by putting one at middle value and the others, one above and the other at an equal interval below middle.*

These are instances of very simple types of balanced values. There are, of course, endless possibilities with which we may experiment and which become so complicated that we have to trust to trained judgment rather than to mathematical calculation. However, the evident balance of a few values is generally most effective and should form the foundation for even the most elaborate combination. These simpler balances of value are of much practical use when only one or two colors are to be used with black and white or with gray. In printing with black ink on white paper, if one color is needed for an initial or ornament, any hue which is at middle value, and thus half-way between the black ink and the white paper,

* For a discussion of tone-balance, see Denman W. Ross, *A Theory of Pure Design*, pp. 158–181.

produces a balance of values and looks well. If a color not at middle value but at full intensity, for example a pure yellow or blue, is used in a piece of printing, the color in most instances does not seem at all harmonious but is unpleasantly assertive. It appears to flutter restlessly in a plane different from that of the black and white, as if it was suspended at a slight distance in front of them. However, if the yellow is darkened or the blue lightened to middle value, each then looks better with the black and white. This more pleasing effect is not wholly due to the change in intensity which occurs automatically when the values of these colors are changed, because, if by adding gray we make a corresponding change in intensity without altering the value of either color, the resulting tone is not so pleasing with black and white as when the value is changed to the middle point. We have seen that red-orange and blue-green occur in the spectrum at full intensity at about middle value. They are therefore generally agreeable when used even at full intensity with black and white. Perhaps it is for this reason that red-orange, which corresponds closely to vermilion, has always been a favorite with manuscript illuminators and with printers, when only one color was desired with black and white. Where black is the active factor in the design and white merely the background, as in printing, red-orange is much more commonly used than blue-green, although theoretically each should be equally pleasing. As an ornament for white, however, blue-green is common. The blinds of a white house are generally blue-green, and the color trimmings on very light stone buildings are frequently the blue-green of the hue of oxidized copper. Either red-orange or blue-green tiles are common on the roofs of cement or light-stone structures, which in the sunshine are approximately white.

Works of Art Give Us the Most Important Examples of Color Harmony.—Naturally we find the most complete illustrations of color harmony in works of art. Familiarity with these educates our eyes as good music does our ears, and develops our discrimination and enjoyment beyond what can be gained in any other way. Works of art show us in perfected form what we are striving to attain in our experiments with color, and thus give a new meaning to our more or less crude results. The combinations of color in nature are often beautiful but are complicated with other interests, and the harmonies, although highly suggestive, are seldom set forth as clearly as in art. The designer works over into artistic form the suggestions which nature presents, somewhat as the writer works over into literary form what life about him hints at.

Fortunately, excellent museums of art are being established throughout the country. Mere familiarity with these collections has undoubted value but will seldom carry us far in discrimination of color harmony. Just to look at a beautiful textile may give better ideas of color harmony than we would possess if we had not seen it. When, however, we copy the hues so as to study intimately the relations of tones, when we try to reproduce from memory an especially pleasing combination, and then compare our results with the original, and try again, just as we practise chords in music until we master them, then we make definite advance in discrimination and enjoyment. By comparing the combinations of hues in a piece of pottery or a textile or a painting with corresponding hues elsewhere, its blues and reds and yellows with blues and reds and yellows which we have made, we see new qualities of tone relations. When we place a finder over a painting so as to isolate portions of its surface, we can then see how the

hues in these portions are related to those of the rest of the picture.

Where important collections of art are not available we may nevertheless find good color harmonies. Color in printing and in other arts is continually improving. If we are looking for it we can collect much excellent material from inexpensive sources. We can select the best from art magazines and from the better grade of publications not dealing primarily with art. Advertising is now becoming a fine art, and much that is good can be found in that field. We can save pleasing combinations of various materials, and in time have a collection of color schemes which will increase our enjoyment and be of practical use.

Color Harmonies in Nature.—Next to art, nature is the most important source of color harmonies, a source that is available for us all and that gives us endless and delightful combinations of hues and qualities of textures. Among plants we find a range from the most brilliant hues to the most delicate and subdued. One of the most profitable ways of analyzing color combinations in nature is to make records of all the hues which we can find in a given instance. These records may be kept at first by means of slips of colored paper cut from the sample book. When we have gained some skill in using water-colors we can make our records with pigments. This method is likely to give us a more intimate acquaintance with the colors because when we actually mix them we see what factors enter into the result. In the case of a color which proves to be difficult to reproduce we can cover a considerable surface with some hue which approximates the hue of the flower, and into this float touches of paint here and there experimentally. Then select and cut out the portion that has most of the character of the flower color.

As we examine a plant we find the differences between the upper and under side of the leaf, between stems and veins, between young leaves and old. We note the color variations in the several parts of a flower. We discover unexpected hues in flowers which we thought we knew thoroughly. After we have matched these with slips cut from the sample book or with paints, we generally find that each plant has furnished us with a long range of tones. If we do not wish to use them all, we can select a few which please us most. (Fig. 26.)

An Oriental poppy will give us a gorgeous scheme. The scarlet of the petals will be balanced by the range of greens from the leaves and stem. Other very dark hues which enrich the combination will be found in the flower. A spray of apple bloom furnishes a delicate group of colors which contrast pleasantly with the dark brown of the bark of the stem. In a twig of pine we have a series of rich browns, with yellowish greens and ochres where the stem is cut across, and other greens in the needles. Quiet and subdued but pleasing tones are found in the lichens, occasionally enlivened with a spot of vermilion or blue-green, or some other bright color. In addition to the color combinations found in plants, there are those furnished by insects, especially moths and butterflies, by birds and by minerals. A collection of analyses of nature's colors, with the hues of each specimen indicated by strips of colored paper or by notes made with paints, gives us new understanding and enjoyment of color qualities and combinations. If we are designers, a collection of this kind furnishes us with valuable material for practical use.

Correcting Inharmonious Combinations.—One of the best tests of our knowledge of colors and how to use them comes when we try to harmonize a given group of colors

which are not pleasing. We should do this intelligently and not by hit-or-miss methods. Take any group of inharmonious colors and study it in the light of one after another of our experiments, in order to see how the hues may be more pleasingly related. It may be that they are already so near to a harmonious adjustment that slightly veiling them all with some one tone, or weaving touches or threads of some one tone here and there among the colors, will be sufficient to bring them into concord. This is, of course, the simplest method and a valuable one, but it is too simple to be sufficient for all cases. If we know only this process, our effects will often be monotonous. Where the contrast between the colors in our group is great, the overlay in order to be strong enough to relate them, will almost obscure some tones which should show, and will make the result too much an affair of one color.

Instead of beginning by introducing a single tone over the whole, analyze the given colors to see whether they ally themselves to any one of the groups which we have studied. Are the more prominent colors complements or nearly complementary? Then we will modify all the hues but the two complements. We can do this by greatly reducing their intensity until they do not compete with the complements, or we can make them adjacent to one or the other of the two complements. This can be done in most cases with only a slight change in the hues of the colors which we are modifying, although we may often have to reduce their intensity considerably. On the other hand, perhaps the combination suggests a group of adjacent hues, or adjacent hues with a touch of the complement of the central color in the adjacent group. We can then subordinate all other hues to the central one. That is, if they range from orange, through yellow to green, we can subor-

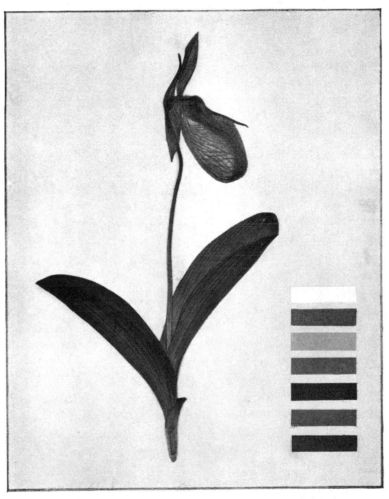

FIG. 26. Method of arranging color schemes of plants.

dinate all to the yellow by reduction of intensity. Again, we may find that the hues lie within the general range of one of the triads. We can then make this relationship more definite. Usually, any given combination of colors will ally itself to one or another of these groups. If this is not the case, and the colors seem wholly accidental, breaking each by playing into it touches of its adjacents will generally bring about some relationship, because one adjacent is pretty sure to be common to two or more hues.

It is surprising to see how few changes of actual hue are necessary to change a wholly accidental group of colors into one which is consistent, in so far as laws of physics and optics are concerned. After we have, in one or another of these ways, brought this type of consistency into a group of colors, then it is a matter of experimenting with qualities and textures and intensities, just as we have to do with any group of colors, even those most definitely related.

When a group of people take as a problem the same combination of inharmonious colors and work out ways of harmonizing the hues with the least possible change from the original, a comparison of results will show how slight an adjustment frequently suffices and how much range there is for individual taste in the final perfection of qualities of surface and texture, even when all are using the same medium.

We will do well to avoid mere thoughtless muddling when we start in to harmonize a group of colors, if we wish to have any intelligent knowledge of how to proceed. Of course, experimental play with colors helps us to understand their behavior, and we do happen upon interesting qualities and combinations at which we should not arrive by intention. The artist frequently finds, even upon his scraped palette, bits of color textures which give him valu-

able suggestions. However, the student of color should add to this accidental kind of experience a clearly reasoned method. A good way to make certain that we are proceeding intelligently is actually to note down, first, the group to which the given combination most nearly accords, because sometimes there is a choice between two groups, and, secondly, to state in detail in what way we will modify each color in the pattern. For problems of this type it is better at first to have examples where the color areas consist of a well-defined pattern, than to attempt to analyze a subject where the colors shade into one another and where the tones are uncertain because of the play of light and shade. After the first analysis is clearly made, and its results worked out, then we can with profit experiment with the nicer adjustments of color qualities which cannot be stated so definitely in words.

QUESTIONS

1. What is the first consideration in selecting colors for a design?

2. What help may principles of physics and optics give?

3. What are some of the qualities which may tend to make an intense hue artistically pleasing?

4. Describe some ways of relating a miscellaneous group of colors and thus rendering them more harmonious.

5. How can the following factors help to harmonize a group of hues: (a) reflections? (b) after-images?

6. What relations exist between the character of lines and spaces in a pattern, and the colors that may appropriately be used with it?

7. What can a proper arrangement of values contribute toward harmonizing colors?

8. How may the hues of an inharmonious color combination be more closely related?

9. What reason is there for not always using, in pictures of nature, the colors just as they appear in the actual scene?

EXPERIMENTS

Experiment IX.—To show how the addition of a common tone to all the colors of any combination relates the hues more closely and therefore more harmoniously. Very simple broad patterns will show the results and avoid the time-consuming difficulties of complicated designs.

1. Work out the experiment indicated in Fig. 24, p. 209.

2. Choose any three colors, and, using each in full intensity, paint two copies of a simple design so that the color patterns are alike in each. When one has thoroughly dried, carry over it a wash of gray sufficiently strong to veil the colors somewhat. Compare the two designs and see how the gray subdues the colors and gives them a common tone which in most cases renders them more harmonious.

3. Choose any two colors that are complementary, and, using each in full intensity, paint two copies of a given design so that the color patterns are alike in each. When one of these colors is dry, carry over the whole pattern a wash of one of the colors used. If one of the colors covered a smaller area in the design than the other, use this color for the second wash. Compare the two designs and see how one of the colors has been intensified and the other subdued, and also how they have been related by a common tone. Compare these also with colored prints, with natural objects, and with textiles, pottery, and other designs in the art museum. Do you find combinations of colors similar to yours?

4. Color three copies of a given design with red, yellow, and blue, so that the color patterns are the same in all. Use each color in full intensity. When two of these designs are dry, carry over them a wash of yellow. When one of these has dried, carry over it a wash of gray. Compare the three and see if each additional process has related the colors more closely.

Make color patterns in a similar way, using orange, green, and violet instead of red, yellow, and blue.

Compare the results of these combinations with natural objects, with textiles, prints, and pottery, and with pic-

tures in art galleries. Do you find any combinations of three colors which are similar in effect to yours?

5. Choose any two colors from the following group of three: red, yellow, and blue. Color a design with these, using each in full intensity. The design should not be cut up into many small areas, or the next step will be somewhat difficult. Color another copy of this design so that the color pattern corresponds to the first but differs from it in that each of the colors is used, not alone, but mingled with the colors adjacent to it in the spectrum. For example, if you used red in the first design, in the second you will use red mingled with orange and violet. Yellow will be mingled with orange and green, blue with green and violet. In trying not to have the colors too thoroughly mixed, you may get an unpleasant spotty effect, so that the colors will have to be washed lightly and then painted over again to strengthen them. Finally, however, you will probably be able to produce tones in which the three colors making up each combination are evident but not enough so to be spotty.

Compare the two designs. Which is the more pleasing? What color appears in both combinations and thus helps to relate them? Can you see similar effects in natural objects or in works of art?

6. Any group of colors will be related to some extent and tend to look well together if all are at middle value.

(a) Color a design with any three hues in full intensity. Color a copy of this design with the same hues, but all at middle value, that is, so that they are no lighter or darker than a gray half-way between black and white, but are as intense as may be at that value. Compare the two designs to see which is the more pleasing. When colors darker than the middle value are raised to that value. they are generally more pleasing if they are slightly grayed with a neutral or complementary, so as to avoid an appearance of thinness or dilution.

(b) Select two copies of a design which is to be mainly in black and white, but which will have a small area of color; as, for example, a piece of printing in black on white

paper, with an initial or ornament which is to have some color. Paint one a bright yellow or blue or red; paint the other with a yellow or red or blue which is at middle value. Which is more pleasing? Collect examples of printing which are mostly in black and white, but which have in each case a letter or word or small ornament in one color. Select those where the color tone is most pleasing and see how many of these tones are at middle value. Can any hues be at middle value and still be at fullest intensity? What are they? Do you find them used frequently in printing where only a little color is used with black and white?

Experiment X.—Analysis of color combinations in nature for use in design.

Select a flower and make notes with water-color of all the colors which you can find. Notice the differences between the colors of the upper and the under sides of petals, the various tones in the stem, etc. Cut out small strips from the samples you have made and arrange them in a pleasing order and mount them on a sheet of paper. Make a note of the name of the flower in which these colors were found. Clippings from your color sample book can also be used for this purpose. (See Fig. 26, facing p. 226.)

Select another plant form which does not seem to have many colors, as, for example, a weed without bright blossoms or a twig from a tree. Match the colors found in the weed, including those where the stem joins the root, or the colors of the twig including the bark and the color of the wood which shows at the place where the twig was cut off. Arrange and mount these.

Make a collection of color schemes from various sources; for example, from vegetables, stones, lichens, pieces of wood, butterflies, moths, etc.

PROBLEM

Problem F.—Choose two or three of the schemes which you like best of those which you made by matching colors of natural objects, and use each of them in coloring a design to

be used in connection with household art, poster-making, tiles, etc. Compare these schemes with color combinations in prints, textiles, costumes, pictures, pottery, and other designs. Do you find any which resemble yours?

VII

COLOR IN NATURE AND ART

Throughout the preceding chapters we have referred continually to the colors of nature and of art. This chapter gathers up a few supplementary suggestions to aid us a little further in seeing color in nature and in understanding some of the methods of using color in art.

The Colors of Nature.—As soon as we make any systematic study of nature's colors, they reward us with continual surprises as to their qualities, delicacies, intensities, and their finely balanced combinations. Sometimes all things seem to be to us as Kipling describes them, "not of one hue, but a thousand." Again they appear not as many-hued but as of one or two hues played upon by a thousand changes of value and of saturation.

When we analyze the groups of colors which any object in nature shows us, we usually find that the various hues are closely related, and therefore harmonious. Frequently we find that through all the apparent hues which an object displays, some single coloring matter predominates, so that this one color communicates its quality throughout. Again two pigments by their complex interweavings and variations may give an appearance as of many hues when only the two are present in any appreciable quantity. In fact, we find that in most cases the apparent diversity of hues in natural objects is based upon a very limited number of factors. An examination of the colors of a few natural forms will illustrate this.

The Colors of Plants.—The colors which occur in plant forms, the hues of flowers and foliage, have always been a

source of pleasure. They are an important factor in our delight in wild nature and in the beauty of gardens. The fact that when we examine the hues of any particular kind of plant we find that it has its own characteristic color scheme, and that the colors in any particular plant usually form a harmonious group, has made the realm of plant forms of particular interest to designers.

When we investigate the material causes for the harmonious relations of the colors in a plant, we find that it is largely because in any one plant the pigments which produce its colors are few. Now, when color combinations are produced by the use of a very limited number of hues, the results are likely to be harmonious, because the common factors which are present throughout tend to relate them closely. For example, if we are matching the colors of a pink moccasin flower or "lady's slipper," we find the hue of the flower to be red, and that of the leaf green, while that of the bracts is a brownish hue. If we attempt to match this brown with colors selected at random without regard to the pigments which we would use in painting the flower and leaf, we can approximate it, but it is not likely to harmonize so well with the other hues as the color of the bracts on the plant does. If, now, we mix the green of the leaf with the red of the flower we can produce a brown like that of the bracts, and since it is actually composed of the colors of the leaf and flower, it is closely related to each, and makes a peculiarly pleasing intermediate step. The coloring matter of the flower and that of the leaf mingle in the bract and produce the third hue.

The color schemes of many flowers are similar to what would appear in a painting if the chief hues were produced by only two pigments and their mixtures in varying proportions, and then the results slightly modified to produce

some vibration. In a large number of wild flowering plants, the two colors which constitute the chief hues of the combination are either yellow and green, or blue- or red-violet and green, with frequently a little spot of yellow in the midst of the violet. The various colors of flowers and foliage and fruits appear to result largely from the presence of three groups of color-producing matter. One of these groups is normally purple, but varies toward the colors adjacent to purple in the color circle; namely, red and blue. These variations depend upon certain chemical conditions. To another group are due the greens and bluish and yellowish greens, which are the ordinary colors of leaves in the summer. To a third group are due the yellows. The infinite variations of plant colors appear to result from chemical variations of these three groups of color-producing matter, or to their presence together, as in a pigment mixture.

The first of these groups of color-producing matter is known as the anthocyans, a word which may be translated as "flower-blues." This group appears to be the cause of the innumerable hues of blue and purple and nearly all the reds which we see in flowers, fruits, leaves, stems, and roots. These pigments are in solution in the cell sap. In their free state the anthocyans are purple. When brought in contact with an acid they tend toward red. When affected by an alkali they tend toward blue. Sometimes a plant containing anthocyans loses one of the chief factors which produce this coloring matter but retains the others. In this case it may be an albino, or white. Occasionally one of these white-flowered strains may be crossed with another which contains the factor which the first lacks, but is itself white because it lacks the other element which the first contains. Then the result of the crossing is likely to be a purple-flowering plant.

The plant colors on the opposite side of the color circle, which comprise the greens and bluish and yellowish greens, appear to be largely due to chlorophyl, a word which means "leaf-green." The yellows are produced in large part by other pigments, prominent among which is xanthein, which means yellow. The chlorophyls and some of the yellow pigments are termed plastids. The flower-blues are soluble and flow freely in the sap, but the plastid pigments appear to be in some way bound up with the structure of the plant tissues and not to be in solution in the sap. The anthocyan or flower-blue pigments, and the chlorophyl or leaf-green pigments are curiously in contrast. The hues of one are on the side of the spectrum circle opposite to that where the hues of the other occur. Therefore they tend to be complementary in color. Where one appears, the other tends to be absent. In leaves where chlorophyl is most abundant, the blue, red, and purple of anthocyanin are less common than in any other part of the plant.

In matured flowers the green of chlorophyl is least common. Therefore, green flowers are rare. In flower-buds, however, and in unripe fruits, chlorophyl is abundant. As these mature, chlorophyl disappears and the red coloring matter develops. On the other hand, in young leaf-buds, the red and purple are more common than in the mature leaf. Any condition that prevents the materials which the leaves produce from being conducted away increases the amount of anthocyanin. This occurs when a leaf stem is wounded or when the connection of the leaf with the stem loosens, as in the autumn. Anthocyanin is more abundant in stems than in leaves, and more common on the under than on the upper sides of leaves. Therefore, most leaves are redder on the under than on the upper side. Some are merely grayer, because the red or purple coloring matter,

approximately complementary to the green, reduces its intensity and produces a gray-green. We notice this when a strong wind blows and we see the tree become a silvery gray as the under sides of the leaves are turned toward us. The under sides of the leaves of many water-plants are of a fairly intense reddish or purplish hue, while the upper sides may be at the same time a glossy green.*

The color combinations of individual plants are likely to be closely related, and therefore harmonious, because generally only two of these three-color groups are prominent. The third, if present, usually, although not always, is subordinate. Consequently we have plants like the dandelion, goldenrod, and buttercup, with practically only two forms of coloring matter, showing yellow flowers and green leaves, or plants like the ordinary red rose, where three colors are present, but only two are prominent; namely, red and green. The yellow is subordinate, appearing chiefly in the stamens. The red of the petals and the green of the leaves are closely related in hue because the red appears infiltrated into the green. This mingling may be seen especially on the under side of the foliage; there the stems and midribs are frequently almost as red as the petals themselves, and the green of the under side of the leaf is grayed, much as it would be if the green of the upper side was mixed with a little of the red of the petals. In fact a remarkably large proportion of the various hues in a given plant can be produced by mixtures in different proportions of the hue of the flower with the hue of the leaf. Match with your watercolors the red of a rose and the green of the upper side of the leaf; then mix a little of the red with this green and see how nearly the result matches the under side of the leaf.

* See M. Wheldale, " Colours and Pigments of Flowers with Special Reference to Genetics," *Proceedings of the Royal Society of London,* Series B. 81, 1909.

In the wild flowering dogwood, an area of red-violet occurs in the large white bracts. Three slightly colored grays usually appear, one in the stem of the flower, one in the growth immediately below it, and one in the older growth still nearer the main branch. These three are distinctly different in color, but the hue of each can be pretty nearly produced by mixing the red-violet of the "flower" with the green of the leaf, using different proportions in each mixture. The close relation between the color of flowers and that of foliage and stems in the same plant is seen when we examine in detail the various parts, and experiment by mixing with paints the hues of flowers and foliage in different proportions. Some plants with purple flowers, for example the fireweed or great willow-herb, appear as if the color of the petals had soaked down and saturated stems and leaves nearest the flowers, and had only gradually given way to green as the distance from the flowers increased. A comparison of the leaves of yellow-flowering plants with those where the inflorescence is blue or purple frequently shows a marked difference in the hues of the greens. For example, compare the leaves of yellow iris with those of purple iris.

The green of vegetation reflects a very wide range of hues. If we try to match the green of a leaf with paints we can easily produce a hue which looks very like that of the leaf. If we analyze the color of the resulting pigment, there is seldom any red in it, while in green leaves the spectroscope shows that the extreme red rays and also a large number of yellow rays are present. If the leaf and the green paint which appeared to match it are exposed in a red light, the leaf will reflect the light and appear reddish, while the pigment, being unable to reflect red light, appears almost colorless. We are familiar with the great richness

of the color of foliage when seen in the reddish light of the setting sun. If we stand facing a mass of luxuriant green oak leaves against which the sun is shining from directly back of us, the leaves assume a gleaming red and yellow together with the green, a combination which the painter finds considerable difficulty in representing. When full sunlight of noon is shining through foliage, the wide range of transmitted and reflected rays gives a gamut of color extending from red, through yellow and green, to blue and even violet. The rays of sunset striking into a forest are reflected in hues of rose and gold as well as of green.

There is also the indeterminate quality of the "black" of heavy foliage seen against a glowing evening sky. Try to represent it with black paint and see how lifeless it appears. Then try a mingling of alizarin crimson and green, and note how these lose their identity but retain a glow which is lacking in the black. Try again with a mingling of pure vermilion and prussian blue, with possibly a little raw sienna. These also produce a luminous "black" in which the gold of twilight is felt.

Each kind of plant has not only its group of harmoniously related colors, but also its own texture of surface which, as we have already discovered, modifies the quality of its color. Compare the red of a rose petal with that of a poppy, a nasturtium, a geranium, or a hollyhock, and see how, even when the hues are practically alike, the quality of the color varies with the texture of the surface. Even in white flowers the quality of white varies greatly; for example, the white of a white geranium differs from that of an Easter lily. The white of the Easter lily is unlike that of a white poppy or a water-lily. We see this difference in fabrics, and usually find difficulty in matching a silk with a velvet. The distinctive textures of natural substances tend toward

harmonizing their colors, because each surface quality goes far toward imparting a particular tonality to all the hues. Thus the texture of the wing scales of a butterfly, or of bird feathers, the cellular structure of flower and leaf forms, the vaporous quality of clouds, the fretted surface of rippled water, each imparts to the colors it reflects to the eye a distinctive quality. This would of itself relate any group of colors somewhat, even if as flat hues they were inharmonious.

Colors of Animal Forms.—The groups of colors found on fish, shells, butterflies, moths, beetles, birds, and mammals give combinations different in character from those of plants, and more frequently arranged in marked patterns, where contrasts of color with grays or blacks or whites or other hues greatly enchance the effects. The remarkable richness of effect produced by patterns and contrasts with only very slight variations of actual hue is seen in the polyphemus moth or the antiopa butterfly, as well as in a multitude of other instances. In insects and birds the effect of surface textures varies from the soft sheen of grays and browns to the splendor of iridescence. The ordinary colors of birds and butterflies are caused by the processes of selective absorption of some rays of white light and the reflection of the remaining rays of the spectrum. But, as Professor Michelson writes: "The colors of certain pigeons, peacocks, humming-birds, as well as a number of butterflies, beetles, and other insects, require another explanation." * He goes on to show that the peculiarly brilliant iridescent colors of the feathers, wing scales, and wing cases of these creatures are due, with few exceptions, to a surface film of a metallic nature, so that these colors are true metallic

* A. A. Michelson, "On Metallic Coloring in Birds and Insects," *Philosophic Magazine*, April, 1911.

colors. The metallic film breaks up the light exactly as it is broken up by the soap-bubble or by a film of oil upon water. The thickness of the film determines what the colors shall be.

Some of the colors of animal forms might literally be called living colors because they fade more or less after the creature is dead. On the feathers of some birds is a bloom which we seldom see because, like the bloom upon grapes, it is immediately rubbed off by handling. Living fish are frequently wonderfully brilliant. Thoreau gives the following description of pickerel:

"Ah, the pickerel of Walden! When I see them lying on the ice or in the well which the fisherman cuts in the ice, making a little hole to admit the water, I am always surprised by their rare beauty, as if they were fabulous fishes, they are so foreign to the streets, even to the woods, foreign as Arabia to our Concord life. They possess a quite dazzling and transcendent beauty which separates them by a wide interval from the cadaverous cod and haddock whose fame is trumpeted in our streets. They are not green like the pines, nor gray like the stones, nor blue like the sky; but they have to my eyes, if possible, yet rarer colors, like flowers and precious stones, as if they were the pearls, the animalized nuclei or crystals of the Walden water." *

Colors of Inorganic Substances.—In specimens of inorganic substances, stones, metals, etc., we find colors ranging from quiet hues of low intensity such as occur generally in common rocks, to the rich colors of some minerals and the flashing brilliancy of polished metals. Among the pebbles on a sea beach, where the waves have smoothed the sur-

* Henry D. Thoreau, "The Pond in Winter," *Walden*, Riverside Edition, chap. XVI, p. 439. Houghton Mifflin Co.

faces of the stones so that the colors are more evident than in rough textures, one can frequently find all the hues of the spectrum in low intensity. The range of hues becomes more striking when the stones are laid in the order of the tones in the color circle. The colors of stones tend to make a harmonious combination because the color-producing materials are usually few in number. In common stones most of the reddish hues are due to the presence of hematite, an iron oxide. Red ochre is hematite with clay. The yellows result from limonite, a hydrous iron oxide, and the greens from chlorite, which is magnesium iron silicate. To these three factors are due the larger proportion of the colors of common stones.

Metals have a peculiar action upon light, so that when they are polished their flashing reflections distinguish "metallic" colors from any others. Light falling upon the surfaces of the larger proportion of non-metallic objects penetrates more or less beneath the surface, and then is reflected. In this penetration much of the light is absorbed. White objects tend to reflect the largest proportion of light, but measurements show that even white paper absorbs more than half the light that falls upon it. The total amount reflected is about forty per cent. Polished silver, however, is capable of reflecting ninety-two per cent. This capacity of metallic surfaces for reflecting so large a proportion of light which falls upon them is due to their extraordinary opacity. Light cannot penetrate the surface of metals to any such extent as in the case of other materials. Consequently if the surface is polished, practically all the light is reflected. In the case of a curved surface, certain areas reflect all the light which they receive directly to the eye, and thus form glittering high lights. Other areas are turned at an angle such that all the light is reflected away from

the eye, and these areas appear nearly black. Moreover, many of the reflections are sharply outlined at portions of their edges, and this greatly increases the effect of brilliancy. For these reasons an object of polished metal placed among non-metallic objects will differ essentially from them in the character of its reflections.

Water, colorless in itself, contributes greatly to the color effects of nature because of its capacity to reflect and transmit hues. The dancing colors reflected from water, whether it is the expanse of the ocean or a tiny pool, have always been a source of pleasure. The colors of broad stretches of water, sympathetic with the sky and responsive to the sun, change with every hour. Smaller bodies of water are more affected by what is on the near-by shore. The reflected colors of objects on the bank of a stream are by the motion of the water woven together. If the colors are at all harmonious this weaving together with the slight graying of surface reflection of white light produces charming effects. When the rippling of the surface is just sufficient to thread the pattern with lines of blue from the sky, the result is like a tapestry woven on a ground of blue.

The water of country streams frequently flows through peaty meadows and becomes tinged with brown. This hue in the sunshine becomes golden, and produces sumptuous color effects which curiously escape notice unless we look for them. They have been recognized in literature by such expressions as "wood-browned pools," and "leopard-colored rills." In shallow water in one of these brooks we may frequently see at the same time the objects in the brook bed under the water, and the surface reflections. In sunshine, stones and other objects under the water of these pools and brooks appear to gleam with yellow and orange and red hues, while the surface reflections present the complemen-

tary tones. The resulting pattern of contrasting colors
has a splendid vivacity and richness. In his poem, "The
Two Rivers," R. W. Emerson well describes this effect when
he says of the river Musketaquit that it

"Of shard and flint makes jewels gay."

Color Expresses Moods of Nature.—In addition to and
transcending the colors of particular objects are those gen-
eral tonalities of atmosphere and illumination which merge
and sometimes submerge the colors of separate things. The
high radiance of tropical sunshine at noon, the golden glooms
of a gathering autumn twilight, the flood of moonlight, are
examples of these general tonalities evident to all. But
there are innumerable less obvious ones which, when we see
them, interpret to us the less evident moods of nature and
many of the more delicate color schemes of art. If there is
spread before our windows a view extensive enough so that
the atmosphere plays a part in the effect, as, for example,
a view over a valley or plain toward distant hills, we can
see, especially in early morning or at twilight, how each day
has its characteristic color aspect. There are mornings in
the same season that are yellow or purple or rosy, not be-
cause the colors of things have changed but because atmos-
pheric conditions are different. Some days look cold and
some warm. On some days things are hard and definite in
their separateness. On others, objects are fused and only
suggest their shapes in the general envelope of the day's
tone. One who has such a view and cares to observe it will
find a pageant of changing effects and will see how expres-
sive of seasons and moods the daily tonalities are.

Color in Art.—We can readily see that the actual colors
of nature would probably exert a less definite influence over
the designer of textiles and pottery and other decorative

works of art than over the painter of pictures. Nature
continually tempts the painter toward literal representa-
tion. Her influence over the designer is of course strong,
but is in the nature of remoter suggestion. Moreover, the
designer, repeating his patterns, is likely to proceed away
from nature's actual appearances and follow the hints which
come from his own consciousness as he contemplates his
design. In the preceding chapters we have already dis-
cussed, as far as the space of this book will allow, some ways
in which a designer may select consistent groups of hues
and relate them harmoniously. We shall therefore con-
sider here a few of the methods which painters have used
in handling color. Typical methods have been selected,
which will help to interpret a wide range of the painter's
problems and how he has met them.

It is a popular idea that colors, as they appear in nature,
are so beautiful that all we can hope to do in painting is
to hint at them, to catch at some aspect of them and imi-
tate it, and that the imitation will necessarily be weaker
and less beautiful than nature because of the limitations of
pigments. This popular idea also includes the belief that
progress in painting has been mainly progress in represent-
ing the appearances of nature. Now while there have been
painters whose work has begun and ended with imitation of
nature, their chief contribution has been an increased knowl-
edge of the facts of appearance, which are the raw materials
that the artist uses. These facts of natural forms and colors
are important and their contribution to art is of great
value, but ability to record them correctly does not consti-
tute art.

The history of color in painting is partly the story of in-
creasing understanding of the facts of nature's hues, partly
the record of the development of the sense of color qualities

and relations and the accumulation of experiences with regard to the capacity of colors to express various moods, and in great part the narrative of experiments in perfecting processes so that the worker might be able to bring out the possible beauty of particular materials. The beauty of water-color is of one sort. The beauty of oil pigments is of another type. Each has its idioms, and all the many ways in which artists have handled them have characteristic possibilities of expression. In addition to subject and composition, painters have always sought to impart life and beauty to the actual surface of paint. When we hold a finder against paintings so that we see just a small area of color framed off from the rest, we will seldom find it lifeless, like the painting of a wall. Sometimes colors are glazed one over the other so that the surface is translucent. Sometimes different colors are woven together by small brush strokes, or two or three colors are put on the brush together and then mingled in a single brush stroke. Frequently one color is painted underneath and another placed over it so that the effect of both is apparent. Our enjoyment of good paintings is greatly increased when we appreciate not only what is painted, but the way in which the materials have been used. We will look briefly at a few of the typical ways in which paint has been handled.

Painting in Pattern.—The earliest use of color of which we have records appears to have been for the purpose of emphasizing and distinguishing areas, somewhat as we use it for distinguishing areas on maps or diagrams. After objects had been drawn in outline, filling in the outline with colors gave the representation an added emphasis. Naturally the color used would tend to be the general tone of the object itself, but the actual facts of nature did not always dictate the color. It was frequently selected for what were

probably purely decorative reasons, as when in Assyrian and Chaldean art the outline of a lion or bull was sometimes filled in with a flat wash of blue or yellow. Color was also used for symbolic reasons. Different levels of society were indicated by different colors, although there may have been naturalistic reasons for this.

What chiefly distinguishes what is here called painting in pattern, is not that the tones are always flat. Indeed they may have much modulation, as in Oriental painting. But it is that the modulations are seldom for the sake of producing effects of modelling, of projection and recession, or of illumination and shadow. Shadows seldom appear in primitive painting nor in the paintings by small children. Nor are they often found in the highly developed painting of China, India, and Japan. Painting in pattern without the effect of shadows has its peculiar effectiveness and has always been used; it occupies a prominent place in our own art. Relieved of the complexities involved in the problem of illumination the artist can give more attention to the refinement of hues and their relationships in his patterns. There is no sharp division between painting in pattern and painting in the full roundness of light and shade. We can find all intermediate steps from perfectly flat silhouette, through intermediate stages of effects of the third dimension to the full illumination of representation of sunshine. If we select, however, a few examples which illustrate wide intervals in the series—a Japanese print, paintings of the twelfth and thirteenth centuries with their low relief, and the high lights and rich glooms of Rembrandt's scenes or the paintings of the Barbizon School, and then the more modern luminists, Monet, Childe Hassam, and others —an examination of areas of color in each, isolated with our finder, will show us what a different problem the handling

of color in each case involved. It is not necessary even to select pictures of different periods. Almost any representative exhibition of modern works will show all of these stages.

Mediums for Painting.—Probably the earliest method of preparing pigments for painting was by mixing them with water and enough of some sizing material like honey, gum, glue, or the white or yolk of eggs with other ingredients, to bind the colors as they dry. Painting with these is known as tempera painting. Colors were also dissolved in wax. Heating rendered these colors usable, and they were often made more fluid by additions of naphtha. Wax-painting was difficult, and was gradually abandoned so that it became practically obsolete about the middle of the fourteenth century. The use of egg as a medium in tempera seems to have been common from very early times down to the fifteenth century. Painters before that time had been experimenting with other mediums and had at last found that some oils, especially linseed, would dry with a hard surface and bind the colors permanently. These oils gave much of the brilliancy and surface quality of egg tempera and were easier to handle. Consequently they gradually took the place of egg. Here and there, groups of painters still experiment with all the older preparations, but to-day oil-painting and water-color painting have generally superseded all the others.

Three Typical Effects in Oil-Painting.—Oil is the most adaptable medium in which colors can be mixed. It can be thinned to extreme fluidity, for example, with turpentine, so that the colors flow easily even from a pliant sable brush. It can hold the colors in heavy and opaque impasto to be spread on the canvas with a palette-knife or with a firm brush. Again, it can be thickened to the consistency

of varnish and thus give both depth and transparency. It lends itself readily to all kinds of handling, so that there are almost as many ways of painting as there are men who paint. Among the various methods of using oil-paints three can be selected which are, perhaps, typical. These are glazing, direct, more or less opaque painting, and painting with broken colors to suggest the vibration of light. The chief characteristics of these methods are as follows:

Glazing.—This consists in carrying films of color, usually much diluted with oil or varnish, and therefore transparent, over a groundwork of white, or over a pictorial composition already painted in its values of dark and light with little color, usually black and white, with perhaps some red. In the latter case the forms show through, as when we carry a thin wash of color over a photograph. All the modelling of a tree and the texture of leaves in the photograph will be evident under a thin tint of green. All oil-painting tends to become somewhat transparent as time passes. If a boat the name of which is painted upon it, receives a fresh coat of paint, the name though invisible at first will usually show after a while. When changes in the composition of a painting are made, unless the painter takes precautions the original composition is likely finally to show through. Sometimes the effects are amusing, as when a portrait is partly painted of a man with a beard and the subject then decides to shave it off and have the portrait changed accordingly, or when the position of hands or feet of a figure painting are changed. There are ways of avoiding this, but the tendency of paint to become transparent has to be considered.

In glazing the painter directly seeks transparency. When he overlays one film after another of colors made pellucid and clear by varnish, the light penetrates deeply and returns

a peculiar richness of color to the eye. Even the glooms of the picture appear to glow. One important resource in securing splendor of color in glazing is to work upon a perfectly white ground. In the early days of oil-painting a ground was prepared by successive coats of gesso, made of chalk or whiting mixed with glue. The last coat was polished until it was very smooth and brilliantly white. The light penetrating the films of color spread upon this ground, was reflected back through them. The white ground thus acts as a secondary source of light for the painting; a sort of inner illumination which causes the colors to glow with the peculiar radiance of transmitted light. The white ground makes the light appear to come from behind and to shine through the translucent colors, thus imparting to them a suggestion of the glory of stained glass.

We can readily see that to obtain the best effect the lighter portions of the picture must be the most thinly painted, so as not to impede the light reflected through them from the white panel. The depth of the darker portions could be regulated by the degree to which the films of dark color obscured the light. A modification already mentioned of this device of a white ground, consisted in painting the composition in different values of some one tone, making the lights white and the darker portions of correspondingly lower values. When the colors were glazed over this pattern, the underlying white supported the lights by reflecting through them, while the lesser degrees of reflection from the darker portions of the ground deepened the tones glazed over them.

While a mixture with varnish renders most pigments translucent, the pigments themselves differ greatly in respect of transparency. Aureolin and cadmium are both brilliant yellows, but a thin coat of aureolin carried over a

page of printing is so transparent that we can read through it perfectly, while cadmium of the same thickness obscures it considerably, and yellow ochre almost hides it. Rose madder and prussian blue are transparent. Vermilion and cobalt blue are opaque. When translucent colors are glazed over polished metal, which reflects almost twice as much light as white paper, their brilliancy is proportionately increased. Mars yellow is so transparent that a glaze of it over a lustrous metal surface gives the appearance of gold. Indeed mars yellow is sometimes used on organ-pipes instead of gold-leaf to impart the look of gold.

A few simple experiments will enable us to recognize the characteristic qualities of glazed colors. The materials needed for the illustrations suggested here are the following:

Panels. These may be cardboard or wood once painted over with white so as not to be too absorbent. On one of these paint any pattern in white, gray about middle value or lighter, and a very dark gray or black. This must be thoroughly dry before the glazes are put on. Leave another panel pure white. Usually this ground does not become sufficiently hard until it has dried for several days.

A Few Oil-Paints. White, black, and a few transparent colors, raw sienna or mars yellow, burnt sienna, alizarin, and prussian blue, which is practically the same as mineral, chinese, or antwerp blue, except that the latter are milder and less assertive.

Mastic Varnish, and Two or Three Bristle Brushes. The brushes should be flat and of fair size, not much less than a half-inch wide. After brushes have been used they should be thoroughly cleaned before being put away. If left over a night with oil-paint upon them the cleansing is a difficult matter. If varnish is used, kerosene will remove most of it. They should then be washed with soap and water.

When no varnish has been used, soap and water are sufficient, but a first cleaning with kerosene or turpentine helps.

Squeeze out of the tubes a little of each color upon a palette, panel of glass, plate, or other smooth surface. Dip a brush into mastic varnish and then into mars yellow, and with the color much diluted with varnish paint over a portion of the white panel. The brush should be full enough of varnish and color so that the glaze may be spread freely. Make it slightly thinner in some places than in others. Over other portions carry glazes of raw sienna and of alizarin. If we have not brushes enough to keep one for each hue we can use the same brush, wiping out with a cloth as much as may be of the previous color, because these are all warm colors. Over another portion carry a glaze of these three colors mingled but not mixed. With another brush carry a glaze of prussian blue over another portion of white surface. Blue is so far removed in wave-length from the warm colors that we cannot use the same brush for both without dimming the luminosity of each. Study the quality of color in each area and see how clear each is. If the surface was somewhat rough, perhaps because the white ground was broadly painted with a stiff brush, the color will be thin on the projections but thicker where it has settled into the depressions and our surfaces will thus have a texture of values and intensities. The quality of the glazed color is still more evident if we paint around a portion of it with gray or black, thus framing it, or if we isolate a portion with a small finder made of dark paper.

Now paint part of one of these areas with the same color mixed with white without varnish. That is, over half of the area glazed with mars yellow, paint mars yellow mixed with white. Use just enough white so that the value of the newly painted portion will be about that of the glazed por-

tion. The glazed portion is light because the under-painting of white shows through. The newly painted portion will be as light because white is mixed with the pigment. But the qualities will be very different. White is the most opaque of pigments. It scatters the light which it receives and swallows up most of the light of the under-painting. The golden luster of the glazed mars yellow is in marked contrast with the dull opacity of the same color mixed with white. Try a similar experiment with each of the other color areas.

The difference between glazing and opaque painting becomes yet more evident when we compare the mixture of colors by each method. Glaze a white area with prussian blue and mastic varnish. After it is fairly dry, which will be in about ten minutes, glaze it again with mars yellow and varnish. Let both of the glazes be somewhat uneven in thickness. The result will be a surface of lustrous and vibrating greens. Now attempt to produce a similar effect, using the same hues, but mixing them with white instead of glazing them over white. A comparison of the results will show us something of the color qualities which are characteristic of each way of painting. We shall find that the slightest admixture of white obscures the glow of the white ground, and thus lessens the amount of transmitted light which bestows on glazes almost the quality of stained glass.

Now over the panel with the pattern of white, gray and black, carry glazes of different colors and varnish, one color to each area. In a few minutes, when these are fairly dry, glaze the whole with one color, say mars yellow. Notice how this glaze brings all the hues into relationship and bestows upon each a peculiar glow. The darks will be deeper than actual black and the grays will be submerged in color.

After observing the results of our experiments we can

see how painters, selecting pigments which were naturally the most transparent and rendering them still more limpid by dilution with varnish, could produce effects in which some areas of color became like jewels lit by an inner radiance.

Since the early days of oil-painting, artists have experimented with effects of translucency made possible by the use of transparent color and a varnish medium, used over a white ground or one with a prepared pattern of values. Perhaps the most thorough experiments when oil-painting was comparatively new were made by Hubert and John Van Eyck in Flanders early in the fifteenth century. Many American painters, especially the so-called tonalists, among whom were Henry W. Ranger, George Inness, and J. Francis Murphy, made much use of glazes. Ranger said:

"It is readily demonstrable that the tonalist's method of using glazes accounts for much of the color charm of the tone picture. For example, when he overlays an opaque color with a thin stratum, semi-transparent and suitably tinted, he makes use of one of the rich properties of stained glass. The light from without must pass twice through the tinted glaze, and as it issues, by reflection, a discordant part of the white light is neutralized." *

Direct Painting.—Glazing with its possibilities of richness and depth of color is so beautiful an art that we sometimes ask why it has been largely superseded by direct painting. Two reasons are prominent among others:

First, glazing is less well adapted to recording quickly the appearances of nature. It is a process more suitable for building up effects in a rather leisurely fashion. The desire for quick records of immediate impressions of nature called for a more direct method of expression.

* Ralcy Husted Bell, *Art Talks with Ranger*, p. 7. **Courtesy of G. P. Putnam's Sons, publishers, New York and London.**

Secondly, the various aspects of nature and of æsthetic experience are wider in range than any one method of expression can compass. Hence as interests and ways of seeing and of thinking change, we have corresponding modifications of technic in all the arts. The transparent lights of the early Flemish painters, thinly glazed, convey one message of form. The thickly painted opaque lights of Rubens, catching added illumination by their actual projection, as real three-dimensioned forms do, express another meaning, an impression of the stable solidity of matter, an added sense of compact reality. The most important difference in actual surface appearance between direct painting and glazing is that in glazing, the light appears to come from beneath the film of color while in direct painting we see mostly the surface color of comparatively opaque pigments. The colors of the high values depend not on their transparency to the light of the ground behind them, but on their opacity to the illumination in front. Our experiments in comparing glazes with the same pigments mixed with white will illustrate clearly this difference. In direct painting the first sweep of the brush is often left untouched. Consequently the effect is more likely to lie at the surface. Theoretically, the color of the ground makes no difference. It might be white, black, brown, or red. Practically, it does make some difference, for there is always a degree of transparency in any painting, so that the tone of the ground finally counts, but it is not the chief factor in imparting the effect of illumination.

Direct painting has its own possibilities of surface beauty and expressiveness. The brush strokes, in spreading the pigment, generally contribute more to the effect of modelling and direction of the surfaces represented than in glazing. When the painter with a stiff-bristle brush has laid the paint

boldly, the surface is furrowed and ridged by the passage of the brush through the pigment, and is eloquent of the actual sweep of the hand. The configuration of land and rocks and the modelling of figures can be indicated in a fashion almost sculpturesque.

By using "broken color" the direct painter can give the impression of nature's intricacy of hues. Broken color is the result of mingling or juxtaposing hues without mixing them. For example, if a mass of green is too cold we can break a warm color, orange or red, into it, so that the cool color becomes interveined with the warm. The total effect is of a warmer green, but more palpitating than as if the whole mass of green had been thoroughly mixed with the warm color. Even in a single brush stroke we can secure this vibrating quality of complexity. Select a broad brush and take up with it a generous amount of oil-paint, white and alizarin lake and mars yellow on the same brushful, without using much if any oil or varnish. Do not mix them but lift up the portion of white, then of alizarin, and then of mars yellow, each by one separate dip of the brush into the particular color. Now, holding the brush so that the side on which the pile of paint lies is downward, draw one full broad stroke with the full width of the brush and about four inches long. See how the pigments become interwoven and how the whole is enlivened by threadings of white. Pigments are never so sparkling as when they are shot through with these filaments of pure white.

Now, with brush or finger mix together thoroughly the colors of an inch or two of one end of the brush stroke just made. (Plate VII, following p. 22.) The pigments in this portion are the same as before, but compare them with the untouched part of the stroke and see how different the two effects are. Experiments of this sort will show us much

regarding the vibrancy of broken colors. The order in which we dip the brush into the colors makes a difference in the result. We can grade the colors from one side of the stroke to the other by dipping one corner of the brush into one color, and the other corner into another, so that the two hues overlap slightly in the middle. The Japanese sometimes do this when using a broad brush with water-colors.

The history of art shows no hard-and-fast dividing-line between the method of glazing and that of direct painting. We find glazes that are considerably opaque. We find deep transparencies in direct painting. Not infrequently a light will be painted thickly with white and then receive a glaze of color. But even though the same picture may employ the resources of both methods, nevertheless they represent two ways of seeing and interpreting our experiences. They constitute two types of analysis of appearances and consequently two schools of painting, each appealing to particular temperaments.

Painting with Pure Colors to Represent Light.—Regarding the painters who followed this movement in art which came to its fulness during the last half of the nineteenth century, Moreau-Vauthier writes:

"Their object was to paint the moment, to paint it exactly, to surprise it in the irradiation of light. . . . The Impressionist holds that the principal person in a picture is the light, and that the subject treated is the effect of this light at the moment of painting. The importance of the light seems to him so great that *local color*—that is to say, the actual tint of an object—ceases to exist for him; what does exist is the coloration of an object at a given moment in a given light. The Impressionist discerns and notes the expressive detail of this chosen moment." *

* C. Moreau-Vauthier, *The Technic of Painting*, p. 57. Courtesy G. P. Putnam's Sons, publishers, New York and London.

To produce the effect of light some painters practise color division. For example, in order to produce an impression of green in sunlight they place side by side touches of blue and of yellow, the hues which when mixed give green. When seen at a distance these separate touches of color are fused by the eye, and we see not blue and yellow but a dancing green. In our experiments with the color-top we found that if we painted half of the outer rim of a disk with one color and half with another, and then painted the inner portion of the disk with a mixture of equal proportions of the same colors, the outer rim, when the top was spinning, appeared much brighter than the inner portion. (Fig. 11, p. 110.) This brilliancy was greatly increased just before the top stopped and when the colors were still revolving, but so slowly that we were conscious of their separateness. Similarly in an impressionistic painting the separate touches, partly because of distance and partly because of the roving motion of the eye, are fused into a tone more brilliant and palpitating than an actual mixture of the pigments could produce.

Sometimes touches of impressionistic color are slightly separated so that the neutral tone of the canvas shows between. The eye passing from color to color across the interstices of neutrals finds the hues slightly intensified by contrast with the neutral. Still another instance of apparently increased energy due to color division occurs when some of the small touches are composed of advancing and others of retreating colors. In our study of color sensations we found that our eyes could not focus on red and blue at the same time if the red and blue were in the same plane. The different degree of refraction in each compelled us to change the focus as we passed from one to the other. We had to focus on red as if it was nearer and upon blue as if it was farther than the plane upon which they were actually

painted. This gave to red the effect of advancing and to
blue the effect of retreating. Consequently when the im-
pressionist paints purple by small strokes of blue and red,
there is besides the brilliancy resulting from the optical
fusion of the two, an added agitation of vision due to the
slight shifting of focus. For this reason purple produced
by fusion in the eye of spots of red and of blue causes a pecu-
liar stimulation. Doubtless much of the purple so com-
monly used by the impressionists in representing sunlight
does really occur in nature, but probably some of what is
put into their pictures is there, not because it actually records
the facts of nature but because the particular excitation
caused by a red-blue purple corresponds curiously to that
produced by brilliant sunlight. This might well cause the
impressionist to use an excess of red-blue purple because
he feels its animating influence to be akin to that of corus-
cating sunshine, even if he does not know the reason.

**Some Advantages of Limiting the Palette to Certain Re-
lated Colors.**—How shall we select our colors for painting?
The dealers offer a bewildering variety. In older times
there were fewer pigments and more definite traditions re-
garding their use. Now the beginner has a disconcerting
freedom.

Because painting usually deals more or less with the ap-
pearance of things, we are likely to conclude that we should
turn to nature and select what colors nature shows us, in
order that we may interpret what we see. If we try to do
this we find, generally to our surprise, that nature seldom
helps us to decide very definitely. A thousand hues seem
to lie before our eyes, even when the means by which they
are produced are few. Moreover, we develop individual
habits of seeing of which we are largely unconscious and
which are hard to break. Unless we begin early to experi-

ment with colors and to analyze what we see, these habits become established on a basis of narrow and juvenile experiences. We have to be shown what lies beyond their range, the purple in out-of-door shadows, the red notes in green foliage, the variation of the blues of sky and sea toward emerald and violet, or whatever else may not have entered our consciousness. Regarding habits of the eye, Sir Alfred East writes:

"It has been said, and said with truth, that if you look for any particular color in Nature you will find it. If you search for purple you will discover purple, and if you want blue, the blue will be sure to show itself. This curious and interesting fact in psychology accounts for the preponderance of certain colors in some artists' landscapes—a specific strain, as it were, running through them all, as particular notes in a musical fugue. We know a man by his predilection for a certain color, yet the artist himself may be completely ignorant of the peculiarity." *

If we turn to painters for advice we generally find that each has his favorite list to the use of which he has become accustomed. His reason for choosing his particular pigments is seldom a simple one. Probably his early habits of seeing and the later instruction which he received have influenced him. Also by long use of them he knows how they will behave and just what effects they will produce in various mixtures. His ways of thinking and working have become adapted to them. Moreover, it is a curious fact that the long-continued use of any group of colors to interpret nature finally leads us to see nature in terms of those particular colors. Having been long employed as a means of analysis and expression they gradually become also a determining factor in the man's way of seeing. Probably the artist never really knows whether he has finally

* Sir Alfred East, *Landscape Painting*, p. 48. J. B. Lippincott Co.

settled upon the paints of his choice because they are capable of interpreting nature as he sees and feels it, or whether the use of certain pigments has led him to read those tones into nature and see appearances in terms of them. In any case the impressions of things seen become strangely fused with the mediums used for expressing them. Thus the color schemes employed by an artist become highly personal and constitute part of the individuality of his work. New ways of seeing await the painter of established habits if he will make a temporary but drastic change in his palette. There is some danger, however, unless he is intellectually elastic, that in getting out of his ruts he may get out of his road and find himself without a compass in the wilderness of fresh impressions.

When the problem of color selection is a pattern for weaving or materials for costume, then we can complete our selection of hues largely on the basis of their harmonious interrelation. We need to pay little attention to the appearances of external nature, and this is a great simplification. The question of hues must be practically decided before the work of final construction is begun. Exact preliminary determination of colors is also necessary in some fields of painting. True fresco-painting is done upon fresh plaster and cannot be changed. The work of one day on a given design must accord with that of other days. Consequently all the tones must be made ready in quantity beforehand. History seems to show that tones were similarly prepared for pictures, and with a definiteness that seems to us almost amusing. Cennini, writing in the fifteenth century, says, under the topic, "How to Paint Faces":

"When you have done the draperies, trees, buildings, and mountains, and got them painted, you must come to painting the faces; and those you should begin in this way.

Take a little terre-verte and a little white lead, well tempered; and lay two coats all over the face, over the hands, over the feet, and over the nudes. But for faces of young people with cool flesh color this couch should be tempered, the couch, and the flesh colors too, with yolk of a town hen's egg, because those are whiter yolks than the ones which country or farm hens produce; those are good, because of their redness, for tempering flesh colors for aged and swarthy persons. And whereas on a wall you make your pinks with cinabrese, bear in mind that on panel they should be made with vermilion. And when you are putting on the first pinks, do not have it straight vermilion —have a little white lead in it. And also put a little white lead into the verdaccio with which you shade at first. Just exactly as you work and paint on a wall, in just that same method, make three values of flesh color, each lighter than the other; laying each flesh color in its place on the areas of the face; still do not work up so close to the verdaccio shadows as to cover them entirely; but work them out with the darkest flesh color, fusing and softening them like a puff of smoke. And bear in mind that the panel needs to be laid in more times than a wall; but still not so much as not to need to have the green, which lies under the flesh colors, always show through a little. When you have got your flesh color down so that the face is about right, make a flesh color a little bit lighter, and pick out the forms of the face, making it gradually lighter, in a careful way, until you finally come to touch in with pure white lead any little relief more pronounced than the rest, such as there would be over the eyebrow, or on the tip of the nose, etc. Then outline the upper edge of the eyes with an outline of black, with a few lashes as the eye requires, and the nostrils of the nose. Then take a little dark sinoper and a trace of black; and outline all the accents of nose, eyes, brows, the hair, hands, feet, and everything in general, as I showed you for a wall; always using that yolk-of-egg tempera."*

* Cennino d'Andrea Cennini, *The Craftsman's Handbook*, pp. 93–94. Dover Publications, Inc., 1959.

The preparation of just the tones that are to be used in a given design or painting may be roughly compared to the tuning of a musical instrument before it is played. Orderly sequences and minglings can be produced with a sureness and rapidity impossible when the strings of the instrument or the colors of the palette occur in accidental tones. If we limit the colors on our palette to a few which are closely related by laws of physics or optics, for example, to various values of a single pair of complements or near complements, or to some triad, the atmosphere or mood which that group of colors is particularly capable of expressing will permeate the whole picture. The very limitations imposed will be an advantage. If in addition to the selection of a group of hues optically related, we modify them until on the palette they have a pleasing tonal relation, this will add to the harmony of the painting. A striking illustration of the tonal consistency and artistic expressiveness of limited palettes is furnished if we paint the same subject a number of times and use for each painting a different group of related hues. In some cases the hues of the pigments may not correspond with those of the subject, but they will nevertheless have an internal consistency and give a particular and sometimes unexpectedly illuminating translation of the actual subject. Even so severe a limitation as that of black and white, as in the case of engravings, gives its own valuable interpretation of colorful effects of nature.

A Scientifically Arranged Palette.—When we have selected colors which are related in hue we have taken one important step toward an orderly arrangement of the palette. For example, if we use a palette set with only yellow, red, blue, black, and white, we have a group of related hues and have thereby limited ourselves to certain tonal effects. Although this triad is freer from restrictions than any other, still the particular tones of the greens, oranges, and violets

which we can produce by mixtures will have a definite kinship with the three colors on the palette. If the blue chosen is ultra-marine, its slightly purple quality will permeate all mixtures. If it is chinese blue the greenish hue will be evident. Thus by establishing certain relations of hue in our choice of the yellow, red, and blue to be used, we have affected the tonality of all the mixtures. But if, instead of putting these three hues on the palette just as they come from the tube, we leave the yellow and red pure, but mix a little of each with the blue, we have now slightly dulled the blue so that all the resulting tones will tend to be warmer. There can be strong yellows and reds but no strong blues.

Or we might leave only the yellow pure and dull the red somewhat and the blue a good deal. Then only yellow can appear strong in the painting, while the others must be less intense. Similarly we can make other modifications. We can add some yellow to the red and the blue, and thus invest all the colors with a golden tinge. We have thus added relations of intensity to those of hue.

But we can go far beyond this and by careful mixing can prepare these colors so that as they lie upon the palette they show perfectly definite steps of value. For example, we can take our yellow, red, and blue, which are already toned to certain harmonious interrelations of hue and intensity, and by mixture with white or with some dark tone, as the occasion requires, can produce, say, five gradations of each color. Now we have upon the palette a very light yellow, red, and blue, a very dark tone of each, and three intermediate groups, as in Fig. 27. If in painting our picture or design we use for the very lightest portions only the yellow, red, and blue of the lightest group, for the darkest portions only the yellow, red, and blue of the darkest group, and for intermediate objects the color group of corre-

sponding value, and do not mix the colors of any one group
with those of another, our painting or design will have a
frankly declared pattern of values and be saved from con-
fusion of light and dark.

Again, we can slightly but consistently change the hues
of each group as the values are made lower. Leaving the
hues of the lightest group as yellow, red, and blue, we can

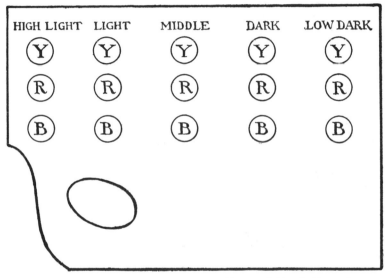

FIG. 27. Palette arranged with red, yellow, and blue in five values.

tinge each color of the group next lower in value with one
of its adjacents. In other words, we can move the position
of all of the colors slightly on the color circle. The second
or next darker group will now be a yellow that is slightly
orange, a red that is slightly violet, and a blue that is tinged
with green. The third or middle-value group will be yellow-
orange, red-violet, and blue-green. The fifth or darkest
will be orange, green, and violet, while the fourth is mid-

way between the third and fifth. Numbers 1, 2, 3, 4, and 5 in Fig. 28, will show the successive changes of hue of each color as it takes its place in the group of next lower value. If, now, we paint with these colors, using them as before

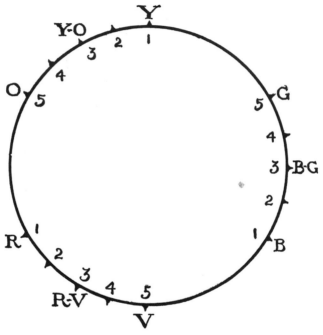

Fig. 28. Diagram showing a consistent change in hue in each group of colors on the palette as the values are lowered.

described, our picture or design will not only be well-defined in pattern, because each area in the pattern is painted with only one group of colors, all in a given range of value, but in addition each succeeding value will change slightly in character because of the corresponding change in hue of the colors which compose it. The lightest values are painted with yellow, red, and blue, or any mixture of these, the

lowest values with orange, green, and violet, while inter-
mediate values are painted with the corresponding inter-
mediate hues. The changes in quality of color between
the highest illumination and the deepest shadow will be

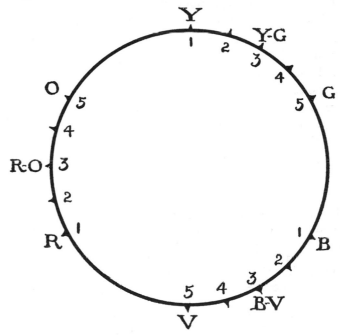

Fig. 29. Diagram showing a consistent change of hue of color groups in a
direction opposite to that illustrated in Fig. 28.

entirely consistent. Of course the movements of hues may
be in the opposite direction on the color circle as the values
deepen, so that, as in Fig. 29, yellow will move toward green,
red toward orange, and blue toward violet. Yellow, which
before became orange in the lowest darks, now becomes
green. Red, which became violet, now becomes orange;
while blue, which became green, now becomes violet. If

we paint the same subject, once with groups of yellow, red, and blue, at different values but with no changes of hue, as in Fig. 27, again with the groups of colors changing in hue, as in Fig. 28, and a third time with the changes in hue as in Fig. 29, each painting will represent the objects in a particular and perfectly consistent quality of illumination.

These examples of set palettes are merely typical of a large number which may be based on spectrum relations, and each of which has its distinctive qualities and its particular possibilities. Perhaps the most helpful and systematic modern treatise on the scientific arrangement of groups of colors for painting is the record by Doctor Denman W. Ross of the results of his experiments with limited palettes, in his book, *The Painter's Palette*. In another volume he refers to a prepared palette as follows:

"It is a great advantage for the designer when he has a few definite tones which he can see before him upon his palette and a few simple rules for mixing them which he understands and obeys. The value of these palettes lies in their several limitations and the possibility of definite thinking which they afford. They are modes in which the imagination becomes active and creative, just as it becomes active and creative in the modes of musical composition, when we think in the sounds of the musical scale and of its several keys and according to the rules of Counterpoint and Harmony. . . . To produce the tones of the set palette in the first place and then to get consistent and beautiful results from it is an art in itself, no less difficult than learning to tune a violin and to play upon it in different keys. Nobody learns to play on the violin without the help of a master and without years of technical exercises and practice. So it is in painting. The use of the set palette is equally difficult. It is an art in itself; an art acquired by scientific instruction and by years of hard work." *

* Denman W. Ross, *On Drawing and Painting*, pp. 55–56. Houghton Mifflin Co., 1912.

Summary.—As we study colors in nature and in art, we find that color in nature appears to follow certain principles of sequence and balance, but that these do not entirely coincide with those principles of reciprocal relationships which constitute beauty in art. The laws of color in natural appearances are not identical with the laws of balance of pigment hues in art. Consequently to transcribe literally what impresses us as beautiful in nature is not always to achieve beauty in art. Each has its own charm but neither dominates the other. We readily see that color in nature offers definite suggestions for color in art. It is equally true, although not so obvious, that art gives us patterns for seeing nature, and that we interpret nature to a considerable extent by what we have seen painted. Therefore, if we are to get full enjoyment of colors in nature and in art we have both to study nature systematically and also to experiment with color relations apart from nature, and on the basis of the direct appeal they make to our eyes.

The brief descriptions given will perhaps suffice to indicate that most of the historic styles of painting have been accompanied by fairly orderly and well-thought-out methods of using color. Experience is teaching us that hues have definite relationships, and that it is possible to work out a problem in the use of color systematically and to some extent scientifically. It is not necessary to muddle it through.

The different methods of painting referred to in this chapter are merely experiments to bring out some particular charm of materials, or the capacity of those materials for artistic expression when used in certain ways. When we become familiar with these methods, we understand more of what art has attempted to do with color, and see with new eyes what nature presents.

QUESTIONS

1. Why do the colors of the leaves, stems, and flowers of plants usually harmonize with each other?

2. How are the colors of flower and leaf sometimes related to the color of sepals and of stem and bark?

3. What is the most common difference between the green of the upper side of a leaf and that of the under side?

4. What colors besides green are reflected by the coloring matter of leaves?

5. Why do metals differ from other substances in their capacity to reflect light?

6. How were colors most frequently used in primitive painting?

7. Contrast three different methods of using oil-paints.

8. How does a "set palette" differ from a palette the colors of which are taken directly from the original tubes?

9. What effect does the continued use of certain colors in painting have upon the way in which the painter who uses them sees nature?

EXPERIMENT

Experiment XI.—To see in how far we can represent the hues of nature, by using only a limited number of colors together with black and white.

1. Select any subject; for example, a plant, a constructed object, or group of objects, a landscape, or a picture. See how nearly you can represent it by using only blue and orange (burnt sienna).

2. Try to represent the same subject, using only blue, burnt sienna, and yellow. (If yellow ochre is available use this in place of the brilliant yellow of the ordinary paint-box.)

3. Select a group containing a red, a yellow, and a blue object; for example, a yellow vase, a red book or fruit, and a blue background. Try to represent these, using only orange, green, and violet paints. Can you produce any suggestions of the red, yellow, and blue of these objects by using only orange, green, and violet?

INDEX

Absorption of light: selective and unselective, 27–29.

Adjacent hues: frequency in nature, 139–142; effects produced by use of adjacents, brilliancy, 142, 143; vibrancy, 143, 144; suggestion of movement of light, 144–149; emphasis of modelling, 149–153; as a means of reducing intensity, 154–163; means of harmonizing colors, 212, 213.

After-image: of white and black, 74; under intense light, 82; appearance of, 104–106; cause of, 107, 108; as a test of complementary hues, 116, 117; adds variety to color combinations, 121–124; helps to harmonize colors, 217.

Anstruther-Thomson, C., 20.

Ayers, Edward A.: light and color, 24, 25; color blindness, 43.

Beebe, William: varieties of green, 92.

Benham disk, 67–69.

Bergson, Henri: rapidity of light-waves of red, 26, 27.

Binyon, Laurence: color in Asian painting, 90.

Black: cause of, 27, 28; symbolism of, 50; artistic qualities of, 63–72; relation to warm colors, 72, 73; apparent black of foliage at dusk, 239.

Blue: preference for, 47, 91; blue and yellow as complements, 112–115; blue and orange as complements, 125, 126.

Breed, F. S.: color preferences, 46–48.

Brightness, see Value.

Carman, Bliss: emotional effect of scarlet, 92.

Cennini, Cennino: painting of flesh, 262.

Color: an important influence, 1; appreciation develops rapidly with study, 1, 2; value in general experi-

ence, 18, 19; aid to perception, 19, 202; affects vital processes, 45, 46; emotional effects, 45–50, 91, 92; relative defining power, 58, 59; warm and cool, 54–55; advancing and retreating, 55–58; summary of typical color combinations, 191–193; adjacent ——, see Adjacent Hues; —— blindness, 18, 43; —— circle, 7, 10; complementary ——, 104–132. See Complements. composite ——, 133–171. —— harmonies, 199–232. See Harmony in Color. —— in nature. See Nature; —— perceptions: physiological causes of, 37, 38; fields of color perception less extensive than fields of vision, 38–41; theories of, 41–43; color perception aided by actual mixing of colors, 4, 5, 158, 164, 190; —— preferences, 45–47, 91, 92, 202, 203; —— qualities: advancing and retreating, 55, 56; brilliancy, consistent with beauty and harmony, 137, 203–207; produced by complements, 119; by adjacents, 142, 143; softness produced by complements, 120, 121, 154–156; by adjacents, 154–163; vibrancy, produced by intricate gradations, 86–89, 93, 133–137; by adjacents, 142–144; warmth and coolness, 54–58; literary descriptions of ——: Keller, Helen, 19; Lowell, Amy, 49; Parker, DeWitt H., 52–54; Ruskin, John, 71, 72, 205; Thayer, Abbott H., 80–82; Keats, John, 89, 185; Hearn, Lafcadio, 91, 137, 138; Beebe, William, 92; Fletcher, Louisa, 92; Carman, Bliss, 92; Ward, Christopher L., 93; Hunt, Leigh, 204; Thoreau, Henry D., 241; —— sensations: causes of, 20–31, 34, 35; mere sensation of color is pleasing, 202; symbolism of ——, 50–54; —— top, 14–16; experiments with, 109–111; typical color combinations; summary of, 5, 191–193.

271

A CATALOG OF
SELECTED DOVER BOOKS
IN ALL FIELDS OF INTEREST

A CATALOG OF SELECTED DOVER
BOOKS IN ALL FIELDS OF INTEREST

CONCERNING THE SPIRITUAL IN ART, Wassily Kandinsky. Pioneering work by father of abstract art. Thoughts on color theory, nature of art. Analysis of earlier masters. 12 illustrations. 80pp. of text. 5⅜ × 8½. 23411-8 Pa. $2.50

LEONARDO ON THE HUMAN BODY, Leonardo da Vinci. More than 1200 of Leonardo's anatomical drawings on 215 plates. Leonardo's text, which accompanies the drawings, has been translated into English. 506pp. 8⅜ × 11¼.
24483-0 Pa. $10.95

GOBLIN MARKET, Christina Rossetti. Best-known work by poet comparable to Emily Dickinson, Alfred Tennyson. With 46 delightfully grotesque illustrations by Laurence Housman. 64pp. 4 × 6¼. 24516-0 Pa. $2.50

THE HEART OF THOREAU'S JOURNALS, edited by Odell Shepard. Selections from *Journal*, ranging over full gamut of interests. 228pp. 5⅜ × 8½.
20741-2 Pa. $4.50

MR. LINCOLN'S CAMERA MAN: MATHEW B. BRADY, Roy Meredith. Over 300 Brady photos reproduced directly from original negatives, photos. Lively commentary. 368pp. 8⅜ × 11¼. 23021-X Pa. $11.95

PHOTOGRAPHIC VIEWS OF SHERMAN'S CAMPAIGN, George N. Barnard. Reprint of landmark 1866 volume with 61 plates: battlefield of New Hope Church, the Etawah Bridge, the capture of Atlanta, etc. 80pp. 9 × 12. 23445-2 Pa. $6.00

A SHORT HISTORY OF ANATOMY AND PHYSIOLOGY FROM THE GREEKS TO HARVEY, Dr. Charles Singer. Thoroughly engrossing nontechnical survey. 270 illustrations. 211pp. 5⅜ × 8½. 20389-1 Pa. $4.50

REDOUTE ROSES IRON-ON TRANSFER PATTERNS, Barbara Christopher. Redouté was botanical painter to the Empress Josephine; transfer his famous roses onto fabric with these 24 transfer patterns. 80pp. 8¼ × 10⅞. 24292-7 Pa. $3.50

THE FIVE BOOKS OF ARCHITECTURE, Sebastiano Serlio. Architectural milestone, first (1611) English translation of Renaissance classic. Unabridged reproduction of original edition includes over 300 woodcut illustrations. 416pp. 9⅜ × 12¼. 24349-4 Pa. $14.95

CARLSON'S GUIDE TO LANDSCAPE PAINTING, John F. Carlson. Authoritative, comprehensive guide covers, every aspect of landscape painting. 34 reproductions of paintings by author; 58 explanatory diagrams. 144pp. 8⅜ × 11. 22927-0 Pa. $4.95

101 PUZZLES IN THOUGHT AND LOGIC, C.R. Wylie, Jr. Solve murders, robberies, see which fishermen are liars—purely by reasoning! 107pp. 5⅜ × 8½.
20367-0 Pa. $2.00

TEST YOUR LOGIC, George J. Summers. 50 more truly new puzzles with new turns of thought, new subtleties of inference. 100pp. 5⅜ × 8½. 22877-0 Pa. $2.25

CATALOG OF DOVER BOOKS

THE MURDER BOOK OF J.G. REEDER, Edgar Wallace. Eight suspenseful stories by bestselling mystery writer of 20s and 30s. Features the donnish Mr. J.G. Reeder of Public Prosecutor's Office. 128pp. 5⅜ × 8½. (Available in U.S. only)
24374-5 Pa. $3.50

ANNE ORR'S CHARTED DESIGNS, Anne Orr. Best designs by premier needlework designer, all on charts: flowers, borders, birds, children, alphabets, etc. Over 100 charts, 10 in color. Total of 40pp. 8¼ × 11.
23704-4 Pa. $2.25

BASIC CONSTRUCTION TECHNIQUES FOR HOUSES AND SMALL BUILDINGS SIMPLY EXPLAINED, U.S. Bureau of Naval Personnel. Grading, masonry, woodworking, floor and wall framing, roof framing, plastering, tile setting, much more. Over 675 illustrations. 568pp. 6½ × 9¼.
20242-9 Pa. $8.95

MATISSE LINE DRAWINGS AND PRINTS, Henri Matisse. Representative collection of female nudes, faces, still lifes, experimental works, etc., from 1898 to 1948. 50 illustrations. 48pp. 8⅜ × 11¼.
23877-6 Pa. $2.50

HOW TO PLAY THE CHESS OPENINGS, Eugene Znosko-Borovsky. Clear, profound examinations of just what each opening is intended to do and how opponent can counter. Many sample games. 147pp. 5⅜ × 8½.
22795-2 Pa. $2.95

DUPLICATE BRIDGE, Alfred Sheinwold. Clear, thorough, easily followed account: rules, etiquette, scoring, strategy, bidding; Goren's point-count system, Blackwood and Gerber conventions, etc. 158pp. 5⅜ × 8½.
22741-3 Pa. $3.00

SARGENT PORTRAIT DRAWINGS, J.S. Sargent. Collection of 42 portraits reveals technical skill and intuitive eye of noted American portrait painter, John Singer Sargent. 48pp. 8¼ × 11⅛.
24524-1 Pa. $2.95

ENTERTAINING SCIENCE EXPERIMENTS WITH EVERYDAY OBJECTS, Martin Gardner. Over 100 experiments for youngsters. Will amuse, astonish, teach, and entertain. Over 100 illustrations. 127pp. 5⅜ × 8½.
24201-3 Pa. $2.50

TEDDY BEAR PAPER DOLLS IN FULL COLOR: A Family of Four Bears and Their Costumes, Crystal Collins. A family of four Teddy Bear paper dolls and nearly 60 cut-out costumes. Full color, printed one side only. 32pp. 9¼ × 12¼.
24550-0 Pa. $3.50

NEW CALLIGRAPHIC ORNAMENTS AND FLOURISHES, Arthur Baker. Unusual, multi-useable material: arrows, pointing hands, brackets and frames, ovals, swirls, birds, etc. Nearly 700 illustrations. 80pp. 8⅜ × 11¼.
24095-9 Pa. $3.75

DINOSAUR DIORAMAS TO CUT & ASSEMBLE, M. Kalmenoff. Two complete three-dimensional scenes in full color, with 31 cut-out animals and plants. Excellent educational toy for youngsters. Instructions; 2 assembly diagrams. 32pp. 9¼ × 12¼.
24541-1 Pa. $3.95

SILHOUETTES: A PICTORIAL ARCHIVE OF VARIED ILLUSTRATIONS, edited by Carol Belanger Grafton. Over 600 silhouettes from the 18th to 20th centuries. Profiles and full figures of men, women, children, birds, animals, groups and scenes, nature, ships, an alphabet. 144pp. 8⅜ × 11¼.
23781-8 Pa. $4.95

CATALOG OF DOVER BOOKS

25 KITES THAT FLY, Leslie Hunt. Full, easy-to-follow instructions for kites made from inexpensive materials. Many novelties. 70 illustrations. 110pp. 5⅜ × 8½.
22550-X Pa. $2.25

PIANO TUNING, J. Cree Fischer. Clearest, best book for beginner, amateur. Simple repairs, raising dropped notes, tuning by easy method of flattened fifths. No previous skills needed. 4 illustrations. 201pp. 5⅜ × 8½.
23267-0 Pa. $3.50

EARLY AMERICAN IRON-ON TRANSFER PATTERNS, edited by Rita Weiss. 75 designs, borders, alphabets, from traditional American sources. 48pp. 8¼ × 11.
23162-3 Pa. $1.95

CROCHETING EDGINGS, edited by Rita Weiss. Over 100 of the best designs for these lovely trims for a host of household items. Complete instructions, illustrations. 48pp. 8¼ × 11.
24031-2 Pa. $2.25

FINGER PLAYS FOR NURSERY AND KINDERGARTEN, Emilie Poulsson. 18 finger plays with music (voice and piano); entertaining, instructive. Counting, nature lore, etc. Victorian classic. 53 illustrations. 80pp. 6½ × 9¼. 22588-7 Pa. $1.95

BOSTON THEN AND NOW, Peter Vanderwarker. Here in 59 side-by-side views are photographic documentations of the city's past and present. 119 photographs. Full captions. 122pp. 8¼ × 11.
24312-5 Pa. $6.95

CROCHETING BEDSPREADS, edited by Rita Weiss. 22 patterns, originally published in three instruction books 1939-41. 39 photos, 8 charts. Instructions. 48pp. 8¼ × 11.
23610-2 Pa. $2.00

HAWTHORNE ON PAINTING, Charles W. Hawthorne. Collected from notes taken by students at famous Cape Cod School; hundreds of direct, personal *apercus*, ideas, suggestions. 91pp. 5⅜ × 8½.
20653-X Pa. $2.50

THERMODYNAMICS, Enrico Fermi. A classic of modern science. Clear, organized treatment of systems, first and second laws, entropy, thermodynamic potentials, etc. Calculus required. 160pp. 5⅜ × 8½.
60361-X Pa. $4.00

TEN BOOKS ON ARCHITECTURE, Vitruvius. The most important book ever written on architecture. Early Roman aesthetics, technology, classical orders, site selection, all other aspects. Morgan translation. 331pp. 5⅜ × 8½. 20645-9 Pa. $5.50

THE CORNELL BREAD BOOK, Clive M. McCay and Jeanette B. McCay. Famed high-protein recipe incorporated into breads, rolls, buns, coffee cakes, pizza, pie crusts, more. Nearly 50 illustrations. 48pp. 8¼ × 11.
23995-0 Pa. $2.00

THE CRAFTSMAN'S HANDBOOK, Cennino Cennini. 15th-century handbook, school of Giotto, explains applying gold, silver leaf; gesso; fresco painting, grinding pigments, etc. 142pp. 6⅛ × 9¼.
20054-X Pa. $3.50

FRANK LLOYD WRIGHT'S FALLINGWATER, Donald Hoffmann. Full story of Wright's masterwork at Bear Run, Pa. 100 photographs of site, construction, and details of completed structure. 112pp. 9¼ × 10.
23671-4 Pa. $6.50

OVAL STAINED GLASS PATTERN BOOK, C. Eaton. 60 new designs framed in shape of an oval. Greater complexity, challenge with sinuous cats, birds, mandalas framed in antique shape. 64pp. 8¼ × 11.
24519-5 Pa. $3.50

THE BOOK OF WOOD CARVING, Charles Marshall Sayers. Still finest book for beginning student. Fundamentals, technique; gives 34 designs, over 34 projects for panels, bookends, mirrors, etc. 33 photos. 118pp. 7¾ × 10⅝. 23654-4 Pa. $3.95

CARVING COUNTRY CHARACTERS, Bill Higginbotham. Expert advice for beginning, advanced carvers on materials, techniques for creating 18 projects— mirthful panorama of American characters. 105 illustrations. 80pp. 8⅝ × 11.
24135-1 Pa. $2.50

300 ART NOUVEAU DESIGNS AND MOTIFS IN FULL COLOR, C.B. Grafton. 44 full-page plates display swirling lines and muted colors typical of Art Nouveau. Borders, frames, panels, cartouches, dingbats, etc. 48pp. 9⅜ × 12¼.
24354-0 Pa. $6.00

SELF-WORKING CARD TRICKS, Karl Fulves. Editor of *Pallbearer* offers 72 tricks that work automatically through nature of card deck. No sleight of hand needed. Often spectacular. 42 illustrations. 113pp. 5⅜ × 8½. 23334-0 Pa. $3.50

CUT AND ASSEMBLE A WESTERN FRONTIER TOWN, Edmund V. Gillon, Jr. Ten authentic full-color buildings on heavy cardboard stock in H-O scale. Sheriff's Office and Jail, Saloon, Wells Fargo, Opera House, others. 48pp. 9¼ × 12¼.
23736-2 Pa. $3.95

CUT AND ASSEMBLE AN EARLY NEW ENGLAND VILLAGE, Edmund V. Gillon, Jr. Printed in full color on heavy cardboard stock. 12 authentic buildings in H-O scale: Adams home in Quincy, Mass., Oliver Wight house in Sturbridge, smithy, store, church, others. 48pp. 9¼ × 12¼. 23536-X Pa. $3.95

THE TALE OF TWO BAD MICE, Beatrix Potter. Tom Thumb and Hunca Munca squeeze out of their hole and go exploring. 27 full-color Potter illustrations. 59pp. 4¼ × 5½. (Available in U.S. only) 23065-1 Pa. $1.50

CARVING FIGURE CARICATURES IN THE OZARK STYLE, Harold L. Enlow. Instructions and illustrations for ten delightful projects, plus general carving instructions. 22 drawings and 47 photographs altogether. 39pp. 8⅝ × 11.
23151-8 Pa. $2.50

A TREASURY OF FLOWER DESIGNS FOR ARTISTS, EMBROIDERERS AND CRAFTSMEN, Susan Gaber. 100 garden favorites lushly rendered by artist for artists, craftsmen, needleworkers. Many form frames, borders. 80pp. 8¼ × 11.
24096-7 Pa. $3.50

CUT & ASSEMBLE A TOY THEATER/THE NUTCRACKER BALLET, Tom Tierney. Model of a complete, full-color production of Tchaikovsky's classic. 6 backdrops, dozens of characters, familiar dance sequences. 32pp. 9⅝ × 12¼.
24194-7 Pa. $4.50

ANIMALS: 1,419 COPYRIGHT-FREE ILLUSTRATIONS OF MAMMALS, BIRDS, FISH, INSECTS, ETC., edited by Jim Harter. Clear wood engravings present, in extremely lifelike poses, over 1,000 species of animals. 284pp. 9 × 12.
23766-4 Pa. $9.95

MORE HAND SHADOWS, Henry Bursill. For those at their 'finger ends,'' 16 more effects—Shakespeare, a hare, a squirrel, Mr. Punch, and twelve more—each explained by a full-page illustration. Considerable period charm. 30pp. 6½ × 9¼.
21384-6 Pa. $1.95

SURREAL STICKERS AND UNREAL STAMPS, William Rowe. 224 haunting, hilarious stamps on gummed, perforated stock, with images of elephants, geisha girls, George Washington, etc. 16pp. one side. 8¼ × 11. 24371-0 Pa. $3.50

GOURMET KITCHEN LABELS, Ed Sibbett, Jr. 112 full-color labels (4 copies each of 28 designs). Fruit, bread, other culinary motifs. Gummed and perforated. 16pp. 8¼ × 11. 24087-8 Pa. $2.95

PATTERNS AND INSTRUCTIONS FOR CARVING AUTHENTIC BIRDS, H.D. Green. Detailed instructions, 27 diagrams, 85 photographs for carving 15 species of birds so life-like, they'll seem ready to fly! 8¼ × 11. 24222-6 Pa. $2.75

FLATLAND, E.A. Abbott. Science-fiction classic explores life of 2-D being in 3-D world. 16 illustrations. 103pp. 5⅜ × 8. 20001-9 Pa. $2.00

DRIED FLOWERS, Sarah Whitlock and Martha Rankin. Concise, clear, practical guide to dehydration, glycerinizing, pressing plant material, and more. Covers use of silica gel. 12 drawings. 32pp. 5⅜ × 8½. 21802-3 Pa. $1.00

EASY-TO-MAKE CANDLES, Gary V. Guy. Learn how easy it is to make all kinds of decorative candles. Step-by-step instructions. 82 illustrations. 48pp. 8¼ × 11.
23881-4 Pa. $2.50

SUPER STICKERS FOR KIDS, Carolyn Bracken. 128 gummed and perforated full-color stickers: GIRL WANTED, KEEP OUT, BORED OF EDUCATION, X-RATED, COMBAT ZONE, many others. 16pp. 8¼ × 11. 24092-4 Pa. $2.50

CUT AND COLOR PAPER MASKS, Michael Grater. Clowns, animals, funny faces...simply color them in, cut them out, and put them together, and you have 9 paper masks to play with and enjoy. 32pp. 8¼ × 11. 23171-2 Pa. $2.25

A CHRISTMAS CAROL: THE ORIGINAL MANUSCRIPT, Charles Dickens. Clear facsimile of Dickens manuscript, on facing pages with final printed text. 8 illustrations by John Leech, 4 in color on covers. 144pp. 8⅜ × 11¼.
20980-6 Pa. $5.95

CARVING SHOREBIRDS, Harry V. Shourds & Anthony Hillman. 16 full-size patterns (all double-page spreads) for 19 North American shorebirds with step-by-step instructions. 72pp. 9¼ × 12¼. 24287-0 Pa. $4.95

THE GENTLE ART OF MATHEMATICS, Dan Pedoe. Mathematical games, probability, the question of infinity, topology, how the laws of algebra work, problems of irrational numbers, and more. 42 figures. 143pp. 5⅜ × 8½. (EBE)
22949-1 Pa. $3.50

READY-TO-USE DOLLHOUSE WALLPAPER, Katzenbach & Warren, Inc. Stripe, 2 floral stripes, 2 allover florals, polka dot; all in full color. 4 sheets (350 sq. in.) of each, enough for average room. 48pp. 8¼ × 11. 23495-9 Pa. $2.95

MINIATURE IRON-ON TRANSFER PATTERNS FOR DOLLHOUSES, DOLLS, AND SMALL PROJECTS, Rita Weiss and Frank Fontana. Over 100 miniature patterns: rugs, bedspreads, quilts, chair seats, etc. In standard dollhouse size. 48pp. 8¼ × 11. 23741-9 Pa. $1.95

THE DINOSAUR COLORING BOOK, Anthony Rao. 45 renderings of dinosaurs, fossil birds, turtles, other creatures of Mesozoic Era. Scientifically accurate. Captions. 48pp. 8¼ × 11. 24022-3 Pa. $2.25

CATALOG OF DOVER BOOKS

JAPANESE DESIGN MOTIFS, Matsuya Co. Mon, or heraldic designs. Over 4000 typical, beautiful designs: birds, animals, flowers, swords, fans, geometrics; all beautifully stylized. 213pp. 11⅜ × 8¼. 22874-6 Pa. $7.95

THE TALE OF BENJAMIN BUNNY, Beatrix Potter. Peter Rabbit's cousin coaxes him back into Mr. McGregor's garden for a whole new set of adventures. All 27 full-color illustrations. 59pp. 4¼ × 5½. (Available in U.S. only) 21102-9 Pa. $1.50

THE TALE OF PETER RABBIT AND OTHER FAVORITE STORIES BOXED SET, Beatrix Potter. Seven of Beatrix Potter's best-loved tales including Peter Rabbit in a specially designed, durable boxed set. 4¼ × 5½. Total of 447pp. 158 color illustrations. (Available in U.S. only) 23903-9 Pa. $10.80

PRACTICAL MENTAL MAGIC, Theodore Annemann. Nearly 200 astonishing feats of mental magic revealed in step-by-step detail. Complete advice on staging, patter, etc. Illustrated. 320pp. 5⅜ × 8½. 24426-1 Pa. $5.95

CELEBRATED CASES OF JUDGE DEE (DEE GOONG AN), translated by Robert Van Gulik. Authentic 18th-century Chinese detective novel; Dee and associates solve three interlocked cases. Led to van Gulik's own stories with same characters. Extensive introduction. 9 illustrations. 237pp. 5⅜ × 8½. 23337-5 Pa. $4.50

CUT & FOLD EXTRATERRESTRIAL INVADERS THAT FLY, M. Grater. Stage your own lilliputian space battles. By following the step-by-step instructions and explanatory diagrams you can launch 22 full-color fliers into space. 36pp. 8¼ × 11. 24478-4 Pa. $2.95

CUT & ASSEMBLE VICTORIAN HOUSES, Edmund V. Gillon, Jr. Printed in full color on heavy cardboard stock, 4 authentic Victorian houses in H-O scale: Italian-style Villa, Octagon, Second Empire, Stick Style. 48pp. 9¼ × 12¼. 23849-0 Pa. $3.95

BEST SCIENCE FICTION STORIES OF H.G. WELLS, H.G. Wells. Full novel *The Invisible Man*, plus 17 short stories: "The Crystal Egg," "Aepyornis Island," "The Strange Orchid," etc. 303pp. 5⅜ × 8½. (Available in U.S. only) 21531-8 Pa. $4.95

TRADEMARK DESIGNS OF THE WORLD, Yusaku Kamekura. A lavish collection of nearly 700 trademarks, the work of Wright, Loewy, Klee, Binder, hundreds of others. 160pp. 8¾ × 8. (Available in U.S. only) 24191-2 Pa. $5.00

THE ARTIST'S AND CRAFTSMAN'S GUIDE TO REDUCING, ENLARGING AND TRANSFERRING DESIGNS, Rita Weiss. Discover, reduce, enlarge, transfer designs from any objects to any craft project. 12pp. plus 16 sheets special graph paper. 8¼ × 11. 24142-4 Pa. $3.25

TREASURY OF JAPANESE DESIGNS AND MOTIFS FOR ARTISTS AND CRAFTSMEN, edited by Carol Belanger Grafton. Indispensable collection of 360 traditional Japanese designs and motifs redrawn in clean, crisp black-and-white, copyright-free illustrations. 96pp. 8¼ × 11. 24435-0 Pa. $3.95

CATALOG OF DOVER BOOKS

CHANCERY CURSIVE STROKE BY STROKE, Arthur Baker. Instructions and illustrations for each stroke of each letter (upper and lower case) and numerals. 54 full-page plates. 64pp. 8¼ × 11. 24278-1 Pa. $2.50

THE ENJOYMENT AND USE OF COLOR, Walter Sargent. Color relationships, values, intensities; complementary colors, illumination, similar topics. Color in nature and art. 7 color plates, 29 illustrations. 274pp. 5⅜ × 8½. 20944-X Pa. $4.50

SCULPTURE PRINCIPLES AND PRACTICE, Louis Slobodkin. Step-by-step approach to clay, plaster, metals, stone; classical and modern. 253 drawings, photos. 255pp. 8⅛ × 11. 22960-2 Pa. $7.50

VICTORIAN FASHION PAPER DOLLS FROM HARPER'S BAZAR, 1867-1898, Theodore Menten. Four female dolls with 28 elegant high fashion costumes, printed in full color. 32pp. 9¼ × 12¼. 23453-3 Pa. $3.50

FLOPSY, MOPSY AND COTTONTAIL: A Little Book of Paper Dolls in Full Color, Susan LaBelle. Three dolls and 21 costumes (7 for each doll) show Peter Rabbit's siblings dressed for holidays, gardening, hiking, etc. Charming borders, captions. 48pp. 4¼ × 5½. 24376-1 Pa. $2.25

NATIONAL LEAGUE BASEBALL CARD CLASSICS, Bert Randolph Sugar. 83 big-leaguers from 1909-69 on facsimile cards. Hubbell, Dean, Spahn, Brock plus advertising, info, no duplications. Perforated, detachable. 16pp. 8¼ × 11.
24308-7 Pa. $2.95

THE LOGICAL APPROACH TO CHESS, Dr. Max Euwe, et al. First-rate text of comprehensive strategy, tactics, theory for the amateur. No gambits to memorize, just a clear, logical approach. 224pp. 5⅜ × 8½. 24353-2 Pa. $4.50

MAGICK IN THEORY AND PRACTICE, Aleister Crowley. The summation of the thought and practice of the century's most famous necromancer, long hard to find. Crowley's best book. 436pp. 5⅜ × 8½. (Available in U.S. only)
23295-6 Pa. $6.50

THE HAUNTED HOTEL, Wilkie Collins. Collins' last great tale; doom and destiny in a Venetian palace. Praised by T.S. Eliot. 127pp. 5⅜ × 8½.
24333-8 Pa. $3.00

ART DECO DISPLAY ALPHABETS, Dan X. Solo. Wide variety of bold yet elegant lettering in handsome Art Deco styles. 100 complete fonts, with numerals, punctuation, more. 104pp. 8⅛ × 11. 24372-9 Pa. $4.00

CALLIGRAPHIC ALPHABETS, Arthur Baker. Nearly 150 complete alphabets by outstanding contemporary. Stimulating ideas; useful source for unique effects. 154 plates. 157pp. 8⅜ × 11¼. 21045-6 Pa. $4.95

ARTHUR BAKER'S HISTORIC CALLIGRAPHIC ALPHABETS, Arthur Baker. From monumental capitals of first-century Rome to humanistic cursive of 16th century, 33 alphabets in fresh interpretations. 88 plates. 96pp. 9 × 12.
24054-1 Pa. $4.50

LETTIE LANE PAPER DOLLS, Sheila Young. Genteel turn-of-the-century family very popular then and now. 24 paper dolls. 16 plates in full color. 32pp. 9¼ × 12¼. 24089-4 Pa. $3.50

CATALOG OF DOVER BOOKS

KEYBOARD WORKS FOR SOLO INSTRUMENTS, G.F. Handel. 35 neglected works from Handel's vast oeuvre, originally jotted down as improvisations. Includes Eight Great Suites, others. New sequence. 174pp. 9⅝ × 12¼.
24338-9 Pa. $7.50

AMERICAN LEAGUE BASEBALL CARD CLASSICS, Bert Randolph Sugar. 82 stars from 1900s to 60s on facsimile cards. Ruth, Cobb, Mantle, Williams, plus advertising, info, no duplications. Perforated, detachable. 16pp. 8¼ × 11.
24286-2 Pa. $2.95

A TREASURY OF CHARTED DESIGNS FOR NEEDLEWORKERS, Georgia Gorham and Jeanne Warth. 141 charted designs: owl, cat with yarn, tulips, piano, spinning wheel, covered bridge, Victorian house and many others. 48pp. 8¼ × 11.
23558-0 Pa. $1.95

DANISH FLORAL CHARTED DESIGNS, Gerda Bengtsson. Exquisite collection of over 40 different florals: anemone, Iceland poppy, wild fruit, pansies, many others. 45 illustrations. 48pp. 8¼ × 11.
23957-8 Pa. $1.75

OLD PHILADELPHIA IN EARLY PHOTOGRAPHS 1839-1914, Robert F. Looney. 215 photographs: panoramas, street scenes, landmarks, President-elect Lincoln's visit, 1876 Centennial Exposition, much more. 230pp. 8⅞ × 11¾.
23345-6 Pa. $9.95

PRELUDE TO MATHEMATICS, W.W. Sawyer. Noted mathematician's lively, stimulating account of non-Euclidean geometry, matrices, determinants, group theory, other topics. Emphasis on novel, striking aspects. 224pp. 5⅜ × 8½.
24401-6 Pa. $4.50

ADVENTURES WITH A MICROSCOPE, Richard Headstrom. 59 adventures with clothing fibers, protozoa, ferns and lichens, roots and leaves, much more. 142 illustrations. 232pp. 5⅜ × 8½.
23471-1 Pa. $3.95

IDENTIFYING ANIMAL TRACKS: MAMMALS, BIRDS, AND OTHER ANIMALS OF THE EASTERN UNITED STATES, Richard Headstrom. For hunters, naturalists, scouts, nature-lovers. Diagrams of tracks, tips on identification. 128pp. 5⅜ × 8.
24442-3 Pa. $3.50

VICTORIAN FASHIONS AND COSTUMES FROM HARPER'S BAZAR, 1867-1898, edited by Stella Blum. Day costumes, evening wear, sports clothes, shoes, hats, other accessories in over 1,000 detailed engravings. 320pp. 9⅜ × 12¼.
22990-4 Pa. $9.95

EVERYDAY FASHIONS OF THE TWENTIES AS PICTURED IN SEARS AND OTHER CATALOGS, edited by Stella Blum. Actual dress of the Roaring Twenties, with text by Stella Blum. Over 750 illustrations, captions. 156pp. 9 × 12.
24134-3 Pa. $8.50

HALL OF FAME BASEBALL CARDS, edited by Bert Randolph Sugar. Cy Young, Ted Williams, Lou Gehrig, and many other Hall of Fame greats on 92 full-color, detachable reprints of early baseball cards. No duplication of cards with *Classic Baseball Cards.* 16pp. 8¼ × 11.
23624-2 Pa. $3.50

THE ART OF HAND LETTERING, Helm Wotzkow. Course in hand lettering, Roman, Gothic, Italic, Block, Script. Tools, proportions, optical aspects, individual variation. Very quality conscious. Hundreds of specimens. 320pp. 5⅜ × 8½.
21797-3 Pa. $4.95

CATALOG OF DOVER BOOKS

HOW THE OTHER HALF LIVES, Jacob A. Riis. Journalistic record of filth, degradation, upward drive in New York immigrant slums, shops, around 1900. New edition includes 100 original Riis photos, monuments of early photography. 233pp. 10 × 7⅞. 22012-5 Pa. $7.95

CHINA AND ITS PEOPLE IN EARLY PHOTOGRAPHS, John Thomson. In 200 black-and-white photographs of exceptional quality photographic pioneer Thomson captures the mountains, dwellings, monuments and people of 19th-century China. 272pp. 9⅜ × 12¼. 24393-1 Pa. $12.95

GODEY COSTUME PLATES IN COLOR FOR DECOUPAGE AND FRAMING, edited by Eleanor Hasbrouk Rawlings. 24 full-color engravings depicting 19th-century Parisian haute couture. Printed on one side only. 56pp. 8¼ × 11. 23879-2 Pa. $3.95

ART NOUVEAU STAINED GLASS PATTERN BOOK, Ed Sibbett, Jr. 104 projects using well-known themes of Art Nouveau: swirling forms, florals, peacocks, and sensuous women. 60pp. 8¼ × 11. 23577-7 Pa. $3.50

QUICK AND EASY PATCHWORK ON THE SEWING MACHINE: Susan Aylsworth Murwin and Suzzy Payne. Instructions, diagrams show exactly how to machine sew 12 quilts. 48pp. of templates. 50 figures. 80pp. 8¼ × 11. 23770-2 Pa. $3.50

THE STANDARD BOOK OF QUILT MAKING AND COLLECTING, Marguerite Ickis. Full information, full-sized patterns for making 46 traditional quilts, also 150 other patterns. 483 illustrations. 273pp. 6⅞ × 9⅝. 20582-7 Pa. $5.95

LETTERING AND ALPHABETS, J. Albert Cavanagh. 85 complete alphabets lettered in various styles; instructions for spacing, roughs, brushwork. 121pp. 8¾ × 8. 20053-1 Pa. $3.75

LETTER FORMS: 110 COMPLETE ALPHABETS, Frederick Lambert. 110 sets of capital letters; 16 lower case alphabets; 70 sets of numbers and other symbols. 110pp. 8⅝ × 11. 22872-X Pa. $4.50

ORCHIDS AS HOUSE PLANTS, Rebecca Tyson Northen. Grow cattleyas and many other kinds of orchids—in a window, in a case, or under artificial light. 63 illustrations. 148pp. 5⅜ × 8½. 23261-1 Pa. $2.95

THE MUSHROOM HANDBOOK, Louis C.C. Krieger. Still the best popular handbook. Full descriptions of 259 species, extremely thorough text, poisons, folklore, etc. 32 color plates; 126 other illustrations. 560pp. 5⅜ × 8½. 21861-9 Pa. $8.50

THE DORÉ BIBLE ILLUSTRATIONS, Gustave Doré. All wonderful, detailed plates: Adam and Eve, Flood, Babylon,life of Jesus, etc.Brief King James text with each plate. 241 plates. 241pp. 9 × 12. 23004-X Pa. $8.95

THE BOOK OF KELLS: Selected Plates in Full Color, edited by Blanche Cirker. 32 full-page plates from greatest manuscript-icon of early Middle Ages. Fantastic, mysterious. Publisher's Note. Captions. 32pp. 9¾ × 12¼. 24345-1 Pa. $4.50

THE PERFECT WAGNERITE, George Bernard Shaw. Brilliant criticism of the Ring Cycle, with provocative interpretation of politics, economic theories behind the Ring. 136pp. 5⅜ × 8½. (Available in U.S. only) 21707-8 Pa. $3.00

CATALOG OF DOVER BOOKS

THE RIME OF THE ANCIENT MARINER, Gustave Doré, S.T. Coleridge. Doré's finest work, 34 plates capture moods, subtleties of poem. Full text. 77pp. 9¼ × 12. 22305-1 Pa. $4.95

SONGS OF INNOCENCE, William Blake. The first and most popular of Blake's famous "Illuminated Books," in a facsimile edition reproducing all 31 brightly colored plates. Additional printed text of each poem. 64pp. 5¼ × 7. 22764-2 Pa. $3.00

AN INTRODUCTION TO INFORMATION THEORY, J.R. Pierce. Second (1980) edition of most impressive non-technical account available. Encoding, entropy, noisy channel, related areas, etc. 320pp. 5⅜ × 8½. 24061-4 Pa. $4.95

THE DIVINE PROPORTION: A STUDY IN MATHEMATICAL BEAUTY, H.E. Huntley. "Divine proportion" or "golden ratio" in poetry, Pascal's triangle, philosophy, psychology, music, mathematical figures, etc. Excellent bridge between science and art. 58 figures. 185pp. 5⅜ × 8½. 22254-3 Pa. $3.95

THE DOVER NEW YORK WALKING GUIDE: From the Battery to Wall Street, Mary J. Shapiro. Superb inexpensive guide to historic buildings and locales in lower Manhattan: Trinity Church, Bowling Green, more. Complete Text; maps. 36 illustrations. 48pp. 3⅞ × 9¼. 24225-0 Pa. $2.50

NEW YORK THEN AND NOW, Edward B. Watson, Edmund V. Gillon, Jr. 83 important Manhattan sites: on facing pages early photographs (1875-1925) and 1976 photos by Gillon. 172 illustrations. 171pp. 9¼ × 10. 23361-8 Pa. $7.95

HISTORIC COSTUME IN PICTURES, Braun & Schneider. Over 1450 costumed figures from dawn of civilization to end of 19th century. English captions. 125 plates. 256pp. 8⅜ × 11¼. 23150-X Pa. $7.50

VICTORIAN AND EDWARDIAN FASHION: A Photographic Survey, Alison Gernsheim. First fashion history completely illustrated by contemporary photographs. Full text plus 235 photos, 1840-1914, in which many celebrities appear. 240pp. 6½ × 9¼. 24205-6 Pa. $6.00

CHARTED CHRISTMAS DESIGNS FOR COUNTED CROSS-STITCH AND OTHER NEEDLECRAFTS, Lindberg Press. Charted designs for 45 beautiful needlecraft projects with many yuletide and wintertime motifs. 48pp. 8¼ × 11. 24356-7 Pa. $1.95

101 FOLK DESIGNS FOR COUNTED CROSS-STITCH AND OTHER NEEDLE-CRAFTS, Carter Houck. 101 authentic charted folk designs in a wide array of lovely representations with many suggestions for effective use. 48pp. 8¼ × 11. 24369-9 Pa. $2.25

FIVE ACRES AND INDEPENDENCE, Maurice G. Kains. Great back-to-the-land classic explains basics of self-sufficient farming. The one book to get. 95 illustrations. 397pp. 5⅜ × 8½. 20974-1 Pa. $4.95

A MODERN HERBAL, Margaret Grieve. Much the fullest, most exact, most useful compilation of herbal material. Gigantic alphabetical encyclopedia, from aconite to zedoary, gives botanical information, medical properties, folklore, economic uses, and much else. Indispensable to serious reader. 161 illustrations. 888pp. 6½ × 9¼. (Available in U.S. only) 22798-7, 22799-5 Pa., Two-vol. set $16.45

CATALOG OF DOVER BOOKS

DECORATIVE NAPKIN FOLDING FOR BEGINNERS, Lillian Oppenheimer and Natalie Epstein. 22 different napkin folds in the shape of a heart, clown's hat, love knot, etc. 63 drawings. 48pp. 8¼ × 11. 23797-4 Pa. $1.95

DECORATIVE LABELS FOR HOME CANNING, PRESERVING, AND OTHER HOUSEHOLD AND GIFT USES, Theodore Menten. 128 gummed, perforated labels, beautifully printed in 2 colors. 12 versions. Adhere to metal, glass, wood, ceramics. 24pp. 8¼ × 11. 23219-0 Pa. $2.95

EARLY AMERICAN STENCILS ON WALLS AND FURNITURE, Janet Waring. Thorough coverage of 19th-century folk art: techniques, artifacts, surviving specimens. 166 illustrations, 7 in color. 147pp. of text. 7⅞ × 10¾. 21906-2 Pa. $9.95

AMERICAN ANTIQUE WEATHERVANES, A.B. & W.T. Westervelt. Extensively illustrated 1883 catalog exhibiting over 550 copper weathervanes and finials. Excellent primary source by one of the principal manufacturers. 104pp. 6⅛ × 9¼. 24396-6 Pa. $3.95

ART STUDENTS' ANATOMY, Edmond J. Farris. Long favorite in art schools. Basic elements, common positions, actions. Full text, 158 illustrations. 159pp. 5⅜ × 8½. 20744-7 Pa. $3.95

BRIDGMAN'S LIFE DRAWING, George B. Bridgman. More than 500 drawings and text teach you to abstract the body into its major masses. Also specific areas of anatomy. 192pp. 6½ × 9¼. (EA) 22710-3 Pa. $4.50

COMPLETE PRELUDES AND ETUDES FOR SOLO PIANO, Frederic Chopin. All 26 Preludes, all 27 Etudes by greatest composer of piano music. Authoritative Paderewski edition. 224pp. 9 × 12. (Available in U.S. only) 24052-5 Pa. $7.50

PIANO MUSIC 1888-1905, Claude Debussy. Deux Arabesques, Suite Bergamesque, Masques, 1st series of Images, etc. 9 others, in corrected editions. 175pp. 9⅜ × 12¼. (ECE) 22771-5 Pa. $5.95

TEDDY BEAR IRON-ON TRANSFER PATTERNS, Ted Menten. 80 iron-on transfer patterns of male and female Teddys in a wide variety of activities, poses, sizes. 48pp. 8¼ × 11. 24596-9 Pa. $2.25

A PICTURE HISTORY OF THE BROOKLYN BRIDGE, M.J. Shapiro. Profusely illustrated account of greatest engineering achievement of 19th century. 167 rare photos & engravings recall construction, human drama. Extensive, detailed text. 122pp. 8¼ × 11. 24403-2 Pa. $7.95

NEW YORK IN THE THIRTIES, Berenice Abbott. Noted photographer's fascinating study shows new buildings that have become famous and old sights that have disappeared forever. 97 photographs. 97pp. 11⅜ × 10. 22967-X Pa. $6.50

MATHEMATICAL TABLES AND FORMULAS, Robert D. Carmichael and Edwin R. Smith. Logarithms, sines, tangents, trig functions, powers, roots, reciprocals, exponential and hyperbolic functions, formulas and theorems. 269pp. 5⅜ × 8½. 60111-0 Pa. $3.75

HANDBOOK OF MATHEMATICAL FUNCTIONS WITH FORMULAS, GRAPHS, AND MATHEMATICAL TABLES, edited by Milton Abramowitz and Irene A. Stegun. Vast compendium: 29 sets of tables, some to as high as 20 places. 1,046pp. 8 × 10½. 61272-4 Pa. $19.95

CATALOG OF DOVER BOOKS

REASON IN ART, George Santayana. Renowned philosopher's provocative, seminal treatment of basis of art in instinct and experience. Volume Four of *The Life of Reason*. 230pp. 5⅜ × 8. 24358-3 Pa. $4.50

LANGUAGE, TRUTH AND LOGIC, Alfred J. Ayer. Famous, clear introduction to Vienna, Cambridge schools of Logical Positivism. Role of philosophy, elimination of metaphysics, nature of analysis, etc. 160pp. 5⅜ × 8½. (USCO)
20010-8 Pa. $2.75

BASIC ELECTRONICS, U.S. Bureau of Naval Personnel. Electron tubes, circuits, antennas, AM, FM, and CW transmission and receiving, etc. 560 illustrations. 567pp. 6½ × 9¼. 21076-6 Pa. $8.95

THE ART DECO STYLE, edited by Theodore Menten. Furniture, jewelry, metalwork, ceramics, fabrics, lighting fixtures, interior decors, exteriors, graphics from pure French sources. Over 400 photographs. 183pp. 8⅜ × 11¼.
22824-X Pa. $6.95

THE FOUR BOOKS OF ARCHITECTURE, Andrea Palladio. 16th-century classic covers classical architectural remains, Renaissance revivals, classical orders, etc. 1738 Ware English edition. 216 plates. 110pp. of text. 9½ × 12¾.
21308-0 Pa. $11.50

THE WIT AND HUMOR OF OSCAR WILDE, edited by Alvin Redman. More than 1000 ripostes, paradoxes, wisecracks: Work is the curse of the drinking classes, I can resist everything except temptations, etc. 258pp. 5⅜ × 8½. (USCO)
20602-5 Pa. $3.50

THE DEVIL'S DICTIONARY, Ambrose Bierce. Barbed, bitter, brilliant witticisms in the form of a dictionary. Best, most ferocious satire America has produced. 145pp. 5⅜ × 8½. 20487-1 Pa. $2.50

ERTÉ'S FASHION DESIGNS, Erté. 210 black-and-white inventions from *Harper's Bazar*, 1918-32, plus 8pp. full-color covers. Captions. 88pp. 9 × 12.
24203-X Pa. $6.50

ERTÉ GRAPHICS, Erté. Collection of striking color graphics: *Seasons, Alphabet, Numerals, Aces* and *Precious Stones*. 50 plates, including 4 on covers. 48pp. 9⅜ × 12¼. 23580-7 Pa. $6.95

PAPER FOLDING FOR BEGINNERS, William D. Murray and Francis J. Rigney. Clearest book for making origami sail boats, roosters, frogs that move legs, etc. 40 projects. More than 275 illustrations. 94pp. 5⅜ × 8½. 20713-7 Pa. $2.25

ORIGAMI FOR THE ENTHUSIAST, John Montroll. Fish, ostrich, peacock, squirrel, rhinoceros, Pegasus, 19 other intricate subjects. Instructions. Diagrams. 128pp. 9 × 12. 23799-0 Pa. $4.95

CROCHETING NOVELTY POT HOLDERS, edited by Linda Macho. 64 useful, whimsical pot holders feature kitchen themes, animals, flowers, other novelties. Surprisingly easy to crochet. Complete instructions. 48pp. 8¼ × 11.
24296-X Pa. $1.95

CROCHETING DOILIES, edited by Rita Weiss. Irish Crochet, Jewel, Star Wheel, Vanity Fair and more. Also luncheon and console sets, runners and centerpieces. 51 illustrations. 48pp. 8¼ × 11. 23424-X Pa. $2.00

YUCATAN BEFORE AND AFTER THE CONQUEST, Diego de Landa. Only significant account of Yucatan written in the early post-Conquest era. Translated by William Gates. Over 120 illustrations. 162pp. 5⅜ × 8½. 23622-6 Pa. $3.50

ORNATE PICTORIAL CALLIGRAPHY, E.A. Lupfer. Complete instructions, over 150 examples help you create magnificent "flourishes" from which beautiful animals and objects gracefully emerge. 8⅛ × 11. 21957-7 Pa. $2.95

DOLLY DINGLE PAPER DOLLS, Grace Drayton. Cute chubby children by same artist who did Campbell Kids. Rare plates from 1910s. 30 paper dolls and over 100 outfits reproduced in full color. 32pp. 9¼ × 12¼. 23711-7 Pa. $3.50

CURIOUS GEORGE PAPER DOLLS IN FULL COLOR, H. A. Rey, Kathy Allert. Naughty little monkey-hero of children's books in two doll figures, plus 48 full-color costumes: pirate, Indian chief, fireman, more. 32pp. 9¼ × 12¼.
24386-9 Pa. $3.50

GERMAN: HOW TO SPEAK AND WRITE IT, Joseph Rosenberg. Like *French, How to Speak and Write It.* Very rich modern course, with a wealth of pictorial material. 330 illustrations. 384pp. 5⅜ × 8½. (USUKO) 20271-2 Pa. $4.75

CATS AND KITTENS: 24 Ready-to-Mail Color Photo Postcards, D. Holby. Handsome collection; feline in a variety of adorable poses. Identifications. 12pp. on postcard stock. 8¼ × 11. 24469-5 Pa. $2.95

MARILYN MONROE PAPER DOLLS, Tom Tierney. 31 full-color designs on heavy stock, from *The Asphalt Jungle,Gentlemen Prefer Blondes,* 22 others.1 doll. 16 plates. 32pp. 9⅜ × 12¼. 23769-9 Pa. $3.50

FUNDAMENTALS OF LAYOUT, F.H. Wills. All phases of layout design discussed and illustrated in 121 illustrations. Indispensable as student's text or handbook for professional. 124pp. 8⅛.× 11. 21279-3 Pa. $4.50

FANTASTIC SUPER STICKERS, Ed Sibbett, Jr. 75 colorful pressure-sensitive stickers. Peel off and place for a touch of pizzazz: clowns, penguins, teddy bears, etc. Full color. 16pp. 8¼ × 11. 24471-7 Pa. $2.95

LABELS FOR ALL OCCASIONS, Ed Sibbett, Jr. 6 labels each of 16 different designs—baroque, art nouveau, art deco, Pennsylvania Dutch, etc.—in full color. 24pp. 8¼ × 11. 23688-9 Pa. $2.95

HOW TO CALCULATE QUICKLY: RAPID METHODS IN BASIC MATHE-MATICS, Henry Sticker. Addition, subtraction, multiplication, division, checks, etc. More than 8000 problems, solutions. 185pp. 5 × 7¼. 20295-X Pa. $2.95

THE CAT COLORING BOOK, Karen Baldauski. Handsome, realistic renderings of 40 splendid felines, from American shorthair to exotic types. 44 plates. Captions. 48pp. 8¼ × 11. 24011-8 Pa. $2.25

THE TALE OF PETER RABBIT, Beatrix Potter. The inimitable Peter's terrifying adventure in Mr. McGregor's garden, with all 27 wonderful, full-color Potter illustrations. 55pp. 4¼ × 5½. (Available in U.S. only) 22827-4 Pa. $1.60

BASIC ELECTRICITY, U.S. Bureau of Naval Personnel. Batteries, circuits, conductors, AC and DC, inductance and capacitance, generators, motors, trans-formers, amplifiers, etc. 349 illustrations. 448pp. 6½ × 9¼. 20973-3 Pa. $7.95

CATALOG OF DOVER BOOKS

SOURCE BOOK OF MEDICAL HISTORY, edited by Logan Clendening, M.D. Original accounts ranging from Ancient Egypt and Greece to discovery of X-rays: Galen, Pasteur, Lavoisier, Harvey, Parkinson, others. 685pp. 5⅜ × 8½.
20621-1 Pa. $10.95

THE ROSE AND THE KEY, J.S. Lefanu. Superb mystery novel from Irish master. Dark doings among an ancient and aristocratic English family. Well-drawn characters; capital suspense. Introduction by N. Donaldson. 448pp. 5⅜ × 8½.
24377-X Pa. $6.95

SOUTH WIND, Norman Douglas. Witty, elegant novel of ideas set on languorous Mediterranean island of Nepenthe. Elegant prose, glittering epigrams, mordant satire. 1917 masterpiece. 416pp. 5⅜ × 8½. (Available in U.S. only)
24361-3 Pa. $5.95

RUSSELL'S CIVIL WAR PHOTOGRAPHS, Capt. A.J. Russell. 116 rare Civil War Photos: Bull Run, Virginia campaigns, bridges, railroads, Richmond, Lincoln's funeral car. Many never seen before. Captions. 128pp. 9⅜ × 12¼.
24283-8 Pa. $6.95

PHOTOGRAPHS BY MAN RAY: 105 Works, 1920-1934. Nudes, still lifes, landscapes, women's faces, celebrity portraits (Dali, Matisse, Picasso, others), rayographs. Reprinted from rare gravure edition. 128pp. 9⅜ × 12¼. (Available in U.S. only)
23842-3 Pa. $6.95

STAR NAMES: THEIR LORE AND MEANING, Richard H. Allen. Star names, the zodiac, constellations: folklore and literature associated with heavens. The basic book of its field, fascinating reading. 563pp. 5⅜ × 8½.
21079-0 Pa. $7.95

BURNHAM'S CELESTIAL HANDBOOK, Robert Burnham, Jr. Thorough guide to the stars beyond our solar system. Exhaustive treatment. Alphabetical by constellation: Andromeda to Cetus in Vol. 1; Chamaeleon to Orion in Vol. 2; and Pavo to Vulpecula in Vol. 3. Hundreds of illustrations. Index in Vol. 3. 2000pp. 6⅛ × 9¼.
23567-X, 23568-8, 23673-0 Pa. Three-vol. set $36.85

THE ART NOUVEAU STYLE BOOK OF ALPHONSE MUCHA, Alphonse Mucha. All 72 plates from *Documents Decoratifs* in original color. Stunning, essential work of Art Nouveau. 80pp. 9⅜ × 12¼.
24044-4 Pa. $7.95

DESIGNS BY ERTE; FASHION DRAWINGS AND ILLUSTRATIONS FROM "HARPER'S BAZAR," Erte. 310 fabulous line drawings and 14 *Harper's Bazar* covers, 8 in full color. Erte's exotic temptresses with tassels, fur muffs, long trains, coifs, more. 129pp. 9⅜ × 12¼.
23397-9 Pa. $6.95

HISTORY OF STRENGTH OF MATERIALS, Stephen P. Timoshenko. Excellent historical survey of the strength of materials with many references to the theories of elasticity and structure. 245 figures. 452pp. 5⅜ × 8½. 61187-6 Pa. $8.95

Prices subject to change without notice.
Available at your book dealer or write for free catalog to Dept. GI, Dover Publications, Inc., 31 East 2nd St. Mineola, N.Y. 11501. Dover publishes more than 175 books each year on science, elementary and advanced mathematics, biology, music, art, literary history, social sciences and other areas.

606